University College for the Creative Arts
at Canterbury, Epsom, Farnham, Maidstone and Rochester

CALIFORNIA DESIGN

CALIFORNIA DESIGN

The Legacy of West Coast Craft and Style

By Jo Lauria and Suzanne Baizerman

Foreword by Eudorah M. Moore
Introduction by Donald Albrecht
"Body Sculpture: California Jewelry"
by Toni Greenbaum

CHRONICLE BOOKS
SAN FRANCISCO

The photographs in this book are part of the California Design Archives of the Oakland
Museum of California and appear courtesy of the museum. The authors and publisher
acknowledge the foresight of the museum's Director, Dennis Power, and Chief Curator of
Art, Philip Linhares, who received the archives for the museum's permanent collection.

Library of Congress Cataloging-in-Publication
Data available.

ISBN 0-8118-4374-2

Design by Brett MacFadden
Typesetting by Janis Reed
Set in Fairplex, designed by Zuzana Licko

Manufactured in China.

Distributed in Canada by Raincoast Books
9050 Shaughnessy Street
Vancouver, BC V6P 6E5

10 9 8 7 6 5 4 3 2 1

Chronicle Books LLC
85 Second Street
San Francisco, California 94105

www.chroniclebooks.com

Contents

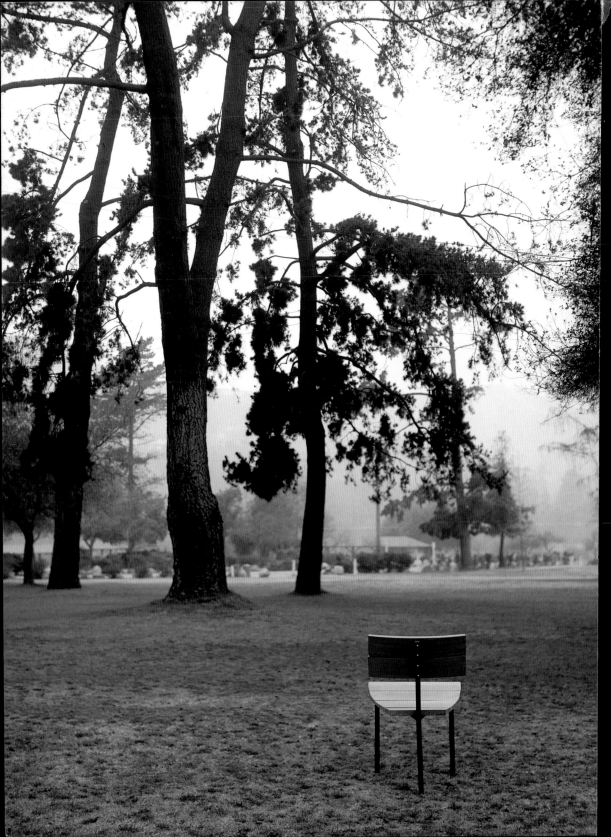

Foreword

EUDORAH M. MOORE, DIRECTOR, CALIFORNIA DESIGN

The period following the Second World War was one of population movement and social flux. Mature young men returned to take advantage of the GI Bill of Rights, in many cases swerving from past patterns to focus on the arts. Teaching jobs opened up, further nurturing what I call "The New Crafts Movement." A pervasive and palpable optimism seemed to permeate the air. Henry Dreyfus commented that instead of timid steps, an ebullient climate of "why not" prevailed. The new field of Industrial Design opened and blossomed, adding an aesthetic dimension to America's well known ingenuity. In the university climate, the age-old materials of wood, clay, fiber, metal, and glass were explored for their aesthetic potential rather than toward only functional ends. There can be no doubt that the emerging new expressions impacted and changed the language of art.

Inevitably, in this heady climate—so broadly productive, pulsing with experimentation—certain particularly strong, original, and able voices rang out.

Now, thirty years after the last *California Design* exhibition in 1976, it is interesting to note that the best work of this period is reemerging, being reevaluated, and being found as sound and interesting as ever. Time has silenced some of the strong voices, others are still productive and fresh, but review of the work reenforces the belief that quality speaks across generations and has enduring value.

Hendrik Van Keppel
for Van Keppel-Green;
Tripod Chair;
Enameled aluminum,
bleached and polished
redwood seat and back.
1962 *(California Design 8)*

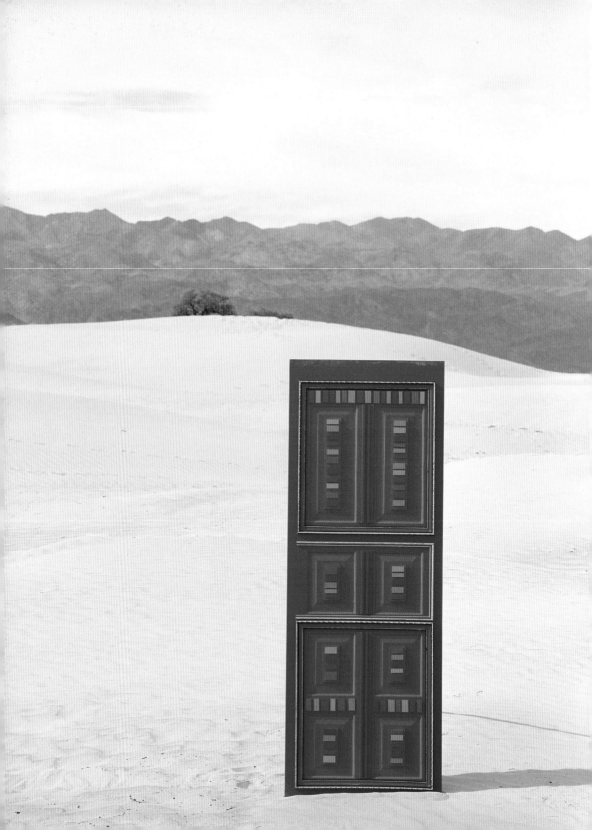

Introduction DONALD ALBRECHT

"One does not need to share all the illusions of the boosters to believe, as I believe," historian Carey McWilliams wrote in 1946, "that the most fantastic city in the world will one day exist in this region: a city embracing the entire region from the mountains to the sea."[1] Although he was boasting about post—World War II Los Angeles, McWilliams's prophesy of growth and prosperity could also be applied to all of California. The state had been a major destination in the vast national migration of Americans who moved during the war in search of well-paid defense work. The whole West Coast, with its massive aircraft and shipbuilding facilities, witnessed remarkable changes, but it was California that profited most from $35 billion in wartime federal funding. After the war, Americans continued to be lured by the state's mild climate and expansive Cold War—related industries. By 1967, California's economy ranked sixth among nations in the world.[2]

These economic and demographic shifts permanently changed the nation's regional balance, giving California newfound status and independence from the East Coast. Benefiting from their exalted position, Californians boldly redefined the American Dream. They popularized then-radical ways of living, from patio houses to automobile-based cities, which were promoted through media such as magazines, movies, and music. High-profile postwar architecture and design initiatives helped raise California lifestyles and their accoutrements to national consciousness. In 1945 the avant-garde magazine *Arts + Architecture* launched the Case Study House Program, which sponsored the design and construction of a series of modern homes as prototypes for postwar housing. Equally ambitious—yet curiously less celebrated—were the *California Design* exhibitions, a series of thirteen shows featuring the applied arts and presented primarily at the Pasadena Art Museum between 1954 and 1976. Combining both handcrafted and mass-produced goods, the series sought to highlight and encourage new talent throughout California. New forms, materials, and technologies were showcased as the state's designers and artisans exploited revolutionary innovations in lightweight metals, molded plywood, reinforced concrete, and plastics. Prototypes of innovative furniture and accessories, persuasive harbingers of things to come, were featured in virtually every show. Ultimately, *California Design* put the Golden State on the national design map.[3]

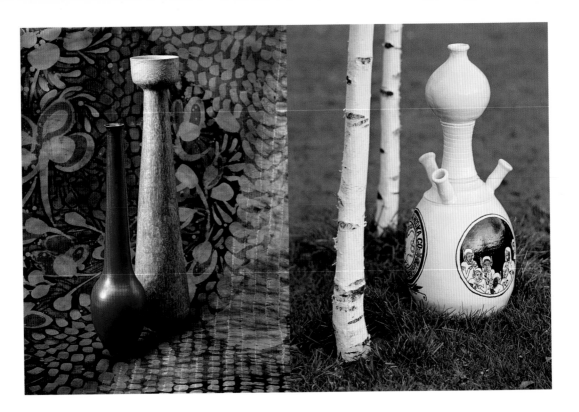

The compelling image of California presented by the exhibitions and their accompanying catalogues suggested a state where people enjoyed the fruits of postwar American life, combining indoors and outdoors, high and low style, contemporary technology, and traditional handicraft. In the series' heyday in the mid-1960s and 1970s, the "far-out" novelty of the objects mirrored the era's ethos of individual expression and "doing your own thing" that was embodied by the hippie counterculture. Fantasy and a back-to-nature environmentalism served as artistic antidotes to social upheavals marked by urban riots and the Vietnam War. At the same time, the inclusive approach of the series blurred the boundaries between art, design, and craft, aligning *California Design* with the era's hybrid aesthetic and defiance of convention.

California's migratory population and cultural diversity were also reflected in the series. "With more than 365,000 people a year moving into the State of California," claimed the *California Design 9* catalogue in 1965, "and with each bringing a fragment of his cultural past to play on the design demands of the area, there is here, perhaps, a more eclectic taste than any other place in the world."[4] This proto-multiculturalism was evidenced not

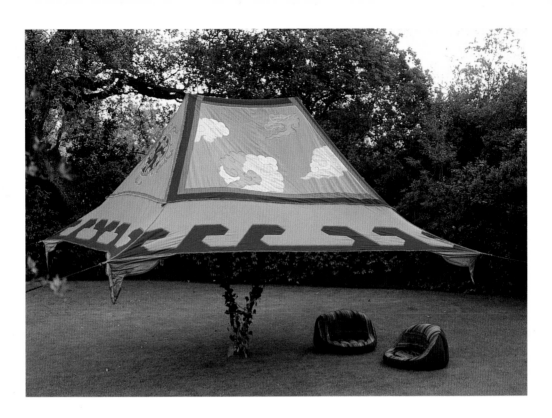

above:
Figure 0.4
Thomas Glenn,
appliquéd canopy.
1976 *(California Design '76)*

only by the inclusion of designers such as Danny Ho Fong of Tropi-Cal and Neda Al-Hilali, but also by showcasing exotic (i.e., non-American) forms and techniques. *California Design 10* (1968), for example, featured Carol Ryoko Funai's tie-dyed and batik silk textiles (fig. 0.2) and Michael Frimkess's *Hookah* ceramic pot, an artifact that also represented the era's drug culture (fig. 0.3). Some featured designers even established cottage industries to bring foreign crafts to the United States and benefit artisans in developing countries. In *California Design '76,* Mark Johnson and Jeanine Brinkman's rug designs were made by weavers in Oaxaca, Mexico, and Tibetan refugees in Nepal produced Thomas Glenn's appliquéd cotton canopy (fig. 0.4) and beanbag chairs. California's democratic taste, the series' organizers suggested, would soon rival the cultural diversity of such postwar powerhouses as Denmark and Sweden, as California's booming population of nearly 20 million in the mid-1960s was approaching that of all the Scandinavian countries combined.[5]

California's own history, mythos, and landscape were inspirational. The catalogue of *California Design 8* (1962), for example, grouped some of the exhibition's objects into "native" themes. "California design in native color orange," for example, drew from the Valencia oranges that Roman Catholic

left:
Figure 0.5
(group of six items)
Wes W. Williams,
outdoor hanging mural,
canvas.
1962 (*California Design 8*)

Wes W. Williams,
Jacks stool,
steel tube frame and
plastic top.
1962 (*California Design 8*)

Hendrik Van Keppel
of Van Keppel-Green,
library table,
enameled metal frame
and stained ash.
1962 (*California Design 8*)

Selje and Bond,
banjo clock.
1962 (*California Design 8*)

John Follis,
pair of matte-glazed urns.
1962 (*California Design 8*)

Gere Kavanaugh,
Daisy Chain wallpaper.
1962 (*California Design 8*)

mission fathers introduced to the state in the mid-nineteenth century. "One hundred years of orange fruit as a part of the native landscape has naturalized orange to indigenous color," the catalogue noted. "The California designer, therefore, understandably employs it as a design tool."[6] Products included a walnut writing chest by Espenet with drawers and compartments lined in orange felt and a walnut and orange leather office chair by Sam Maloof. Homage was also paid to the state's "native earth," represented by such objects as Sheldon Kaganoff's massive stoneware pot, and to "the beauty of gold," with Wes Williams's gilded furniture reflecting "California life since the days of the early prospectors"[7] (fig. 0.5). In a nod to the state's demographic openness in *CD 9* (1965), a selection of door designs represented "a symbol of welcome, of entry to new horizons and new possibilities"[8] (fig. 0.1).

In order to justify its claim of showing the best of California design, the series gathered material from every region in the state. The Los Angeles area, however, served as the ideal arena for the exhibitions themselves. Southern California was the home of glamorous and popular Hollywood movies and television programs. It was also the second-largest furniture manufacturing center in the United States (after North Carolina). Equally important for the series' experimental thrust was the region's promise of a bright, technological future. After World War II, Southern California's

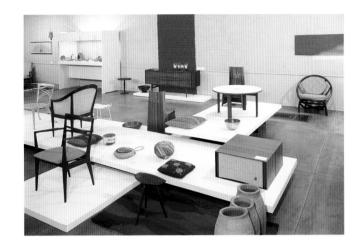

forward-looking defense and aerospace manufacturing fostered tremendous urban growth that expanded the metropolitan area exponentially for the next three decades.[9]

The twenty-one-year history of this remarkable series of exhibitions and catalogues divides into two phases, separated by differences in concept, scope, personnel, and geographic range. *California Design* was launched in 1954 as an annual project of the Pasadena Art Museum. The first seven annual shows and their modest booklets—*California Design 1* in 1954—55 through *California Design 7* in 1961—were conceived as showcases to educate consumers about designs that had "simplicity, appropriate form, function, and economy."[10] Furnishings such as simple hi-fi sets, televisions, outdoor furniture, and wall dividers represented antidotes to the frenzied pace of modern life and the "transitory interest" of contemporary design clichés, presumably Chinese modern motifs or extravagant boomerangs.[11]

The spirit of the first seven shows was similar to that of the Museum of Modern Art's 1950—55 *Good Design* exhibitions, organized by the museum for the Merchandise Mart in Chicago and shown each year at both venues. While the primary difference between the two series was New York's international scope versus its West Coast counterpart's California focus, both sought to promote modern design to middle-class homeowners. Both featured mass-produced and handcrafted products, offered a wide range of contemporary furnishings, appliances, textiles, and accessories, and shared an avid interest in the furniture of legendary Los Angeles designers Charles and Ray Eames. The 1960 *California Design 6* exhibition celebrated these local design leaders by elevating their 1940s molded-plywood chairs to "classic" status. The Eameses would continue to exhibit in the series, their

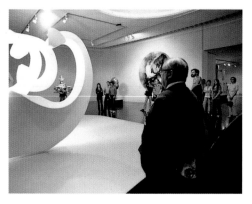

presence serving to raise the prestige not only of the other entries but of the exhibition project itself.[12]

The 1962 *California Design 8* exhibition marked an important turning point in the series. Not only did the shows become triennial rather than annual exhibitions, but their focus and ambition shifted under the auspices of a new director, Eudorah M. Moore, who had been president of the Pasadena Art Museum's board of trustees. (Elizabeth F. G. Hanson was Moore's codirector for *CD 8*). Catalyst, muse, and talent scout, Moore had the vision to expand the scope and scale of the series and its catalogues, and her enthusiasm kept *California Design* fresh and innovative for almost fifteen years. She served as the pied piper of an army of volunteers, mostly the craft community but also some Pasadena high society women, who cleaned, painted, and installed the expansive exhibitions on shoestring budgets. (Moore, for example, mounted *CD 8* in 1962 and published its catalogue for only $20,000.)[13]

Moore also instituted changes that raised the quality of the exhibitions' artifacts. Whereas the selection process for the first seven shows involved searching local furniture marts, a jury system was established with *California Design 8*. People were invited to submit entries, which were judged by leading designers and craftspeople. Submissions were allowed from the entire state of California. (During the first phase, the range was limited to goods that had been manufactured or designed in Los Angeles County, since the exhibitions received funding from the Los Angeles Board of Supervisors.) These changes resulted in a show that occupied virtually all of the Pasadena Art Museum, approximately 12,000 square feet of space with more than 750 pieces on display.

California Design 8 ushered in other changes as well. There were increasingly large, lavishly illustrated catalogues, which Moore felt should include every participant in order to ensure the prolonged life of their work

and which thus disseminated the shows' excitement and diversity beyond the people who actually attended them. Moore also launched national promotional campaigns (first with Elizabeth Hanson, then traveling solo), bringing suitcases full of photographs to New York editors and ultimately succeeding in winning major coverage for the series in decorating magazines and newspapers across the country. "Every three years," *House Beautiful* announced in a colorful, seven-page spread in 1968, "creative design in California explodes with a bang."[14]

At the same time, the forms of the objects became increasingly unconventional, colors were brighter and in unexpected combinations, patterns bolder, and textures thicker, more sculptural, and seemingly wrought by hand. Handcrafted furniture, ceramics, glass, textiles, jewelry, and industrial products that simulated hand processes were celebrated throughout these shows, exemplifying the powerful role of craft, which had emerged as a popular artistic trend after World War II. At that time, some of the more innovative American woodworkers, ceramicists, and metalsmiths moved beyond the previously accepted emphasis on traditional materials and function. Throughout the country, the postwar education boom, spurred by the

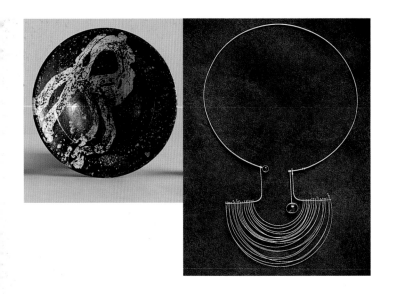

far left:
Figure 0.11
William C. Quirt,
raku platter.
1968 (*California Design 10*)

left:
Figure 0.12
John Snidecor,
necklace,
gold and amethyst.
1968 (*California Design 10*)

opposite:
Figure 0.13
(multiple views)
Duane Brown,
door,
foam and fiberglass.
1971 (*California Design 11*)

GI Bill, brought craftspeople into university art departments and art schools and introduced them to the same training and conceptual concerns as their fine art contemporaries.[15] The rough surface and bold brushstroke effects that exposed the hand-done process of William Quirt's raku platter (*CD 10,* 1968) were akin to the powerful, gestural strokes of Abstract Expressionist painting (fig. 0.11). The postwar enthusiasm for geometric abstraction characterized Max Neufeldt's *Welded Metal Tapestry* (fig. 0.10), John Snidecor's gold and amethyst necklace (both *CD 10*) (fig. 0.12), and, perhaps the series' most extravagant design, Duane Brown's slowly opening and rotating six-piece doors in sculptured foam and fiberglass (*CD 11,* 1971) (fig. 0.13).

In explaining the merging of craft and fine art interests, Eudorah M. Moore credited California's famous university system, which from the late 1950s to the late 1960s grew from a group of specialized campuses to a system of eight general campuses with twice the number of students. She noted in 1971 that a "strongly individual almost frontier syndrome of doing things oneself . . . has been abetted by an educational system. . . . This period of freedom to adventure in materials—most particularly in the State College system—has brought about a great surge in the quality and diversity of the crafts output in California."[16]

The series' eclectic mix of art, design, and craft was not always universally praised. "The diversity of design is surprising and perhaps confusing," *House Beautiful* said of *California Design 10* (1968).[17] *Craft Horizons* felt the show was "too big and too unselective—pruning of at least one-third would have been beneficial."[18] Moore defended the series' exuberance on various

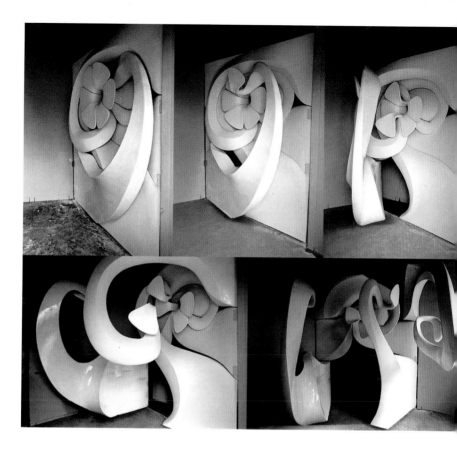

levels. She was determined to promote as many California designers as possible. She told *House Beautiful,* "There is a difference in attitude between the indigenous Easterner and the Westerner. A careful and overly cautious attitude [exists] in the East. The Westerner asks 'Why not?' . ∴. Even our quality of light is different. We live in an open, permissive brilliance that must affect people's attitudes and expression." The series' designs were also extroverted, like Californians themselves, "with a personality expression," Moore ironically noted, "that doesn't have to do so deeply with the inner psyche and the final and terrible grim compulsions of modern man."[19]

In its promotion of both craft and manufactured goods, the *California Design* series also dramatized what many Americans had begun to fear: that the uniformity of the postwar landscape—mass-produced Levittowns and trailer parks, steel-and-glass offices, fast-food restaurants, and chain motels, all indistinguishable from one another—was turning people into auto-matons. The Beat Generation brought these concerns to the fore in art and literature, as did Saul Steinberg's lighthearted cartoons of skyscrapers with

glass walls gridded like accountants' ledgers. Even Hollywood promoted the value of working with one's hands. In Douglas Sirk's 1956 film *All that Heaven Allows,* a widow (Jane Wyman) narrowly escaped the cold, conformist, country-club world of her late husband by marrying a young gardener (Rock Hudson), whose friends were craftspeople and who was converting a barn into a unique residence. Craft and do-it-yourself activities were thus seen as ways to counteract the dehumanizing effect of postwar modern life, as both the craftsperson, who produced one-of-a-kind objects with his or her own hands, and the designer-craftsperson, who worked for industry, were called into service. "The combination of intellect and manual . . . dexterity," Moore said, "is what becomes valuable in any century."[20]

The lure of California's spectacular natural landscape was a major theme explored in the shows. Moore was especially interested in presenting designs that facilitated an active outdoor lifestyle such as sailboats, canoes, tents, dune buggies, lightweight backpacks, outdoor furnishings, and even a hanging chair made from a curved tree branch (fig. 0.15). The allure of nature was equally evident in the catalogues' photography. With *California Design 8* (1962), photographer Richard Gross was hired to shoot catalogue and publicity stills and preferred to use natural settings and available light. Driving a rented RV, Gross and Moore brought exhibition pieces to dramatic locations that ranged from forested parklands to the Death Valley desert. This technique served to contextualize the objects by placing them in the California landscape, suggesting the metaphorical origins of the work. Bernard Kester, who exhibited his ceramics in the shows and designed many of the installations, employed a similar vignette style to make the objects "readable" for visiting homeowners and show how they could be displayed together in domestic environments.[21]

Not all the objects displayed in *California Design* embraced nature and the great outdoors. Although there had been little criticism of metropolitan growth after World War II, by the 1960s and 1970s many people saw the problems of Los Angeles and California as symptomatic of postwar America's problems. Alongside chronic pollution (dubbed "smog"), race riots, and student antiwar demonstrations, California's shrinking landscape was a cause for concern. In *California Design 11* (1971), for example, products included self-contained contemplative environments such as Jack R. Hopkins's *Womb Room* and Barbara Shawcroft's *Arizona Inner Space.* Refuges from the modern world, these designs evoked the era's search for altered modes of consciousness in the form of Eastern transcendental meditation, mind-body theories, and hallucinogenic drugs.

above:
Figure 0.14
Photo shoot for
California Design '76

opposite, left:
Figure 0.15
James Roger Dupzyk,
hanging chair,
wood,
16 x 36 x 72 inches.
1968 (*California Design 10*)

opposite, center:
Figure 0.16
Eudorah M. Moore
on photo shoot for
California Design 10,
1968

opposite, right:
Figure 0.17
Douglas Deeds and
Associates,
chairs.
1962 (*California Design 8*)

Environmentally and aesthetically tied to the state of California, the design exhibitions were institutionally linked to the fortunes and outlook of their host venue, the Pasadena Art Museum (PAM). Although founded in 1924, the museum would not reach its international heyday until after World War II, when it became the most important venue in California for contemporary art and music and introduced to the region such artists as Andy Warhol and Roy Lichtenstein.[22] Throughout the 1960s, *California Design* both benefited and suffered from its association with the museum. On the one hand, PAM was an institution that celebrated the cross-pollination between art and design. The museum's championing of assemblage sculptures comprised of detritus and junk, such as George Herms's *The Librarian* (1960) and Edward Kienholz's *The Secret House of Eddie Critch* (1961), mirrored the selection of similar objects in the design exhibitions, such as the chair in *CD 8* (1962) designed by Douglas Deeds and Associates and made entirely of discarded beer cans (fig. 0.17). Presentation of ceramicist Peter Voulkos's expressionist work in *CD 2* (1956), *CD 3* (1957), and *CD 4* (1958) was quickly followed by a solo show of his work at the museum in 1958. Experimenting with modern industrial materials such as Plexiglas, fiberglass, and resins was of as much interest to artists in PAM's collections, such as Craig Kauffman, as it was to *California Design* participants from Duane Brown to Svetozar Radakovitch. Known as an environment of "unlimited possibilities," according to Lois Boardman, an integral member of the series' team, PAM also possessed a vaunted avant-garde status that advanced the design series' progressive agenda throughout the United States.[23]

On the other hand, the populism of *California Design* was often at odds with the museum's more elite, internationalist approach, especially

after the legendary gallery owner and critic Walter Hopps assumed the role of curator of fine art in 1962. (Hopps would later serve as the museum's director.) While the design shows attracted the largest crowds of any PAM exhibitions, they did not adhere to the high aesthetic standards of the new generation of directors and fine arts curators. Those involved in *California Design* came to feel that the museum did not fully support their efforts.[24]

The real cause of the demise of the *California Design* exhibitions was the Pasadena Art Museum's dire financial straits, which were exacerbated by the opening of a new building in 1969. In 1974 the museum's board of trustees agreed to a takeover by financier and collector Norton Simon, who converted the formerly public museum into a private one for his own collection. The entire staff was fired. Moore and her team struggled to present two additional exhibitions under private auspices at other venues. *California Design 1910* in 1974, held at the Pasadena Exhibition Center, was a landmark and influential survey of the Arts and Crafts movement, which was the basis of the series' emphasis on nature and design for everyday life. *California Design '76,* presented at the newly opened Pacific Design Center, projected "a fresh vitality," *Craft Horizons* magazine noted, "particularly reflective of the young generation of craftsmakers actively pursuing a wide range of ideas, forms, and media."[25]

By this time, however, Moore, the driving force behind the series, questioned whether her original exhibition concept of exploring the shared concerns of design and craft was still viable. "The dialogue between industrial design and craft had changed," Moore told *American Craft* magazine in 1997, alluding to the separation of the disciplines as they each became more specialized and professional. "The languages didn't mesh as well. Increasingly, I felt there was less and less amenability."[26]

Within a few years, after attempts to keep the series alive failed, *California Design* ended. While it had achieved a number of goals—bringing unknown talent to public attention, spurring artists and craftspeople to new aesthetic heights, and paving the way for refinements in crafts during the 1980s and 1990s—the series' greatest achievement was its advocacy of national ideals. Building on the broad perspective she had developed for the *California Design* series, Eudorah M. Moore soon moved to Washington, DC, to become craft coordinator for the National Endowment for the Arts. In 1977 a book of comments by craftspeople conceived by Moore and written by Olivia Emery, titled *Craftsman Lifestyle: The Gentle Revolution,* was published. At that time, oil crises, crippling inflation, and the nation's defeat in Vietnam were souring many Americans on their country. Moore, however,

remained steadfast in her support of an American dream that fostered action, optimism, and individual expression, and she concluded the book's introduction by praising people who create objects that merge mind and heart and serve to better the lives of everyone. Like Moore's own career, the *California Design* exhibitions had extended a regional ethos to a national agenda, making California both stage and symbol of that agenda. "What America is," Los Angeles journalist Farnsworth Crowder noted before the post—World War II boom, "California is, with accents, in italics."[27]

1. Carey McWilliams, *Southern California: An Island on the Land* (Salt Lake City: Gibbs M. Smith/ Peregrine Smith Books, 1983), 20. (Orig. pub. 1946.)

2. John M. Findlay, *Magic Lands: Western Cityscapes and American Culture After 1940* (Berkeley and Los Angeles: University of California Press, 1993), 19. (Orig. pub. 1992.)

3. I am indebted to Jo Lauria and Suzanne Baizerman for their insightful comments on the *California Design* series.

4. Robert A. Rowan [president, board of trustees, Pasadena Art Museum], "Introduction," *California Design 9* (Pasadena: Pasadena Art Museum, 1965), 9.

5. Ibid.

6. *California Design 8* (Pasadena: Pasadena Art Museum, 1962), 21.

7. Ibid., 56.

8. *California Design 9,* unpaginated.

9. Findlay, *Magic Lands,* 19.

10. *California Design 6* (Alhambra: Museum Reproductions, 1960), 7. This catalogue was written by the exhibition's director, Robert

Clemens Niece. The person most consistently associated with the first seven shows is Clifford Nelson, who directed and/or designed *CD 1* through *CD 5.*

11. Ibid.

12. Interview with Jo Lauria, Suzanne Baizerman, and Eudorah M. Moore, January 15, 2004.

13. Moore interview.

14. Sue Nirenberg, "Behind the California Vision," *House Beautiful* 110, no. 10 (April 1968), 66.

15. Davira S. Taragin and Edward S. Cooke, Jr., *Furniture by Wendell Castle* (New York: Hudson Hills Press/Founders Society, Detroit Institute of Arts, 1989), 15.

16. Eudorah M. Moore, "Foreword," *California Design 11* (Pasadena: *California Design,* 1971), 9.

17. Nirenberg, "Behind the California Vision," 66.

18. Helen Giambruni, "California Design X," *Craft Horizons 28,* no. 2 (March/April 1968), 11.

19. Nirenberg, "Behind the California Vision," 66, 68.

20. Ibid., 68.

21. Interview with Jo Lauria, Suzanne Baizerman, and Bernard Kester, January 14, 2004.

22. For a valuable assessment of the postwar Pasadena Art Museum, see the catalogue to the exhibition *Radical Past: Contemporary Art & Music in Pasadena, 1960—1974* (Pasadena: Armory Center for the Arts and Art Center College of Design, 1999).

23. Interview with Jo Lauria, Suzanne Baizerman, and Lois Boardman, January 15, 2004.

24. Boardman interview; Jay Belloli, "Lasting Achievements: The Pasadena Art Museum," *Radical Past,* 14.

25. Bernard Kester, "California Design '76," *Craft Horizons 36,* no. 2 (April 1976), 44.

26. Quoted in Jo Lauria, "Riding the Wave: The California Design Exhibitions, 1955—1976," *The Modernism Magazine 4,* no. 2 (Summer 2001), 35.

27. Quoted in McWilliams, *Southern California: An Island on the Land,* 370.

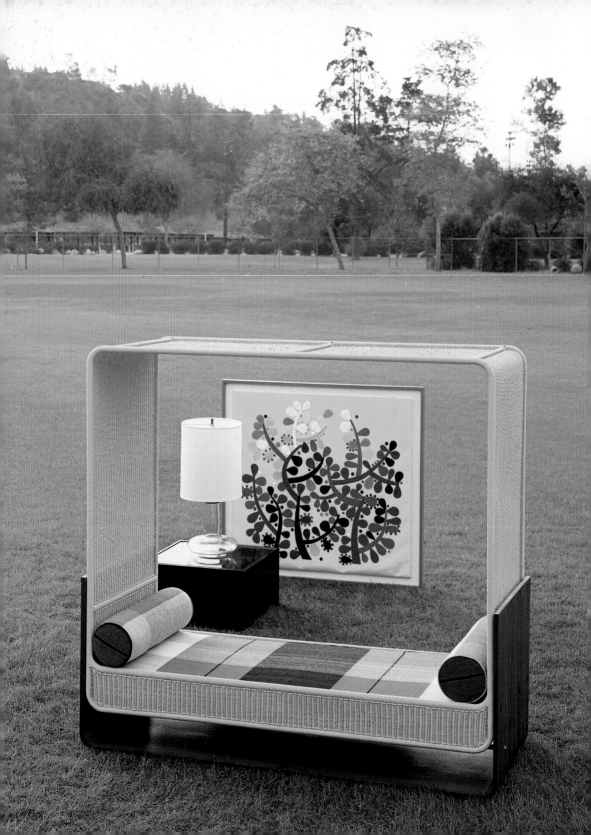

Chapter 1

Production Furniture: Manufacturing a California Style

JO LAURIA

The modern production furniture featured throughout the *California Design* series was an exciting, eclectic mix of everything from plastic TV trays and kitchen appliances to ultra-hip Eames chairs, to kookie knock-down components to complete modular office systems. According to the press release issued for *California Design 2* (1956), the visitor would enjoy a unique design experience at the exhibition site: "Arranged in groups and 'rooms,' the forms, colors and textures of the Pasadena exhibits are like abstract patterns in space, enlivening the imagination, engendering a feeling of freedom, teaching the public what possibilities unconventional ideas may offer for the building of their environment. One might find in this design show a reflection of California spirit and casual living."[1] Due to the wide-ranging and diverse selection of products, and their engaging installations into room settings, production furniture satisfied the culturally curious, as well as those striving to keep up on the most exhilarating and progressive developments in the field. This section also accounted for the largest number of pieces and dominated the display space. It was a veritable feast for the eyes, as museumgoers strolled through the furniture exhibits and were wowed by the expressive possibilities and advanced solutions presented by the state's most innovative designers. The most actively promoted of the categories, production furniture also forged the strongest link between manufacturer and consumer.

The exhibition directors generally accepted the broad definition of "production furniture" established by the large manufacturing companies at mid century and affirmed by the design community of makers, writers, and historians. Briefly, production furniture is furniture design reduced to its most simplified form. Production items must be manufactured in multiples in assembly-line fashion, and at an affordable cost, for both the producer and the consumer. The original concept of the designer is necessarily influenced by the materials chosen for production and by current technology. In 1948, George Nelson, the now-legendary designer who was head of production at Herman Miller, outlined the principles that guided production at the company (and would ultimately influence furniture production for the next half century). He stressed not only the importance of good design, but also the necessity of the designer's continued involvement as the design evolved through the production process.

As a category, production furniture was also the most consistent in design throughout the twenty-one-year span of the exhibitions, in contrast to the handmade pieces executed by designer-craftsmen, which underwent dramatic transformations. The handcrafted, one-of-a-kind objects more deeply reflected the spirit of their time and often mirrored social changes and the resulting aesthetic shifts. Production furniture, however, was much less responsive to cultural influences. Designs for mass production had to have wide appeal and a long shelf life (to realize return on investment). Therefore, change was a slow and considered process. Technological innovations and development of new materials were the factors that had the greatest effect on production furniture designs.

With rare exceptions, the production pieces displayed in the *California Design* exhibitions reflected the furniture trends and developments of manufacturers in Southern California, predominantly those from the Los Angeles region. During this period, there were only a few furniture production companies in Northern California, and their wares represented only a small percentage of the exhibited works.[2] Therefore, to tell the story of modern furniture as showcased in the *California Design* exhibitions is to recount the story of post—World War II Los Angeles. It was the time and the place where new ideas, new technologies, and economic affluence converged to position furniture at the center of design innovation. The radically new production furniture promoted by the exhibitions underscored Los Angeles—and, by extension, California—as a location where progressive design and modernist furniture were at home.

With postwar population growth and the expansion of industry, mid-twentieth-century Los Angeles became a model of modern suburbia, a sprawling city of interconnecting highways linking mountain and valley, desert and ocean. Eternal sunshine, a sense of endless space, and an openness that seemed both physical and social were the city's alluring promises. Los Angeles was "far west" of the established social systems and traditionalism that had taken root in East Coast cities.

Drawn to this progressive environment were many talented and influential architects and designers who made Southern California their home after the war. They soon found in Los Angeles a vital center for cultural experimentation. Resourceful and imaginative, they applied their skills to architectural structures, interiors, industrial design, and furniture production. Eudorah M. Moore, director of the *California Design* exhibitions from 1962 through 1976, incisively assessed this time period: "The war was a great design breeder. The displacement of people, people returning or deciding to

page 22:
Figure 1.1
Danny Ho Fong for Tropi-Cal; *Form* bed, or *Canopy* bed; woven rattan and formed plywood legs. Displayed with Jean Ray Laury, *Peyote Patch*, stitchery panel; Clyde O'Gorman Morrison for Morrison Imports, *Captain's Decanter*, hand-blown crystal lamp; Murray Feldman, A.E. Furniture Manufacturing Co., *Cube* table, enameled steel top, lacquered wood base. 1968 (*California Design 10*)

change their places of abode, or their directions; the development of new materials to experiment with; the existence of the G.I. Bill. All gave major impetus to a new attitude and movement."[3]

The massive increase in housing developments created an urgent need for accessible, affordable, and well-designed home furnishings. "From Grand Rapids to Southern California, furniture called 'modern' started pouring out of the factories, and it could hardly be produced fast enough to satisfy demand," design historian Cara Greenberg noted, commenting on the postwar marketplace.[4] Factories in Los Angeles that had been engaged in the wartime production of steel, cast aluminum, welded wire mesh, molded plywood, rubber, fiberglass, and plastics were already tooled up to manufacture the materials and components needed to meet the design demands of modernist furniture forms. By the early 1950s, Los Angeles was rated as the nation's second-largest center for furniture production, outranked only by the long-established furniture manufacturing centers of North Carolina.[5]

The first seven *California Design* exhibitions, from 1954—1955 through 1961, were broadly conceived explorations in the area of home furnishings, decorative accessories, and household consumer goods. The spectrum of exhibited items was so wide ranging that a sliding door frame, a transportable television set, cooking pans, kitchen bowls, a pocket radio, and an aluminum suitcase could share the same display space (figs. 1.2, 1.3, 1.4). These early exhibitions contained the most exemplary pieces of home furnishings from the commercial displays at the Los Angeles Furniture Mart. The directors used the Furniture Mart as the primary source for their selections, and since

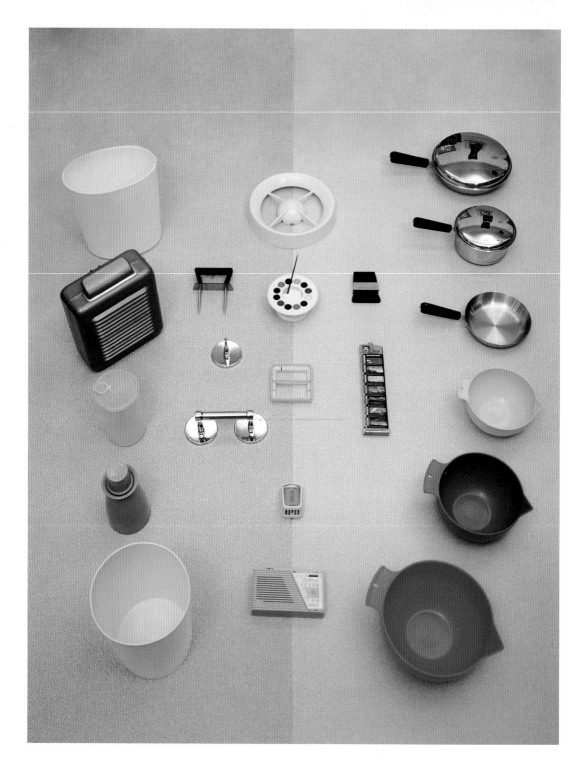

California Design

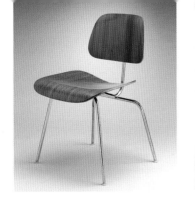

it predominantly showcased production wares, furniture designed for mass production far outnumbered limited-production crafts pieces. In the first seven shows, only a few handcrafted, made-to-order pieces appeared, and most were by master furniture maker Sam Maloof. By contrast, production furniture was consistently well represented, covering the full spectrum of household and exterior furnishings, including chairs, sofas, beds, tables, and lamps.

Objects were selected for the exhibitions based on how well they followed the exhibition guidelines established and refined by the first directors and passed on to subsequent organizers. The guidelines included four core principles of design against which an object was judged: simplicity, appropriate form, function, and economy.[6] The now-iconic Charles and Ray Eames dining chair of molded plywood and metal, the *DCM* (fig. 1.5), was selected by the director of *CD 6* (1960), Robert Clemens Niece, "as one of the examples of 'classic' design shown to underline the approach used in the judging for the exhibition," as it demonstrated "design according to principles."[7] Another fluent expression of these design standards from *CD 6* was the elegant, trim *Low Table* by Gerald McCabe, which demonstrated, again according to Niece, "a clear reflection of the materials used and the manufacturing methods."[8] In the table, McCabe deftly combined an inlaid wood top with legs fabricated of metal—a cold and exacting industrial material—to create a hybrid modernist form tempered by organic and naturalistic properties. Furthermore, McCabe employed the innovative production method of flame-cutting the metal to achieve precision joinery, a technique he had learned working in the shipbuilding industry during the war. McCabe's ingenuity with construction methods and materials was further demonstrated in his *Slat Chaise Lounge* (fig. 1.6), where he combined a precision-cut and joined metal frame with flexible and upholstered wood slats, resulting in a stylish reclining form that achieved both grace and comfort.

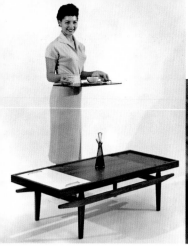

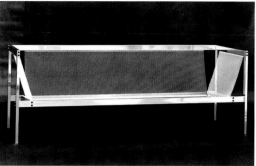

These design standards were securely in place from the very beginning. In the foreword to the catalogue of the first exhibition in 1954—55, director W. Joseph Fulton stated: "The primary requisites for objects included in the exhibition are that they be designed in California and that they solve the various design problems involved with unusual interest and success from a visual viewpoint."[9] In *CD 2* (1956), the exhibition photograph of Garry M. Carthew's walnut *Cocktail Table* with black-and-white removable plastic trays clearly supports these principles (fig. 1.7): an attractive young "modern" woman demonstrates the functionality of the removable trays (solving the design problem with "unusual interest"), and the cocktail table confirms the modernist design credo of clean lines, elegant geometries, undecorated surfaces, and innovative use of materials.

As noted in Donald Albrecht's introduction to this book, a sea change occurred when Eudorah M. Moore assumed directorship of the *California Design* exhibitions in 1962. Moore's establishment of a jury system and her vigorous solicitation of submissions from designers and craftsmen had great impact on the quality and diversity of the objects chosen. In the case of production furniture, Moore encouraged designers to submit prototypes, a category that had not previously been included. She believed that the exhibitions should be used as forums for designers to introduce their concepts to prospective manufacturers, thereby "cutting down on the time they spend knocking on manufacturers' doors."[10] The inclusion of the highly experimental and exploratory prototypes substantially altered the mix (fig. 1.8). Production furniture became a more dynamic category, as the prototypes stimulated ideas as well as discussions about the possible applications of new forms, new production and construction techniques, and new materials.

above, left:
Figure 1.7
Garry M. Carthew;
manufactured by Tempo
Furniture Manufacturing;
publicity photograph;
Cocktail Table;
walnut, plastic black-and-
white removable trays
(entry no. 31).
1956 (*California Design 2*)

above, right:
Figure 1.8
William Rietkerk and
Gordon Bird;
Bird-Rietkerk Associates;
prototype sofa;
polished aluminum,
chainmail, removable
down pads (not shown).
1968 (*California Design 10*)

opposite:
Figure 1.9
Tim M. Uyeda and Robert
Fujioka for Design West;
manufactured by
Samsonite Corporation;
stacking chairs;
chrome steel rod,
polypropylene seat
and back.
1968 (*California Design 10*)

An overview of the production furniture featured in all twelve exhibitions highlights the prominence of a few designers and manufacturers whose products were consistently recognized as being on the cutting edge of California design, and whose furniture pieces were a unique expression of the West Coast lifestyle. Their products emphasized versatility; adaptability for indoor and outdoor use; straightforward structure; contemporary approaches to traditional materials and methods; and the employment of new synthetics and machine processes (fig. 1.9).

Catalogue descriptions revealed attempts to define the design response to the California environment: "California design for native needs and way of life," and "California designs many moods" with "new freedom and experimentation." Themes were created by the grouping of objects according to variations on a form or design trends: "Multiplicity of Solutions to the Problem of Seating"; "The New Look of Elegance"; "Furniture for Public Spaces—Street, Airport, and Contract Furniture"; "Accent on Lights"; and "Knockdown and Interchangeable Furniture."

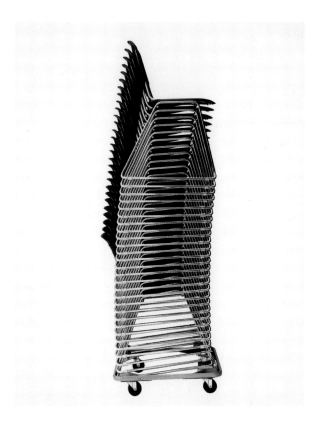

The designer that best exemplified the "palpable sense of delight in the way of life of the Southern California country,"[11] as Moore put it, was Danny Ho Fong, owner of Tropi-Cal, established in 1952. Tropi-Cal's name reflected Fong's attitude about rattan furniture—that it was tropical and also very Californian. According to Danny's son, Miller, who became a design partner in the company, his Chinese immigrant father was an American success story: "He had little education, no technical skill, but had native gifts of design. He was truly a pioneer in contemporary rattan, a category he invented, as no one at that time was using rattan to create modern forms"[12] (figs. 1.10, 1.11).

Several pieces from Tropi-Cal's furniture line were selected for each *California Design* exhibition. Working with the craftspeople of Hong Kong, Danny and Miller were able to develop patterns and shapes that adapted the traditional material to the sculptural forms of contemporary styling.[13] Furthermore, the father-and-son design team keenly understood the informality and the mobility of Southern California culture, and they created designs embodying these qualities. The *Portable Cabana* of *CD 3* (1957) (fig. 1.12) and the *Collapsible Cabana* of *CD 8* (1962) (fig. 3.3, page 95) by Danny Ho Fong were emblematic of the casual lifestyle. Both cabanas had a woven rattan roof supported by a metal frame and used covered sailcloth for a surround. The structures were lightweight, collapsible, and mobile, providing the perfect shelter for the stylish California nomad, looking to set up camp on Malibu Beach or searching for shade on a sun-drenched pool deck. Similarly, the rattan and formed plywood bed featured in *CD 10* (1968) (fig. 1.1, page 22) offered a total sleeping environment of continuous rattan walls, platform base, and ceiling that was airy, compact, and portable enough to be moved between rooms as needed.

above, left:
Figure 1.10
Danny Ho Fong
for Tropi-Cal;
Mold-chair;
woven driftwood rattan,
steel frame.
1965 (*California Design 9*)

above, right:
Figure 1.11
Miller Fong
for Tropi-Cal;
wall-hung wine rack (detail);
woven rattan.
1965 (*California Design 9*)

opposite:
Figure 1.12
Danny Ho Fong for
Tropi-Cal;
Portable Cabana;
woven driftwood rattan,
metal frame, sailcloth.
1957 (*California Design 3*)

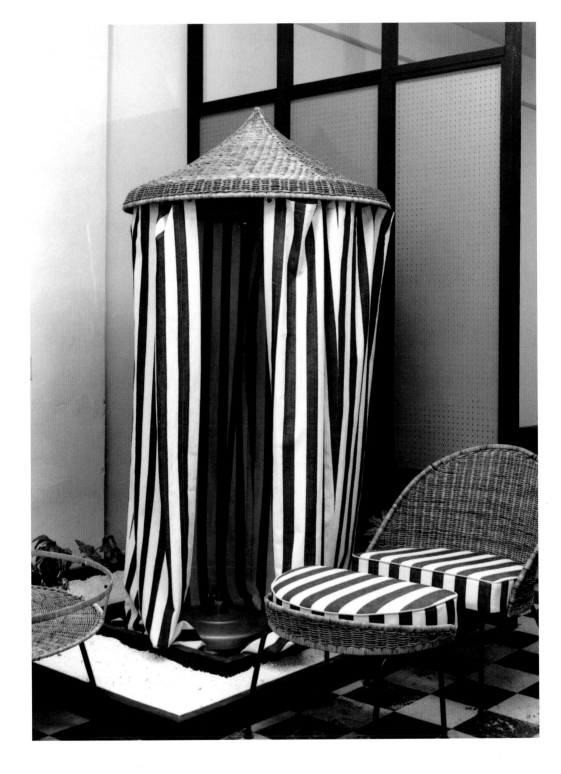

Production Furniture

left:
Figure 1.13
Miller Fong for Tropi-Cal;
Lotus Chair;
woven driftwood rattan,
steel frame.
1968 (*California Design 10*)

opposite:
Figure 1.14
Danny Ho Fong
for Tropi-Cal;
installation photograph
of contour chaise lounge
and chair.
1961 (*California Design 7*)

Miller expanded upon the concept of joining the strength of a metal frame with the warmth and tactility of rattan in his fluid design for the *Lotus Chair* exhibited in *CD 10* (fig. 1.13), in which the steel frame was molded into two opposing C-curves, connected in the middle. The chair frame was elevated on a bifurcated base that gracefully fanned out beneath the seat, making it appear weightless and buoyant, like a lotus flower floating on water. "Driftwood" rattan, tightly woven in an undulating pattern, was wrapped over the armature to create an embracing cradle of comfort and texture. Indeed, the *Lotus Chair* was equal parts sculpture and sitting unit.

One of the "many moods of California" frequently expressed in the exhibition series (via catalogue photography and gallery installations) was that of outdoor living—on patios and lanais, alongside pools, in the garden, at the park, and on the beach. California's temperate climate (in the most populated areas of the state) promoted an alfresco lifestyle, and the necessary accoutrements were highly desired. Designers of production furniture responded by creating a panorama of imaginative outdoor chairs, ottomans, and chaises. Advanced technologies of aluminum casting and extruding, and the invention of plastic-based materials, pioneered by the aerospace industry, enabled the production of furniture ideally suited to such environments. Lightweight, durable, and waterproof, these new forms could weather the elements year-round.

The Brown Jordan Company was the most prolific exhibitor of leading-edge patio and casual furniture in the exhibition series. Formed in 1945 by the partnership of Robert Brown and Hubert Jordan, this Pasadena-based manufacturer captured the leisure market in 1948 when it produced a line of weather-resistant tubular-aluminum chairs with vinyl-corded seats.[14]

above:
Figure 1.15
Hall Bradley for
Brown Jordan;
Leisure sun lounge
chair, ottoman, dining
table, and chairs.
1960 (*California Design 6*)

opposite:
Figure 1.16
Hendrik Van Keppel
and Taylor Green
of Van Keppel-Green;
manufactured by
Brown Jordan;
Dining Table and Chairs;
aluminum, Formica (table);
aluminum, vinyl cord
(chairs).
1965 (*California Design 9*)

Along with those of Tropi-Cal, Brown Jordan designs were shown in every *California Design* exhibition. The products of several company designers were featured, but furniture collections by lead designer Hall Bradley dominated the submissions. Bradley's *Leisure* sun lounge chair with ottoman and dining table and chairs, shown in *CD 6* (1960), demonstrated the application of the latest technologies and new materials: the frames were fabricated of bent aluminum tubing, and the chair seat and back structure were composed of extruded vinyl lacing (fig. 1.15). In *CD 9* (1965), *Bradley's Climatic Dining Group* introduced the company's newly developed material, Alumicane, sheet aluminum pierced to simulate natural caning. "Sculptured strength, lightness and weatherproofing" was how Alumicane was described by designer William Sanders, who wrote the furniture commentary for the filmstrip that accompanied the exhibition.[15] What Sanders might have added was that, due to the durability and flexibility of Alumicane, the chairs were easily stackable (fig. 1.22).

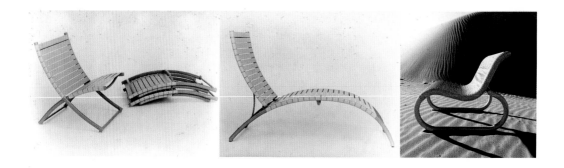

Designer John Caldwell also put a high priority on economy of space and mobility. His outdoor *Folding Chair* for Brown Jordan, featured in *California Design 10* (1968), was compact, lightweight, stackable, and portable (fig. 1.17). But what was undoubtedly more appealing to the exhibition jurors was Caldwell's adventuresome approach to updating the ubiquitous folding side and lounge chairs. His redesign featured a low-slung arcing profile that replaced the rigid rectilinear structure of the old-fashioned wooden folding units. Caldwell's contemporary version featured a curving, graceful line more compatible with modern styling. Moreover, fabricated of water-resistant extruded aluminum and vinyl straps, these folding chairs stood up to the demands of exterior use (fig. 1.18).

Two other designs for Brown Jordan selected for their intriguing use of vinyl cording were Don Colby's *Colby Chair* (*California Design '76*) and Van Keppel-Green's *Dining Chairs and Table* (*California Design 9,* 1965) (figs. 1.16 and 1.19). In the *Colby Chair,* the ropelike vinyl cord was wrapped tautly around the bent aluminum tube frame and strung across the snaking curves of the seat form. The end result was a voluptuous, organic statement that suggested comfort and resiliency. Van Keppel-Green's treatment of the material was entirely different but no less interesting: the vinyl cord was flattened, woven in a basket-weave pattern, and stretched over sharply angled aluminum frames to form the seat and back of the dining chairs. Here, the design team of Hendrick Van Keppel and Taylor Green used the texture and pattern of the vinyl cording to deliberately echo natural wicker. This design element served as the perfect foil for the clean-lined machined look of the welded frames.

The Los Angeles—based Landes Manufacturing Company, founded in 1953, also had a constant presence in the exhibition series. Landes furniture was shown consecutively from *California Design 7* (1961) through *California Design '76*. The company's most compelling submissions represented experi-

above, left:
Figure 1.17
John Caldwell
for Brown Jordan;
Folding Chair;
aluminum, vinyl.
1968 (*California Design 10*)

above, center:
Figure 1.18
John Caldwell for
Brown Jordan;
Folding Lounge Chair;
aluminum, vinyl.
1968 (*California Design 10*)

above, right:
Figure 1.19
Don Colby for
Brown Jordan;
Colby Chair;
aluminum, vinyl cord.
1976 (*California Design '76*)

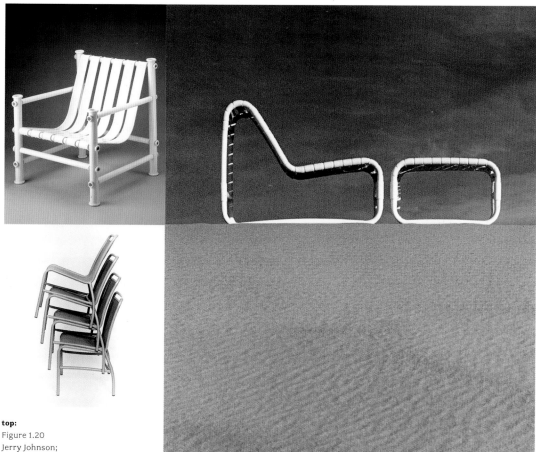

top:
Figure 1.20
Jerry Johnson;
manufactured by
Landes Inc.;
Idyllwild Chair;
plastic tubing.
1968 (*California Design 10*)

above, right:
Figure 1.21
Jerry Johnson;
manufactured by
Landes Inc.;
Lounge Chair and Ottoman;
plastic tubing.
1971 (*California Design 11*)

above:
Figure 1.22
Hall Bradley for Brown
Jordan; *Climatic* stacking
chairs; Alumicane (aluminum
simulating natural caning).
1965 (*California Design 9*)

mental designs for outdoor furniture emphasizing technical innovations and new materials. Landes's design engineer Jerry Johnson developed a wholly new material—polyvinyl chloride, or PVC plastic—which he formed into tubes and slats by adapting machines tooled for metal forming. Landes announced that the PVC line was totally weatherproof and maintenance free.

Johnson's *Idyllwild Chair* and *Lounge Chair and Ottoman,* shown in *CD 10* (1968) and *CD 11* (1971), respectively, revealed the versatility of the material and its rich design possibilities (figs. 1.20 and 1.21). *The Idyllwild Chair,* made of interlocking PVC tubes rolled down at the edges, presented a casual and whimsical form, while the flowing, curved geometries of the tubular-framed *Lounge Chair and Ottoman* gave a more elegant and elevated presence to outdoor furnishings. Each expressed a boldness that was highly regarded by the exhibition jury.

Elsie Crawford's design for an outdoor *Lounge Chair,* part of Landes's Laguna Group, also took advantage of the new possibilities engendered by plastics (fig. 1.24). Crawford's chair, ottoman, and table, cut and formed from a single sheet of plastic, were flexible, sturdy, inexpensive to produce, and naturally water-resistant. The cushions of the chair and ottoman were covered in a new synthetic waterproof material—"Acrilan"—developed for outdoor use. Citing the chair's low profile and volumetric shape, *Retailing Home Furnishings* magazine commented that Crawford's outdoor chair looked "more like modern sculpture"[16] than it did a seating unit.

Regarding one of the exhibition series' primary objectives—to present a "multiplicity of solutions to the problem of seating"—designer Paul Tuttle's production pieces and prototypes were exemplary. Eudorah M. Moore considered Tuttle to be "one of America's outstanding designers" and praised his work for its "taut, spare, disciplined" qualities.[17] In fact, Moore was so impressed by Tuttle's "cerebrated" solutions to design problems that she offered him a solo exhibition at the Pasadena Art Museum in 1966.[18]

Tuttle chairs—armchairs, side chairs, conference chairs, lounge chairs—appeared in the first and last *California Design* exhibitions, as well as in five of the intervening shows. Tuttle always felt he was a "constructionist"—conscious of how structure works—and his chair designs support that claim.[19] Three of his later, highly evolved designs, exhibited in *CD 9* (1965) and *CD 10* (1968), demonstrate Tuttle's advanced sensibility and engineering aptitude, his skillful analysis of how structure, function, materials, and aesthetics work together to produce an original statement.

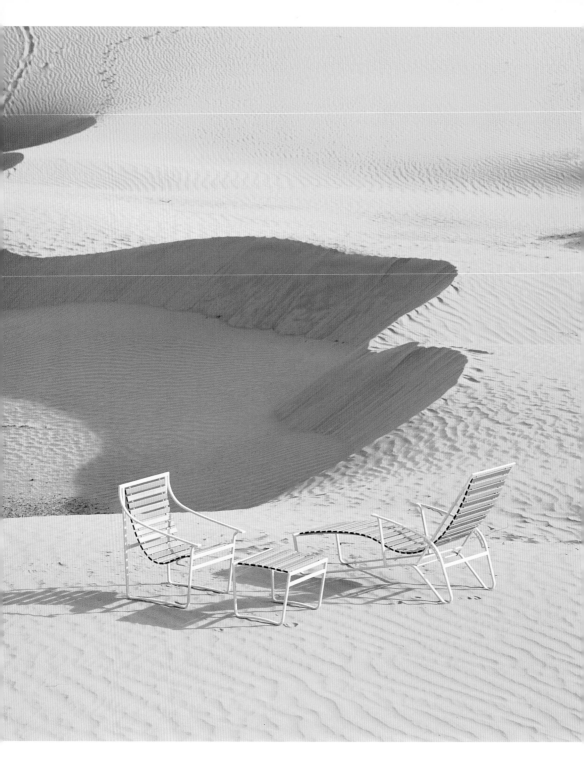

California Design

opposite:
Figure 1.25
Arthur W. Ellsworth and
Robert Fujioka;
Design West Inc.;
*Sunrest Outdoor
Furniture* (chaise, lounge
chair, and ottoman);
aluminum frame,
extruded plastic slats.
1965 (*California Design 9*)

right:
Figure 1.26
Heinz Meier;
manufactured by
Landes Inc.;
Rickshaw Chaise;
steel, absite coating,
fabric.
Charles Hollis Jones;
adjustable table (available
in round, square, and
triangular configurations);
polished steel and absite;
limited production piece.
1976 (*California Design '76*)

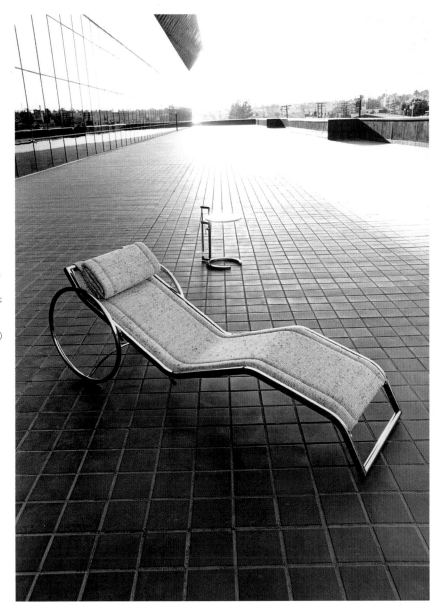

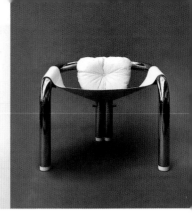

In the metal, leather, and wood prototype chair of *CD 10* (known as the *Field Officer's Chair*), Tuttle made evident the mechanics of construction by exposing and emphasizing the metal framework upon which the leather seat and back hang (fig. 1.27). This chair was based on the simple, portable camp chairs used by the military. As design historian Michael Darling noted, Tuttle's *Field Officer's Chair* "offered an abstract demonstration on how a chair works" and thus was an "utterly conceptual object" that commented on "conventions of use and construction."[20]

The *"Z" Chair,* exhibited in *CD 9,* was Tuttle's tour de force. It also successfully realized what Moore referred to as "the new look of elegance" (fig. 1.32). Tuttle originally called this chair the *Rocket Launcher,* and it is easy to see why: the acute upward pitch of the leather seat, slung between the dynamic curves of the steel frame, inspires thoughts of being launched into space. Essentially, the elegance of the *"Z" Chair* derives from its daring cantilever construction, a design principle Tuttle adapted from architecture. Floating the seat and back over the base invested the chair with fluid lines and a sense of graceful motion.[21] Tuttle's striking chair was an inventive design in the literal sense, as the cantilever was made possible by the invention of steel alloys that provided the tensile strength needed to support the load. For his originality, Tuttle was awarded the first Carson Pirie Scott Young Designers Award in 1966.

The most dramatic example of how the discovery and use of a new material affected the design and function of furniture can be seen in the invention of the glass-reinforced plastic known as fiberglass. Fiberglass was first developed by the defense industry during World War II for use in military aircraft and, in combination with resin, to fabricate crash helmets.[22] Charles and Ray Eames, the first designers to experiment with fiberglass, saw in this strong, lightweight, low-cost material a great potential for use in

above, left:
Figure 1.27
Paul Tuttle;
executed by Stan Reifel;
prototype,
Field Officer's Chair;
steel, wood, leather.
1968 (*California Design 10*)

above, center:
Figure 1.28
Edward Julian;
manufactured by IPOLAR;
#P-EC-700 Easy Chair;
chrome steel, suede.
1976 (*California Design '76*)

above, right:
Figure 1.29
Byron Botker;
manufactured by
Landes Inc.;
Palo Alto Lounge Chair;
chrome steel, vinyl.
1971 (*California Design 11*)

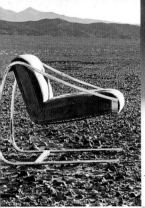

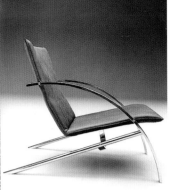

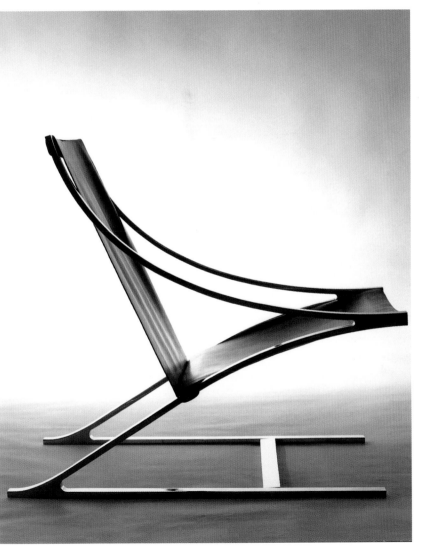

above, left:
Figure 1.30
Charles A. Gibilterra for
Glenn of California;
Lounge Chair;
steel, suede.
1971 (*California Design 11*)

above, right:
Figure 1.31
Paul Tuttle; manufactured
by Strässle International;
Lounge Chair;
chrome steel, leather.
1976 (*California Design '76*)

right:
Figure 1.32
Paul Tuttle; manufactured
by Carson Johnson Inc.;
"Z" Chair;
steel, leather.
1965 (*California Design 9*)

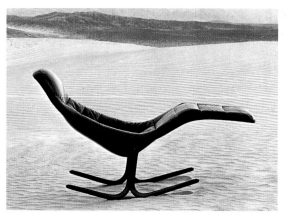

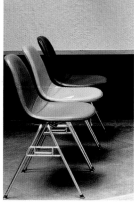

furniture. Their experiments led in 1948 to the fiberglass *Shell Chair,* now a design icon. These chairs were shown in several *California Design* exhibitions, in many iterations (fig. 1.34 and fig. 3.8, page 98).

Fiberglass technology opened the door to new horizons in production furniture. Chairs based on molded fiberglass shell construction proliferated and soon became an integral part of the cultural landscape, appearing indoors and outdoors and in domestic environments as well as public spaces. Some designers stretched the concept to the outer limits, as seen in the *Zero G Lounge* of *CD 11* (1971), manufactured by Capsule, Inc. In this lounge, the molded fiberglass shell has been radically adapted to cradle the curve of the body in the resting position. The title reflects America's obsession with the space race and implies that the lounging occupant would feel as weightless as an astronaut in orbit (fig. 1.33).

Versatile, mutable, virtually indestructible molded fiberglass provided greater freedom to design sculpturally. New refinements in the process of rotational molding generated hollow, structurally sound furniture with a slick surface. It is of interest to note that, according to designer Donald Chadwick, the fiberglass process had been developed by the defense industry for use in molding large, hollow containers that carried napalm. Fiberglass furniture truly represents a more positive, productive use of a process that originated from military applications. Due to developments and refinements, one-piece forms constructed entirely of plastic were now possible. (The pinnacle of fiberglass shell furniture remains the Eames chairs supported by legs or metal bases.) These wholly fiberglass forms exhibited in the early 1960s were indeed vanguard. For example, the now classic single-piece injection-molded plastic chair by Danish designer Verner Panton was designed in 1960 but did not go into commercial production until 1967.

above, left:
Figure 1.33
Capsule Inc. (staff designed);
Zero G Lounge
or contour lounge and
rocker; urethane foam,
molded fiberglass, vinyl,
cast aluminum.
1971 (*California Design 11*)

above, right:
Figure 1.34
Charles and Ray Eames;
manufactured by
Herman Miller, Inc.;
Shell Chairs; interlocking
for mass seating;
Naugahyde upholstery,
fiberglass, metal base.
1956 (*California Design 2*)

opposite:
Figure 1.35
John Follis for
Architectural Fiberglass,
planters,
fiberglass.
1962 (*California Design 8*)

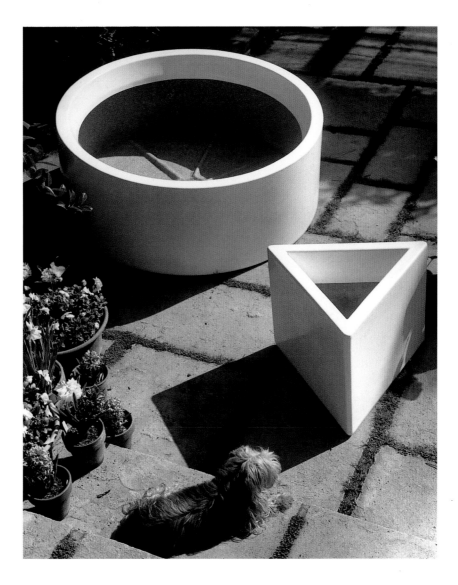

Freed from the restraints imposed by right-angle joinery, designers could create sculpturally curved, seamless shapes. These fantastic plastics began to appear as early as *CD 8* (1962) in the form of monolithic planters—products of Architectural Fiberglass—and these and other plasticized objects maintained a strong presence through *CD 11* (1971) (fig. 1.35). It is apparent from the submissions that Architectural Fiberglass (a division of Architectural Pottery) was on the razor edge of this new technology. Innovations in the fabrication of fiberglass cars, canoes, and surfboards paved the way for the company to mass-produce furniture using this new synthetic.

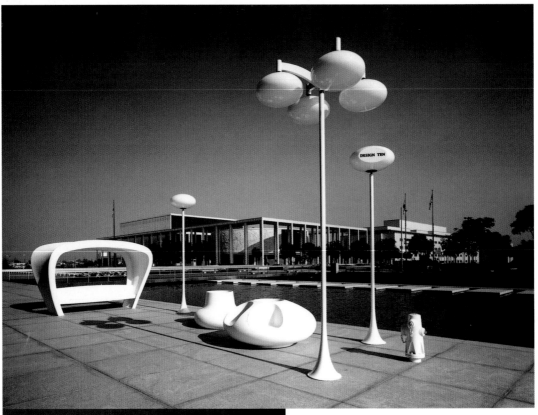

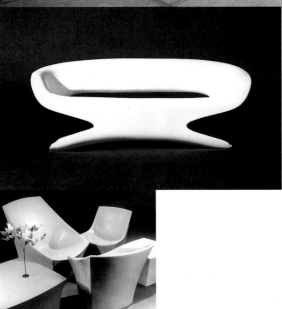

above:
Figure 1.36
Douglas Deeds for
Architectural Fiberglass,
Bus Stop Bench (far left),
fiberglass.
Displayed with Elsie
Crawford's planter
and planter seat for
Architectural Fiberglass;
lights by Wayne Compton
and Associates, manufac-
tured by Kim Lighting, Inc.;
and prototype fire hydrant
designed by Don Baldocchi
and Cornelius Sampson of
Cornelius Sampson and
Associates.
1968 (*California Design 10*)

above, left:
Figure 1.37
Douglas Deeds for
Architectural Fiberglass,
park bench with back,
fiberglass.
1971 (*California Design 11*)

below, left:
Figure 1.38
Douglas Deeds for
Architectural Fiberglass;
three chairs (models
FGFC-1002, FGFC-1001, and
FGFC-1000), two table-
ottomans (models *FGFT-
1100* and *FGFT-1101*);
fiberglass.
1968 (*California Design 10*)

opposite:
Figure 1.39
Douglas Deeds and
Richard Thompson for
Architectural Fiberglass;
Ventura Bench by Deeds
(back), modular seating
unit by Thompson (front);
fiberglass.
1971 (*California Design 11*)

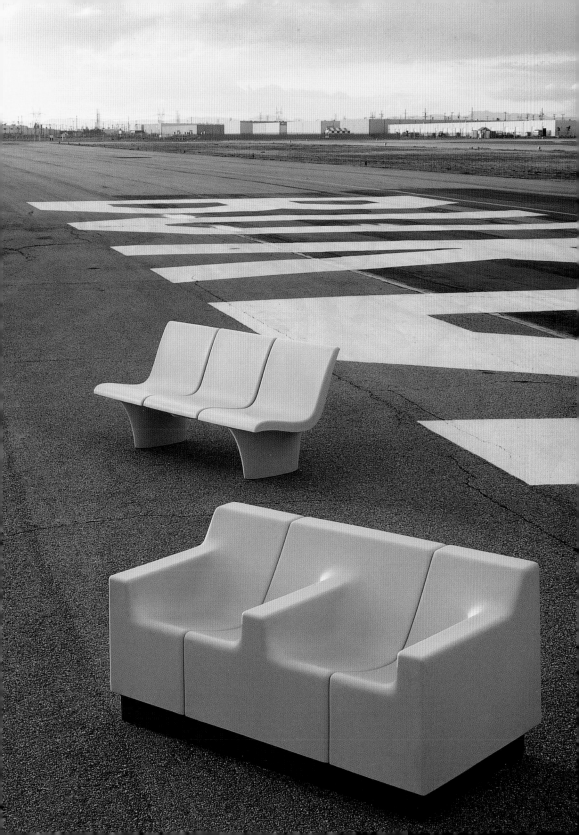

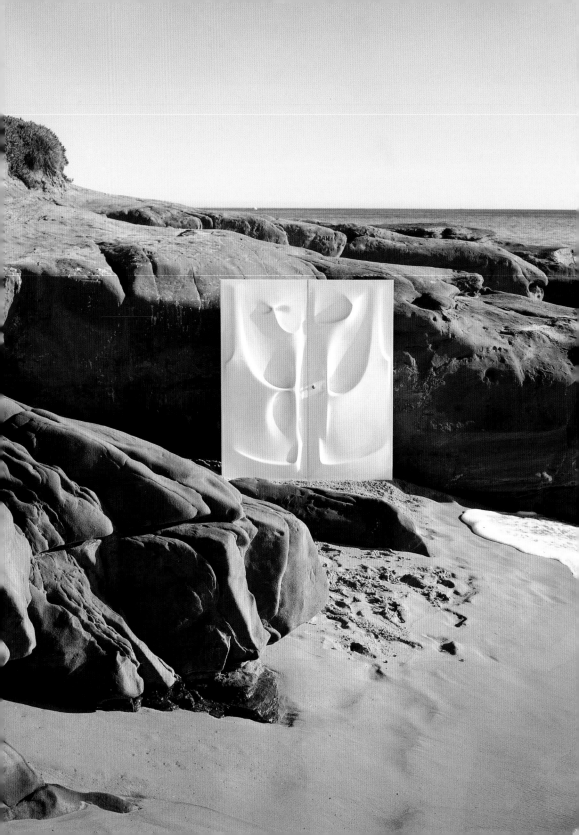

opposite:
Figure 1.40
Svetozar Radakovitch in
collaboration with Karl
Eckburg; manufactured by
Architectural Fiberglass;
Double Door;
fiberglass, polyurethane
foam, wood.
1968 (*California Design 10*)

below:
Figure 1.41
Douglas Deeds for
Architectural Fiberglass,
White Bench,
fiberglass.
Shown with La Gardo
Tackett's *Ceramic Planter*
for Architectural Pottery.
1965 (*California Design 9*)

Groundbreaking fiberglass forms for public places and garden spaces were designed for the company by Douglas Deeds and Elsie Crawford. Deeds's curvaceous, sculptural benches for streets, gardens, airports, and bus stops were exhibited in *CD 9* (1965), *CD 10* (1968), and *CD 11* (1971) (figs. 1.36, 1.37, 1.39, 1.41). Additionally, a Deeds-designed line of futuristic-looking contract furniture, composed of three chairs and two table-ottomans, was shown in *CD 10* (fig. 1.38). No less prolific was Elsie Crawford, whose highly imaginative, large-scale garden planters, planter benches, and gracefully fluid *Light Column* appeared in *CD 10* and *CD 11* (figs. 1.45, 1.46, 1.47). Designs by Donald Chadwick were also noted for their thoughtful exploitation of the material properties of plastic. Chadwick's prototype *Plastic Dining Chair* was a highly abstract shape of flowing lines and intersecting curves, whose monolithic construction and exaggerated volumes endowed it with great sculptural presence (fig. 1.42). Similarly, his prototype *Side Chair/Dining Chair* of bright red molded plastic wedded functional, economic, and ergonomic imperatives

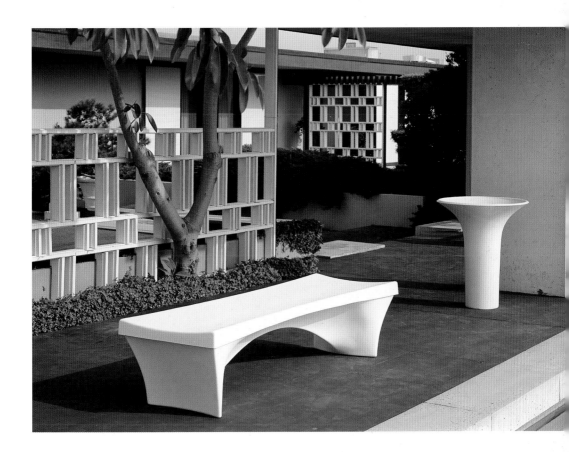

with aesthetic appeal and playfulness (fig. 1.43). Chadwick has continued to experiment with new materials and challenge technologies. In 1994, he designed the Aeron chair with partner Bill Strumpf, the high-style ergonomic chair that has come to define the modern office environment.

Collectively, the plastic designs introduced by Deeds, Crawford, and Chadwick for settings as varied as street, garden, and home were original, forward-looking, and full of verve. They introduced an entirely new vocabulary of sculptural contours and biomorphic shapes to the American furniture industry and anticipated the wildly exuberant forms of the postmodern style that would follow in the next decade (as comparatives: figs. 1.40, 1.44).

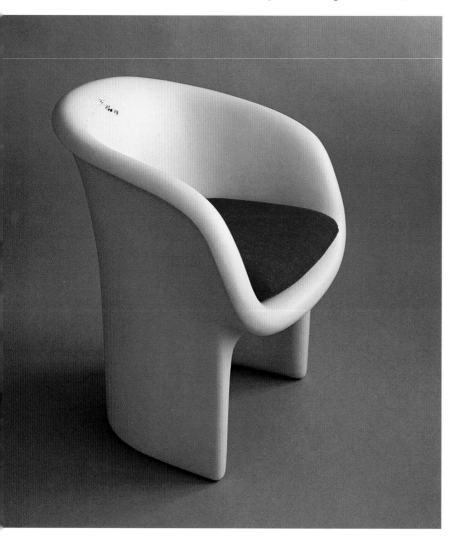

left:
Figure 1.42
Donald T. Chadwick;
manufactured by
Knoll Associates;
prototype,
Plastic Dining Chair;
fiberglass, Lucite, or
other plastic.
1968 (*California Design 10*)
Courtesy of Donald
Chadwick & Associates.

opposite:
Figure 1.43
Donald T. Chadwick;
manufactured by Stow
Davis; prototype,
Side Chair/Dining Chair;
molded plastic.
1971 (*California Design 11*)

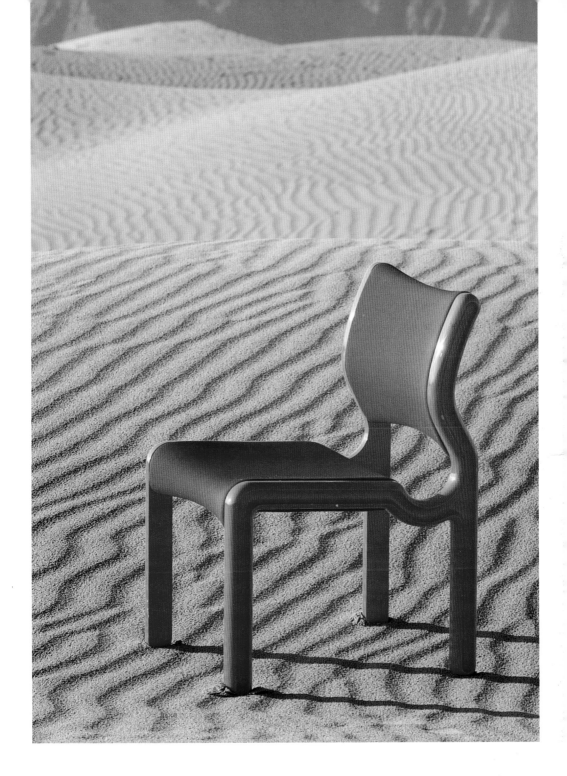

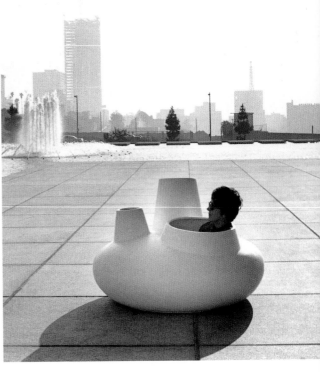

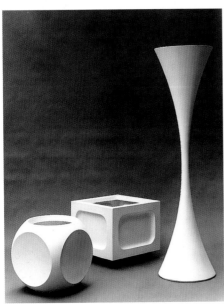

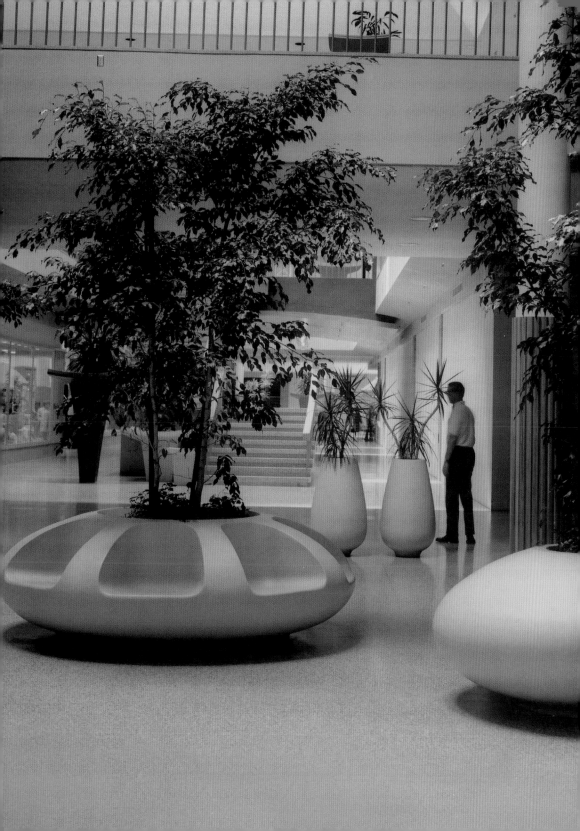

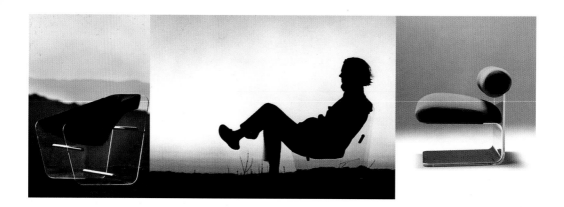

Transparent acrylic, also known by the trade names Lucite and Plexiglas, did not enjoy the same wide appeal as molded plastics and fiberglass, though it became popular on the West Coast in the 1970s. A diverse array of furnishings made entirely or partially of acrylic were selected for *CD 11* (1971) and *CD '76,* demonstrating that several furniture designers were seduced by the material.

Byron Botker's design for the *Riviera,* an acrylic and leather lounge chair, took advantage of the material's transparency to produce a structural framework that was almost invisible. A person sitting in the chair would appear suspended aboveground (figs. 1.48, 1.49). A similar illusionist device was employed by Roger Leib in his aluminum and acrylic design for the *Floater* chair. Mounting the rolled upholstered seat and back on a clear acrylic frame created the illusion that the chair was hovering in space (fig. 1.50). Designer Charles Hollis Jones made clever use of the material's translucency in his metal and Lucite *Edison Lamp.* When the lamp was lit, the smoked Lucite shade dematerialized, revealing the bulbs inside (fig. 1.51). Jones's Plexiglas *Étagère* was the ultimate statement in clarity: constructed without the use of bolts, screws, or adhesives, the cabinet was clean lined, pristine, and wholly transparent (fig. 1.53). The same economy of construction and emphasis on the innate seduction of Lucite were used by Jones to fabricate the stackable folding tables (fig. 1.54). These objects expressed a fluid synthesis of material and design, and were eminently suited to contemporary life.

The introduction of plastic-based materials, such as vinyl and plasticized paper sheets, created many possibilities for designers of lighting fixtures. In 1952, the esteemed Midwestern designer George Nelson created hanging *Bubble* lamps of plastic and steel wire. These vanguard models

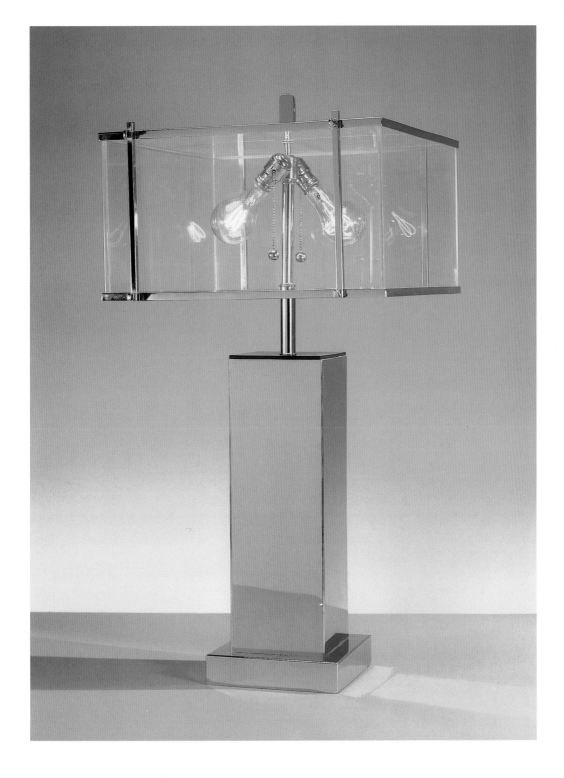

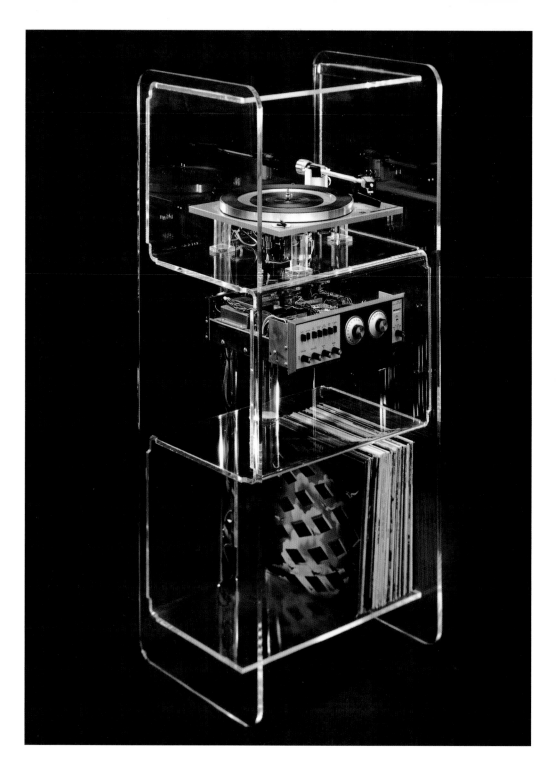

opposite:
Figure 1.52
Frank M. Vigneri, designer
and manufacturer;
Space Case 009,
stereo case;
Plexiglass.
1971 (*California Design 11*)

right:
Figure 1.53
Charles Hollis Jones;
Hr-97 Étagère;
brass, Lucite, glass.
1971 (*California Design 11*)
Courtesy of Charles
Hollis Jones.

below:
Figure 1.54
Charles Hollis Jones;
Hr-100 Folding Tables;
polished chrome, Lucite,
black leather straps.
1971 (*California Design 11*)

illuminated the way for the next generation of designers to develop new approaches to interior lighting. Although Nelson's lamps were never shown in *California Design*, they were mass-produced by the Herman Miller Company and had become the standard of modernism and new materials by the mid-1950s.

Of the "light sources" showcased in *CD 9* (1965), the pleated geometric, translucent vinyl lamps of Ben Gurule were the obvious standouts (figs. 1.55, 1.56, 1.58). Gurule's intriguing origami-like designs were based on complex patterns derived by joining together a "multiplicity of rectangles," as the catalogue put it, or by echoing geodesic geometry. When illuminated, the creases and folds created shadow patterns that reflected the form's sharp diagonals, giving floor lights and chandeliers the appearance of freestanding or hanging sculptures. The artfulness of Gurule's lamps prompted renowned designer Henry Dreyfus to name him "the Leonardo da Vinci of folded paper."[23] The plasticized paper *Zipper* lights designed by Elsie Crawford were also noteworthy. Their conical, dimensional shapes evoked the language of sculpture, while their interlocking structure—the "zipper"—allowed them to be taken apart and shipped flat (fig. 1.57).

Perhaps the one category of production furniture that best captured the California zeitgeist was "Knockdown and Interchangeable Furniture," introduced in *CD '76*. Collapsible and transportable items appeared throughout the exhibition series, the highlights being the ingeniously constructed *M-bend* chair designed by Judith Wachsman in *CD 11* (1971) and the almost infinitely mutable *Folding-Tilting Lounge Chair* by William Saunders in *CD 9* (1965) (figs. 1.60, 1.61). But it wasn't until *CD '76* that truly multipurpose furniture and knockdown furniture-in-a-box were featured. These were representative of what designer Charles Anacker called "furniture for the nomadic generation."[24] Anacker's own *Convertible Table and Chair* were definitive examples of multiuse furniture that spoke to "a more mobile and casual approach towards life and the tools for living."[25] The chair frame could be flipped from dining to lounging height, and the table could be set at three different levels—from cocktail to dining—by repositioning the tubular steel frame (fig. 1.59).

below:
Figure 1.59
(multiple views)
Charles Anacker;
manufactured by
Landes Inc.;
Convertible Table and Chair;
chrome steel tubing,
butcher-block top on table,
vinyl suede on chair.
1976 (*California Design '76*)

right:
Figure 1.60
(multiple views)
Judith Wachsman;
Prototype M-bend Chair;
chrome metal, leather.
1971 (*California Design 11*)

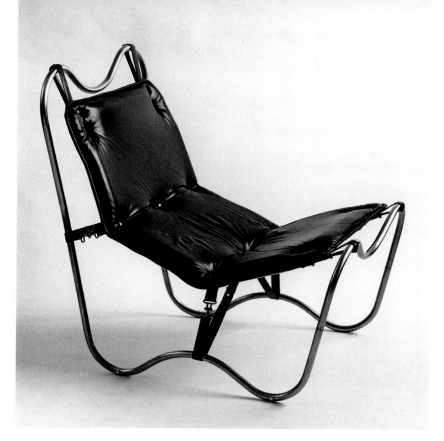

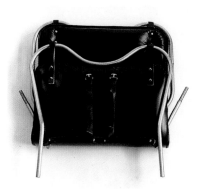

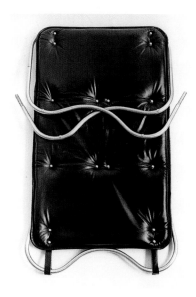

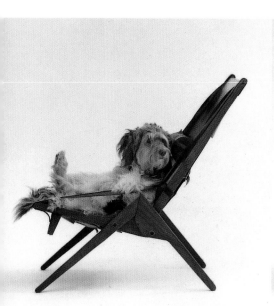

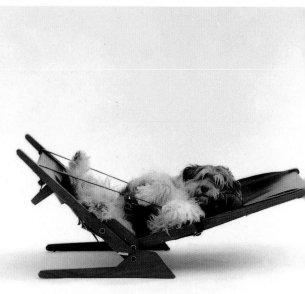

Figure 1.61
(multiple views)
William Saunders;
*Folding-Tilting Lounge
Chair;* walnut, aluminum,
leather.
1965 (*California Design 9*)
Dog courtesy of designer.

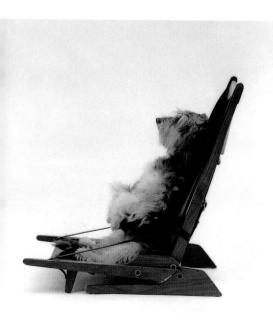

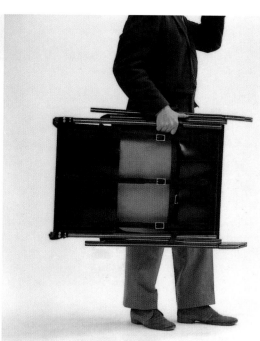

Knockdown systems varied, but all shared the trait of do-it-yourself assembly. Elsie Crawford's Cambria collection was designed to be shipped in parts and assembled without tools, nuts, or bolts: the wooden frame elements were held into place by integral locking devices (fig. 1.63). The *Chair in a Box* by designer Donald Vandervort was exactly that: the wood frame and canvas covers were packed flat in a box, ready for assembly (fig. 1.62). The most holistic approach was Jayme Odgers's Kit Furniture for table, chair, sofa, and shelving unit, manufactured by Heartwood Corporation (figs. 1.64 and 1.65). Simply designed, the unfinished furniture components would be packed in a kit, along with instructions, a piece of sandpaper, a spray can of finish, and a package of tree seeds. In this way, Odgers promoted the concept of conservation and sustainable materials with cleverness and humor.

below:
Figure 1.62
Donald W. Vandervort;
prototype,
Chair in a Box,
knockdown armchair;
birch, canvas, hardware.
1976 (*California Design '76*)

opposite:
Figure 1.63
(multiple views)
Elsie Crawford;
manufactured by
Page Furniture Co.;
Knockdown series,
Cambria collection,
interchangeable furniture;
wood, either ash or oak;
prototypes were executed
by David Edberg.
1976 (*California Design '76*)

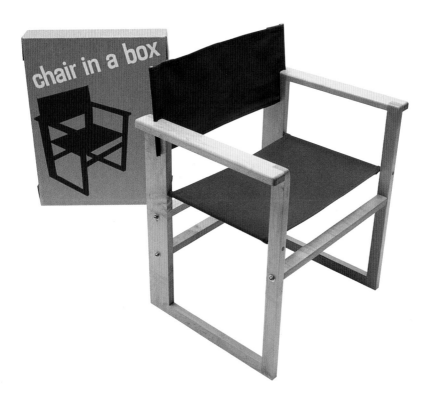

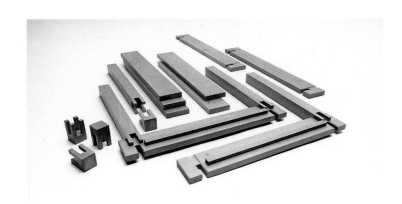

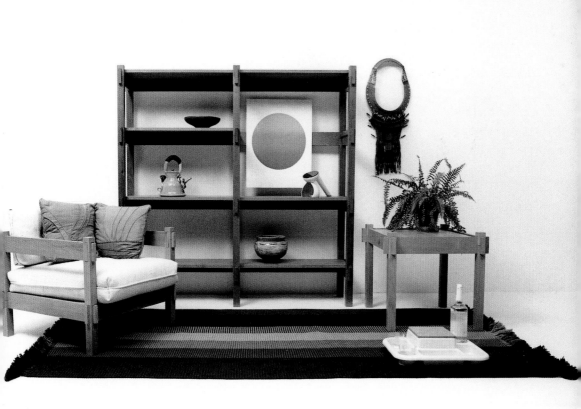

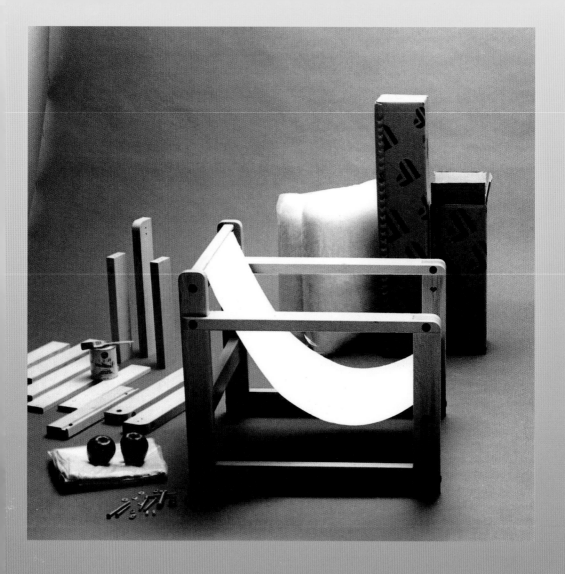

Figures 1.64 and 1.65
Jayme Odgers;
manufactured by
Heartwood Corporation;
Kit Armchair (left), *Kit
Table and Loveseat,* (right);
wood, canvas, upholstery.
1976 (*California Design '76*)
(Note: the two apples—
whole and eaten—placed
in the photographs,
represent the amount of
time it takes to assemble
the table and loveseat.)

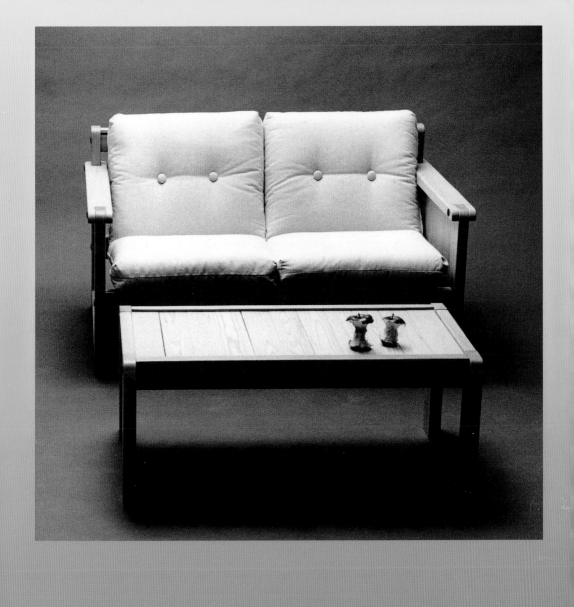

The *California Design* series brimmed with a sense of discovery and was dense with energy. The production furniture sections proclaimed unique power and authority, and presented captivating visual encounters with the new, the next, the trendsetting. These displays also examined how mass-produced furniture was influenced by the times, especially the role new technologies played in the design process. The exhibits represented both the finest in "classic" furniture design—before these designs became "the classics"—and a galaxy of quirky, unpredictable pieces that were clearly a response to the emotions and sensations of the era in which they were created.

Los Angeles maintained its status as the center of stylistic adventurousness, and California furniture designers produced exciting new work while expanding the vocabulary of modernism. In the beginning of the series, the manufactured furniture was more rigorously aligned with the modernist principle of "form follows function," and traditional materials dominated. Straightforward, essentialist designs were crafted at drafting tables with restraint and economy. However, as the series progressed, designs for production furniture reached a higher pitch of innovation and became completely in the moment, snaring the imagination of the public. Designs shifted toward a more organic and sculptural expression that resonated with the biomorphic motifs popular in painting and sculpture of the late 1960s and early 1970s. The newly introduced synthetics—fiberglass and plastic—became the low-cost material of choice for mass production. Later mass-produced furniture—most notably shown in *CD '76*—more closely reflected the attitudes and needs of younger consumers who began to dominate the marketplace and demand more flexibility and range. The resulting pieces were smaller in size, designed to be knocked down, and adaptable to multiple contexts: what *McCall's* magazine called "space-saver furniture for studio-apartment suburban singles."[26] By the end of the *California Design* series in 1976, compelling panoramas of production furniture—hundreds of riveting examples—had been showcased.

These designs established a standard of excellence, reflective of their time, and would become the benchmarks against which future designs would be measured (as comparatives: figs. 1.65, 1.66).

Figure 1.66
Donald T. Chadwick;
manufactured by
Herman Miller, Inc.;
Modular seating system;
molded foam, upholstery.
1976 (*California Design '76*)
Courtesy of
Donald T. Chadwick

1. Dr. Armin Kietzmann, "Pacific Design: Inventive Yet Conciliatory," News Release from the Pasadena Art Museum, printed in the *San Diego Union*, February 12, 1956.

2. For the first seven exhibitions, the purview was limited to goods that had been manufactured or handcrafted in Los Angeles County, a stipulation of the Los Angeles Board of Supervisors, which awarded a yearly grant of $10,000. Thereafter, Eudorah M. Moore expanded the purview to include goods from all of California. In the case of production furniture, this change did not have a significant impact, as there were few such manufacturers outside the Los Angeles region during this period.

3. Interview with Eudorah M. Moore, January 29, 2001.

4. Cara Greenberg, *Mid-Century Modern: Furniture of the 1950s* (New York: Harmony Books, 1984), 28.

5. John M. Findlay, *Magic Lands: Western Cityscapes and American Culture After 1940* (Berkeley and Los Angeles: University of California Press, 1993), 19.

6. *California Design 6* (Alhambra: Museum Reproductions, 1960), 7.

7. Ibid.

8. Ibid., 26.

9. W. Joseph Fulton, "Foreword," *California Design 1* (Pasadena: Pasadena Art Museum, 1954), 1.

10. Eudorah M. Moore, "The Designer Is Knocking—Are You Listening?" Speech, National Home Fashions League, Illinois chapter (January 7, 1969).

11. Ibid.

12. Interview with Miller Fong, March 12, 2004. Miller attended college to study architecture and industrial design at the University of Southern California—acquiring "all the technical skills that my father didn't have"— and ultimately became an architect. Soon after his father's death in 1993, Miller and his brother decided to continue the family business. They dropped the name Tropi-Cal, chosen by Danny Ho Fong in 1952, and reclaimed the original name of Fong Brothers Company, established in 1936 by Danny Ho Fong and his brothers. The company is still operating under this name today.

13. Fong interview.

14. Emily Young, "He's Got the Patio Covered," *Los Angeles Times,* May 30, 2002, sec. E1, E9.

15. *California Design 9*. Filmstrip booklet (Pasadena: *California Design,* 1965), 31.

16. *HFD/Retailing Home Furnishings* (October 15, 1982), 72.

17. Moore, "The Designer Is Knocking," 4.

18. Marla C. Berns with Michael Darling and Kurt G. F. Helfrich, *Paul Tuttle Designs* (Santa Barbara: University Art Museum, 2003), 7, 39.

19. Ibid., 30.

20. Ibid., 141.

21. Ibid., 36.

22. Greenberg, *Mid-Century Modern,* 75.

23. Moore, "The Designer Is Knocking," 4.

24. *Arizona Citizen,* January 21, 1975, quoted in Landes Furniture Company publicity clips.

25. *California Design '76* (Pasadena: *California Design,* 1976), 43.

26. *McCall's* magazine (February 1975) quoted in Landes Furniture Company publicity clips.

Chapter 2

California Studio Furniture: Revealing Skill and Spirit

SUZANNE BAIZERMAN

Certain characteristics define studio furniture makers. They are individuals who, often with the help of assistants, engage in custom production of a relatively small number of works. They have usually studied design and construction in college or are self-taught. Maintaining their own workspaces, they oversee the making of furniture from concept and design through production. Their furniture is not marketed through the same channels as the items of manufacturers, but is sold through their own studios, or through shops, galleries, and craft shows. While occupying a unique niche, studio furniture makers are influenced by the same trends in architecture and interior design, in California and nationwide, as furniture manufacturers.[1]

Studio furniture that appeared in the *California Design* exhibitions documented the transition from an emphasis on function and the use of wood to the exploration of new materials and forms that often stressed aesthetics or message over function. There was a steady increase in the number of studio furniture makers throughout the series, with a steep increase in the last three exhibitions. In *CD 1* (1954—55) one maker was represented. By the time of *CD '76,* thirty-seven were included.

Each of the first seven exhibitions, from 1954 to 1961, featured only a handful of studio furniture makers. The shows' emphasis was clearly on production furniture and industrial design. However, industrial design as well as Scandinavian furniture design greatly influenced the early studio furniture style, and many of the studio furniture makers called themselves "designer-craftsmen." They shared an appreciation of the appeal and beauty of wood, showed a concern for how their furniture fit the human body, and generally emphasized comfort. The term "warm modernism" could be used to describe the resulting furniture, with its sculptural embellishments that softened sharp lines.[2] The furniture exuded good taste and harmonized with the architecture and interior design of the day.

The most visible furniture maker throughout the *CD* exhibitions—and still the best known—was Sam Maloof, the first craftsman to receive the prestigious MacArthur Fellowship (1985). His work appeared in all the *CD* exhibitions with the exception of *CD '76.* Because of his early employment as a graphic designer and his connection to industrial designer Henry Dreyfus

page 70:
Figure 2.1
Arthur Espenet Carpenter,
lecturn or book stand,
walnut.
1965 (*California Design 9*)

left:
Figure 2.2
Sam Maloof,
drop-leaf side table
with wood hinges,
walnut.
Also pictured are a hand-
loomed wool accent rug by
Trude Guermonprez and a
black-walnut salad bowl by
Bob Stocksdale.
1962 (*California Design 8*)

opposite:
Figure 2.3
Sam Maloof,
rocking chair,
rosewood.
1965 (*California Design 9*)

(Dreyfus commissioned him to make furniture for his own home), Maloof was perceived as an industrial designer. However, in a 1958 *Los Angeles Times* article featuring a photograph of the area's leading furniture designers, Maloof was the only one who did not work for manufacturers.[3]

Maloof's pieces in the *CD* exhibitions were characteristic of his designs, some of which are still made today. A small drop-leaf side table of walnut in *CD 8* (1962) had distinctive, hand-fashioned wood hinges (fig. 2.2). A tall, space-conserving, cradle/cabinet in *CD 10* (1968) was also of walnut, intended to serve several of an infant's needs in an original and handsome way (fig. 2.6). Maloof's signature piece, a rocking chair with long runners of elegant proportion, appeared in *CD 9* (1965) (fig. 2.3). One of the best-known items of handmade furniture in the United States, it is in numerous museum and private collections. Maloof's warm, friendly, and enthusiastic demeanor has contributed to his key role in the studio furniture movement.

California Design 8 (1962) was the first exhibition in the series to include Northern California participants. The work of the widely respected Bolinas, California, furniture maker Arthur Espenet Carpenter, known professionally as Espenet, appeared in *CD 8,* as well as *CD 9* (1965), *CD 10* (1968), and *CD 11* (1971). Born in New York City, Carpenter was educated at Dartmouth College in New Hampshire. Moving to the West Coast in the post—World War II era, he eventually settled in 1957 in the small town of Bolinas. He lived in a novel home of his own design and construction. Carpenter was one of the founders of the Baulines Craftsman's Guild in 1972,[4] an interdisciplinary group that exhibited together and shared views about how a craftsperson's lifestyle could contribute to the contemporary counterculture's political goals. The group also began an apprenticeship program, in which Carpenter took part.

Carpenter's work captures early studio furniture makers' reverence for wood, sensitivity to sound design, and concern for comfort—and adds to this mix a splash of originality. His compact rolltop desk of walnut in *CD 11* (1971) (fig. 2.4) was made in what was later called the "California roundover style," identified by smoothly rounded finishes, both a labor-saving technique and an aesthetic choice. According to Carpenter, writer John Kelsey coined the term in the early 1980s.[5] The exquisite detailing on the interior features round-edged drawers and cutouts forming a rhythmic pattern of naturalistic forms. Carpenter exhibited a double music stand of walnut in *CD 8* (1962) (fig. 2.8) and a curvaceous walnut lectern in *CD 9* (1965) (fig. 2.1). The catalogue photograph showed the lectern to great advantage in snow, the perfect foil for the warm wood. A walnut print stand, part of *CD 10* (1968), had a place for a portfolio and adjustable arms that accommodated prints of various sizes (fig. 2.5). Carpenter is probably best known for his *Wishbone Chair,* not shown in *California Design.* However, *CD 10* featured one of Carpenter's most unusual chairs, an experimental piece called the *Great Rib Chair.* The chair featured a high back and a series of ribs that contained segmented, padded leather upholstery (fig. 2.9).

below:
Figure 2.4
Arthur Espenet Carpenter,
rolltop desk,
walnut.
1971 (*California Design 11*)

opposite:
Figure 2.5
Arthur Espenet Carpenter,
print stand,
walnut,
6 feet.
1968 (*California Design 10*)

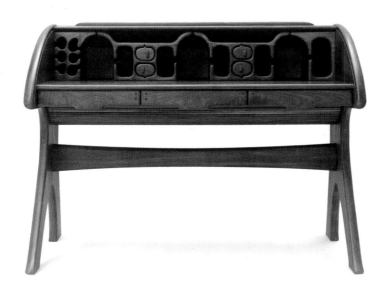

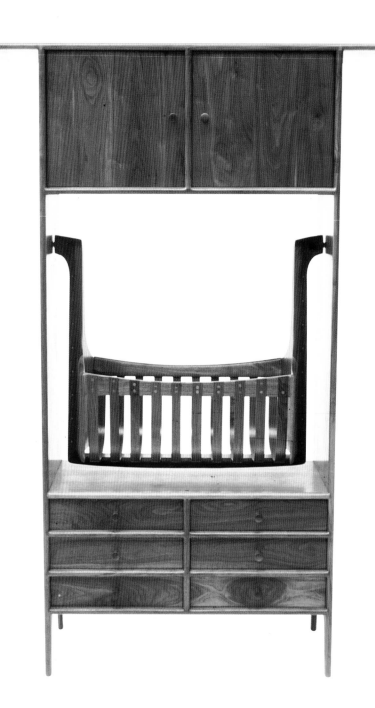

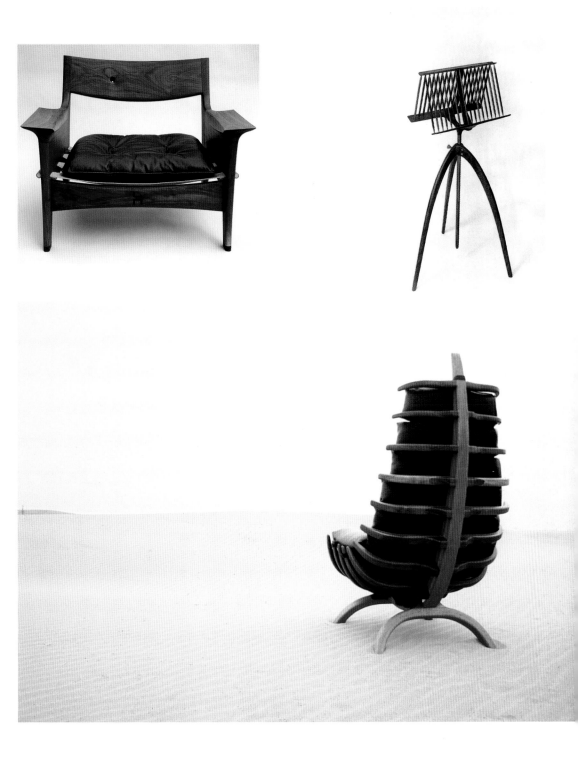

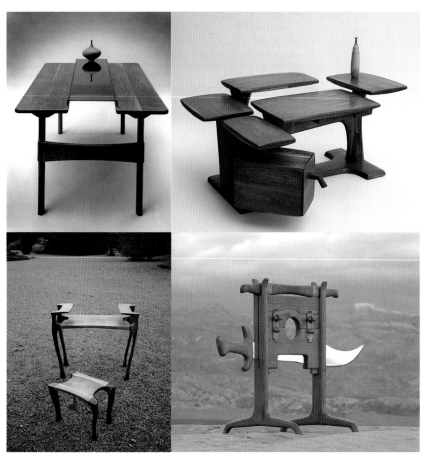

top left:
Figure 2.10
Leland D. Marean;
dining table;
walnut, glass;
6½ feet.
1971 (*California Design 11*)

top right:
Figure 2.11
Eben W. Haskell, Lynn
McLarty, and Michael
Kirchner for Haskell
Design Studio;
table-desk;
walnut.
1971 (*California Design 11*)

bottom left:
Figure 2.12
James D. Nash,
desk and stool,
koa wood.
1976 (*California Design '76*)

bottom right:
Figure 2.13
John Gaughan;
Magician's Guillotine;
oak, metal;
3 x 3 x 2 feet.
1971 (*California Design 11*)

opposite:
Figure 2.14
John Kapel,
hanging wall cabinet.
1965 (*California Design 9*)

Among the other well-designed pieces in the *California Design* exhibitions, John Nyquist's work showed a strong Scandinavian influence in materials and design. One of his walnut and leather chairs in *CD 11* (1971) could be considered a California interpretation of Hans Wegner's 1947 *Peacock* armchair. The well-placed knothole in the chair back was a distinctive element (fig. 2.7). The same year, Leland D. Marean exhibited a two-tiered dining table of walnut and glass (fig. 2.10). The elevated glass portion was designed as a convenient place to hold condiments and serving dishes. Haskell Design Studio's walnut table-desk in *CD 11,* designed by Eben Haskell, Lynn McLarty, and Michael Kirchner had multiple-level work areas that curved slightly around its user, anticipating the modern computer workstation (fig. 2.11). James D. Nash's desk and stool with gracefully shaped legs and cutouts in *CD '76* successfully used negative space to add novelty to the piece (fig. 2.12). Offering

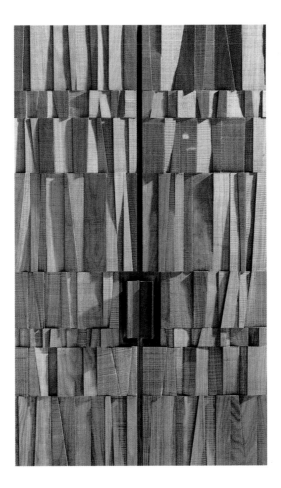

a humorous use of furniture techniques, John Gaughan's *Magician's Guillotine* in *CD 11* was a magician's prop made of oak in the California roundover style, complete with an oversized metal sword and wooden locks (fig. 2.13).

During the 1960s and 1970s, artists working in craft media became increasingly interested in cultures outside the United States. Having learned hand-carving techniques in the village of Kumasi in Ghana, Frank E. Cummings III applied them in an untitled oak chair in *CD 11* (1971). Contemporary in feel, the chair successfully adapted traditional carving to a modern idiom (fig. 2.20).

The work of John Kapel indicates the somewhat blurry boundary between industrial design and manufacturing and studio furniture making. After graduating from Cranbrook Academy in Michigan, Kapel worked for New York designer George Nelson, one of America's best-known designers in the post—World War II era. Kapel subsequently moved to the San Francisco

far left:
Figure 2.15
John Kapel;
manufactured by
Glenn of California;
dining chair;
walnut, cane, leather.
1965 (*California Design 9*)

center:
Figure 2.16
Tim A. Crowder,
Wishbone Rocker,
oak.
1976 (*California Design '76*)

left:
Figure 2.17
John Cederquist;
hanging cabinet;
wood, leather;
13 x 16 inches.
1971 (*California Design 11*)

opposite:
Figure 2.18
John Snidecor,
jewel stand,
Nara wood.
1971 (*California Design 11*)

Peninsula and set up a workshop where he planned and constructed furniture prototypes for manufacturers *and* made custom-designed furniture for private clients. An example of his prototyping appeared in *CD 9* (1965): a dining chair, for Glenn of California (Los Angeles), tightly designed in walnut with a cane back and leather seat (fig. 2.15). Kapel's custom work was shown the same year—a hanging cabinet, its surface composed of pieced wood in a striking light-and-shadow pattern (fig. 2.14).

Experimental furniture was displayed alongside the finely crafted individual works designed to blend with the residential interiors of individual clients. Like artists working in ceramics, metal, glass, and fiber, furniture makers questioned the limitations of the forms traditional to their genre, as well as the materials, tools, and techniques used. Content-laden messages involving humor or social commentary began to be expressed in furniture. This development was reflected in *CD 10* (1968) and especially in *CD 11* (1971) and *CD '76,* culminating in what Art Carpenter pointedly referred to as "artiture," a combination of art and furniture. In his opinion, this furniture placed too much emphasis on art, rather than good, sound design.[6]

The experimental end of the spectrum was reflected in Tim Crowder's beautifully shaped *Wishbone Rocker* in *CD '76.* The oak chair exuded strength and solidity. The wishbone elements formed the arms and back support (fig. 2.16). The sensitively formed legs of John Snidecor's nava wood jewel stand resembled refined twigs or animal legs (fig. 2.18). In *CD 11* (1971) John Cederquist exhibited an unusual hanging cabinet of wood and leather (fig. 2.17). The leather and hardware combined to give the piece an industrial, masculine feel.

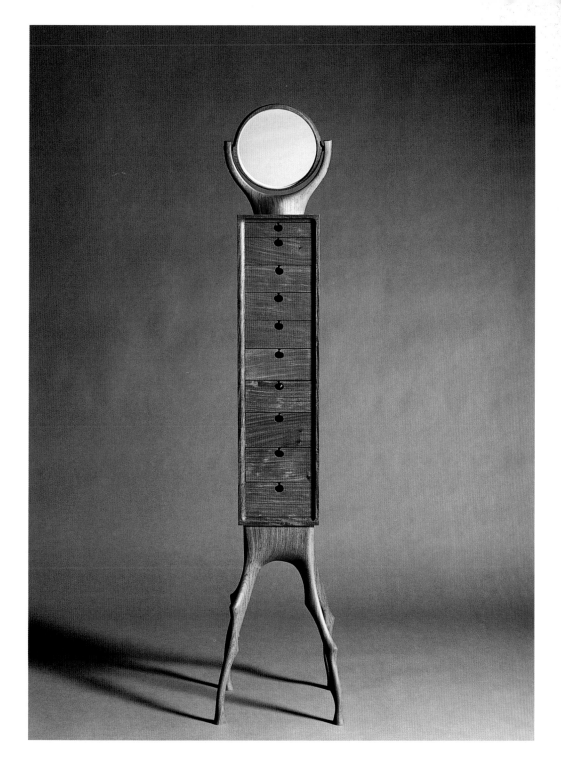

far left:
Figure 2.19
Kirk O'Day,
chest of drawers,
black walnut.
1976 (*California Design '76*)

left:
Figure 2.20
Frank E. Cummings III,
hand-carved chair,
oak,
30 x 31 inches.
Shown with Ron Blanton,
grandfather clock,
sculptured teak and cast,
forged brass.
1971 (*California Design 11*)

opposite, top:
Figure 2.21
Robin Stewart Metze;
desk seat;
laminated ash bands,
upholstery.
1968 (*California Design 10*)

opposite, bottom left:
Figure 2.22
J. B. Blunk,
bench,
redwood,
4 x 3 x 7 feet.
1976 (*California Design '76*)

opposite, bottom right:
Figure 2.23
John Gaughan,
clock with wood gears,
Brazilian rosewood,
12 x 18 x 70 inches.
1971 (*California Design 11*)

Intensive attention to sculptural details characterized Kirk O'Day's untitled black walnut dresser in *CD '76* (fig. 2.19). The dresser had all the expected parts, except that the drawer fronts appeared to be melting, challenging assumptions about the stability of wood. (The carved drawer fronts concealed the drawer pulls.) In John Gaughan's updated version of a grandfather's clock of Brazilian rosewood exhibited in *CD 11* (1971), the extensive use of glass in the case put the emphasis on the inner workings of the clock. The exposed wood gears and unusually shaped weights and pendulum worked together as kinetic sculpture (fig. 2.23).

Experiments with techniques led to some exciting results. J. B. Blunk "carved" furniture with a chain saw. Blunk's path to this unusual technique is reflected in his background. He studied ceramics at the University of California, Los Angeles, and, after serving in the Korean War, trained in Japan in both ceramics (with Japanese masters) and sculpture (with Isamu Noguchi, who became his longtime friend). He settled on a secluded Marin County mountaintop and nurtured his aesthetic, drawing from his study of ceramics and other art forms in Japan. Although Blunk associated with other studio furniture makers of the Baulines Craftsman's Guild, his work broke with convention, exemplified in the untitled redwood bench in *CD '76* (1976) (fig. 2.22). Using a chain saw, he was able to make dramatically large furniture—the bench measured three-by-four-by-seven feet, and other pieces were well over fifteen feet wide—with a bold and appealing ruggedness that was monumental in its impact, like the sculpture he also made.

Some of the most unusual furniture shown in *California Design* exhibitions used laminated woods. Since laminated wood could be produced in any size, it was a way to get around the limitations posed by the standard dimensions of lumber. The resulting furniture was often eye-catching. In

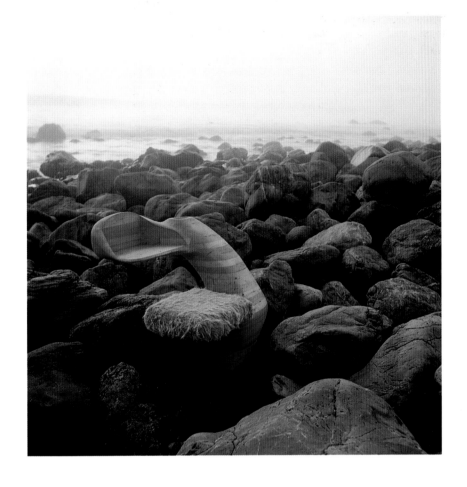

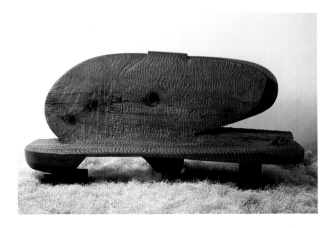

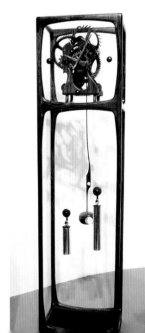

California Studio Furniture

CD 10 (1968), Robin Stewart Metze exhibited an unusual one-piece desk and seat of laminated ash with furry upholstery (fig. 2.21). Constructed at a sharp angle, the piece challenged gravity and had to be bolted to the floor.

In a series of works, Jack Rogers Hopkins concentrated on laminated wood furniture environments that had an almost otherworldly appearance. The cherrywood *Tri-pod chair/coffee table* in *CD 11* (1971) had sweeping lines that were reinforced by the curvilinear placement of the wood grain (fig. 2.26). In the same exhibition, Hopkins outdid himself with *Womb Room,* a four-section piece that he described as "environmental sculptured furniture," with seat, table, bookcase, and radio in a fully integrated form. At six feet high, fifteen feet wide, and six feet deep, it was indeed monumental, with flaring winglike extensions (fig. 2.27). His entry in *CD '76* was a modestly sized cradle, ingeniously fashioned with one rocker and one leg. Its lively surface was adorned with lamination patterns, handles, and cutouts arranged asymmetrically (fig. 2.24).

Another material that allowed freedom of expression was aluminum, which was widely available after World War II. In *CD 10* (1968), Thomas P. Lynn exhibited fluid organic forms: a table with a glass top and a chair (fig. 2.25). The table frame (and built-in candelabra) were made of aluminum; the glass top rested on the aluminum structure (fig. 2.28).

The potential of fiberglass was explored by Mark Abramson in his humorous *Jawbone Throne,* complete with removable molars and a red vinyl tongue in *CD '76.* The work showed the versatility of these industrial materials to respond to the maker's imagination (fig. 2.29). In Lawrence B. Hunter's cozy and inviting rocker shown in *CD 11* (1971), fiberglass was used to form a streamlined vessel, thirty-four inches wide, that was lined with a thick ram-skin cushion (fig. 2.30).

Felipe Leon Escobar made a novel coffee table from an everyday material—plumbing pipes, complete with faucet and valve—shown in *CD 11* (1971) (fig. 2.32). The fragile glass top provided a counterpoint to the industrial material of the base. Another imaginative piece, exhibited in *CD 10* (1968), was James Roger Dupzyk's oversized (sixteen by thirty-six by seventy-two inches), moon-shaped hanging chair, made from a tree bough to which a seat and footrest were added (fig. 0.15, page 19).

In contrast, John Michael Cooper's *Captain's Chair* in *CD '76* was hardly a piece of furniture at all, but an artwork that encouraged viewers to look at furniture in a new way (fig. 2.31). Stunning in its craftsmanship, it was a humorous take-off on the well-known captain's chair form but included a peg leg.

opposite, top left:
Figure 2.24
Jack Rogers Hopkins,
cradle,
laminated sculpted woods.
1976 (*California Design '76*)

opposite, top right:
Figure 2.25
Thomas P. Lynn,
chair,
cast aluminum,
3 x 4 feet.
1968 (*California Design 10*)

opposite, below:
Figure 2.26
Jack Rogers Hopkins;
Tri-pod chair/coffee table;
laminated, sculptured
cherry wood;
2 x 3 x 7 feet.
1971 (*California Design 11*)

pages 86–87:
Figure 2.27
Jack Rogers Hopkins;
Womb Room;
environmental sculptured
furniture in four sections,
wood, leather, metal;
6 x 15 x 6 feet.
1971 (*California Design 11*)

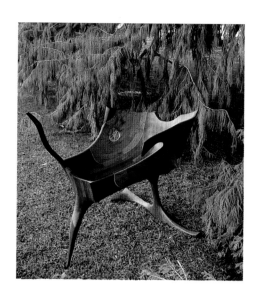

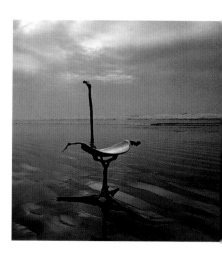

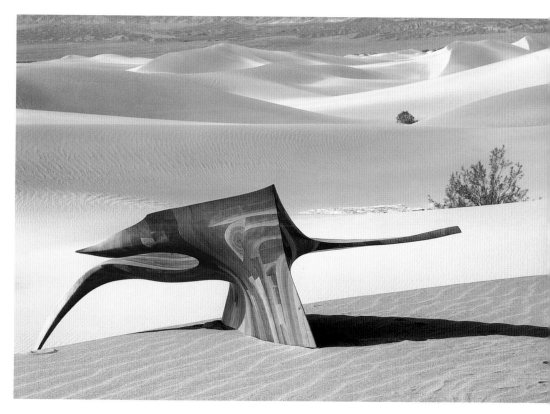

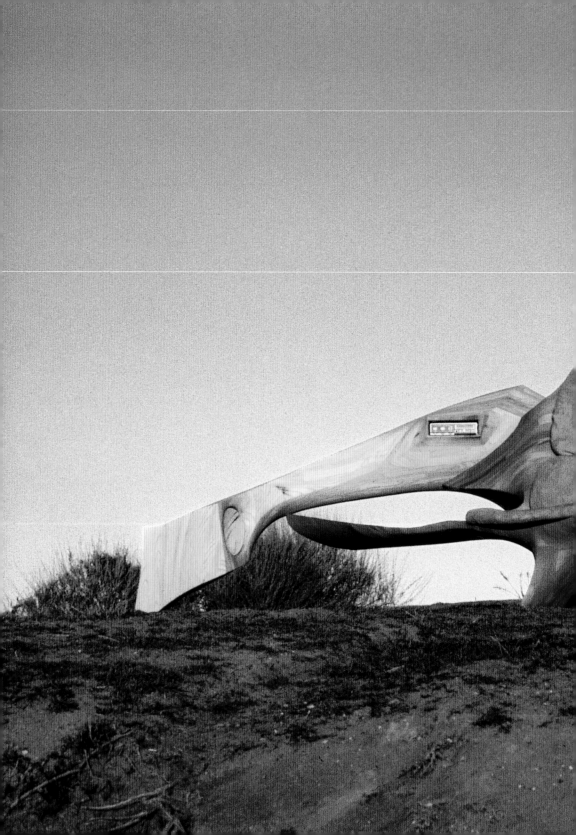

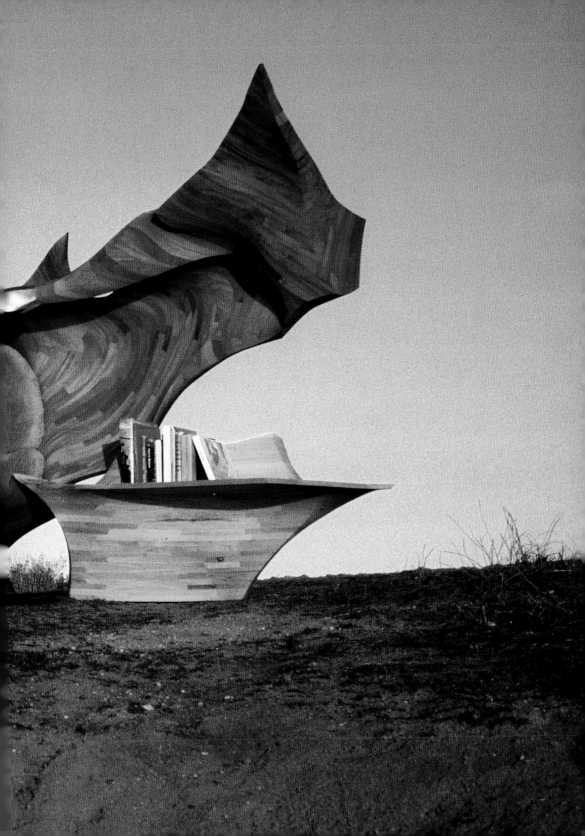

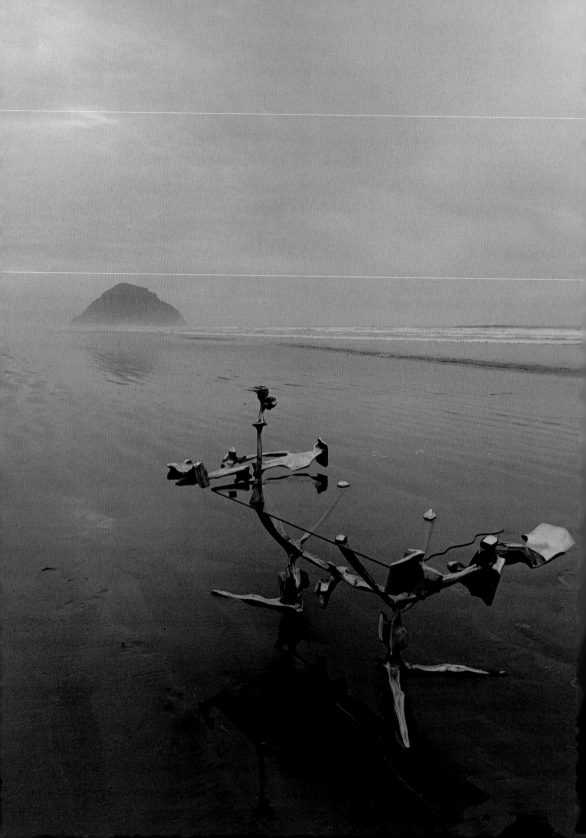

opposite:
Figure 2.28
Thomas P. Lynn;
table with candelabra;
aluminum, glass;
4 x 7 feet.
1968 (*California Design 10*)

right:
Figure 2.29
Mark A. Abramson;
Jawbone Throne (with
removable molars);
fiberglass, vinyl;
3 x 5 feet.
1976 (*California Design '76*)

far right:
Figure 2.30
Lawrence B. Hunter,
rocker,
fiberglass with ram-skin
cushion and upholstery,
34 inches wide.
1971 (*California Design 11*)

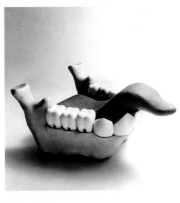

bottom left:
Figure 2.31
John Michael Cooper,
Captain's Chair,
laminated hardwoods.
1976 (*California Design '76*)

bottom right:
Figure 2.32
Felipe Leon Escobar;
coffee table;
steel plumbing pipes, glass.
1971 (*California Design 11*)

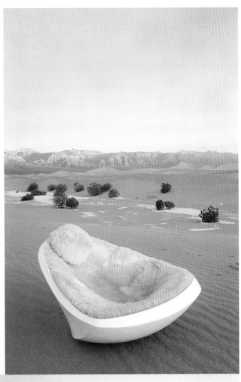

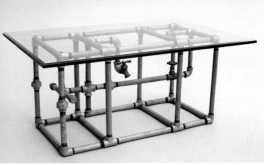

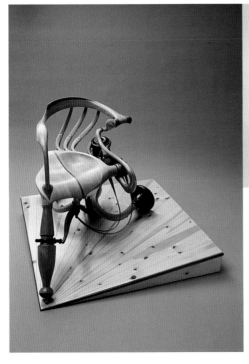

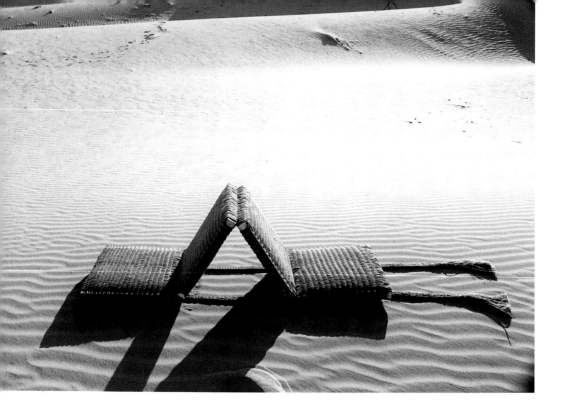

In *CD '76*, furniture made by artists working in fiber was exhibited for the first time, coinciding with the growing experimentation with three-dimensional fiber objects. Cindy Sagen used card weaving to construct a multiposition jute deck chair, built upon a wood frame with brass corner fittings (fig. 2.33). Victoria Mournean's chair, made of pieces of velvet, shaped into dimensional form, allowed a group of people to be seated (fig. 2.34). Katherine Burns's crude but inventive chair of raffia and sisal used basketry techniques to form a seat over oak staves. The fiber components trailed off the piece like vines or tendrils (fig. 2.35).

The last of the *California Design* exhibitions may have pushed the wildly experimental phase of studio furniture to the limit. What followed in the next decades was the refinement of these initial forays and, for some of the studio furniture makers, long careers as artists. Support for studio furniture makers has also come from the Furniture Society of America, founded in 1996. The organization has grown rapidly, bringing together furniture makers, enthusiastic collectors, teachers, gallery professionals, and curators.

above:
Figure 2.33
Cindy Sagen;
multiposition deck chair;
card-woven jute, foam
rubber, wood, brass.
1976 (*California Design '76*)

opposite, left:
Figure 2.34
Victoria Mournean,
chair/multiple seating,
velvet,
3 x 8 x 6 feet.
1976 (*California Design '76*)

opposite, right:
Figure 2.35
Katherine Burns;
chair;
oak, raffia, sisal.
1976 (*California Design '76*)

Opportunities for furniture makers have grown since the last *California Design* exhibition in 1976. As documented in *The Maker's Hand,* a history of American studio furniture, twenty-five galleries in the United States now sell studio furniture, and twenty-five schools teach woodworking or furniture making; of them, five are in California.

1. A more thorough discussion of the term "studio furniture" can be found in Edward S. Cooke, Jr., Gerald W. R. Ward, and Kell H. L'Ecuyer, *The Maker's Hand* (Boston: MFA Publications, 2003), 13—16.

2. In discussing a music stand made by furniture pioneer Wharton Esherick, Cooke said the "whole object can be interpreted as a warm, soft version of modernism." Ibid., 25.

3. Jeremy Adamson, *The Furniture of Sam Maloof* (New York: Norton, 2001), 78.

4. The guild opted to use an older spelling, Baulines, rather than the town's current name, Bolinas.

5. Arthur Espenet Carpenter, "Memoir," in John Kelsey and Rick Mastelli, eds., *Furniture Studio: The Heart of the Functional Arts* (Free Union, VA: The Furniture Society, 1999), 47.

6. Arthur Espenet Carpenter, "The Rise of Artiture," *Fine Woodworking,* no. 38 (January—February 1983), 98—103.

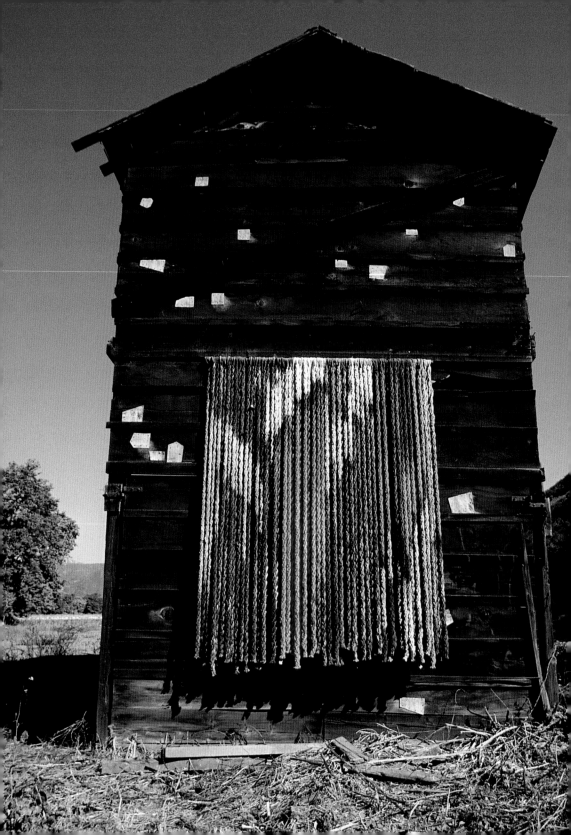

Chapter 3　　　　The Fiber Revolution

SUZANNE BAIZERMAN

"The artists of the fiber medium have found new freedom—
freedom from the loom, and, perhaps more important, or at least
more universal, a transformation of purpose—the freedom
to choose an aesthetic over a utilitarian need."

—MILDRED CONSTANTINE AND JACK LENOR LARSEN, 1972[1]

　　　　　　　The sentiments of Constantine and Larsen pinpoint
the essence of an international revolution in fiber that began in the 1960s.
California artists participated in and influenced this revolution, and examples
of their experimental work were part of the *California Design* exhibitions,
particularly the last two in 1971 and 1976. Taken as a whole, the *California
Design* series showcased the transition from fabrics for daily use to one-of-a-
kind fiber artworks, documenting artists enjoying "freedom from the loom"
and "transformation of purpose." Coverage of the shows drew people from all
parts of the country to witness the dramatic changes taking place in fiber media.
　　　Touring *California Design 11* (1971), a visitor might have been startled
to encounter an environment by Barbara Shawcroft, *Arizona Inner Space,*
(fig. 3.19), a marked contrast to earlier exhibited works largely in flat woven
cloth. Shawcroft's imposing piece—17 by 6 feet—was a coarsely textured,
three-dimensional object made of a single strand of bulky yarn, worked
improvisationally in a knotless netting technique. The colors were tied to
nature: greens, rusts, golds, and white. The dark, nestlike form was a place
of solace and comfort for a human being. *Arizona Inner Space* was destined
from its inception to be a work of art rather than a functional object.
Emphasis was placed on process: each step derived from the one before.
The work could be amended to create additional spaces and connections at
its maker's discretion.
　　　The *California Design* exhibitions reflected the fiber revolution cen-
tered in Berkeley and Los Angeles. Particularly in Northern California, fiber
work expressed the powerful social and political climate of the time: the
civil rights and anti-war movements and the anti-establishment attitude of
the hippies with their signature tie-dyed garments. For fiber art, the women's
movement was especially important because of the traditional association
of women with textiles in the domestic sphere. Men were part of the fiber
revolution, but they were a minority.

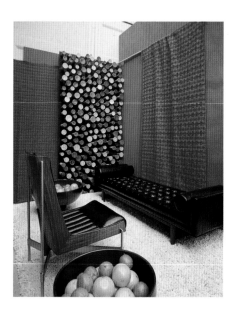

Fiber art was also affected by dramatic changes that occurred in the 1950s when a potter, Peter Voulkos, questioned the limitations imposed upon craft media. He and his students explored clay as a sculptural medium and gained worldwide attention for their gestural, expressive, large-scale clay work. His iconoclastic ideas led those working in other media to question self-imposed limits. Voulkos taught at Los Angeles's Otis Art School beginning in 1954, then went to the Decorative Arts Department (later the Design Department) at the University of California, Berkeley, in 1959.

Voulkos was urged to take that position by Ed Rossbach, head of the department's fiber program, who shared Voulkos's open-minded attitude toward the limitless potential of craft media. Rossbach began teaching there in the 1950s. He brought with him a visionary approach to experimenting with fiber (on and off the loom) and a keen interest in ethnic textiles and their diverse structures. He spawned a new generation of influential teachers from among his students. At the California College of Arts and Crafts in Oakland, German-born Trude Guermonprez applied her Bauhaus training to her weaving classes. The free, experimental spirit of Katherine Westphal, Ed Rossbach's wife, energized students at University of California, Davis. Bernard Kester and James Bassler at the University of California, Los Angeles, and Mary Jane Leland at Long Beach State College inspired students in the southern part of the state.[2] Critical to the development of fiber art was the fact that all of these teachers had studied art and trained their students to see themselves as artists working in fiber.

page 92:
Figure 3.1
Marian Clayden,
wall hanging,
dyed cotton,
10 x 7 feet.
1976 (California Design '76)

above, left:
Figure 3.2
Maria Kipp,
hand-loomed upholstery
fabric. Displayed with
Louis Sugarman's Portuguese wool rug for
Decorative Carpets Inc.
1962 (California Design 8)

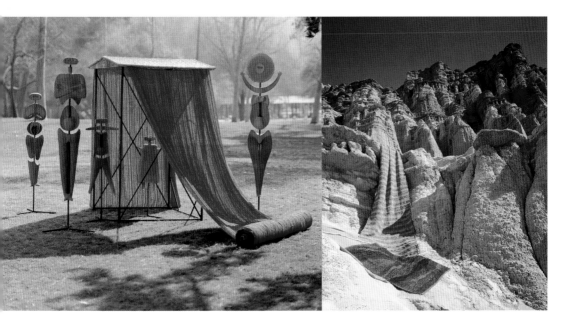

above, left:
Figure 3.3
Webb Textiles,
Collapsible Cabana,
handwoven fabric of
mixed fibers draped over a
cabana by Danny Ho Fong
for Tropi-Cal. Pictured
with Kenneth Starbird's
Watch the Birdie,
ceramic.
1962 (*California Design 8*).

above, right:
Figure 3.4
Robert Webb, designer;
fabric, *Red Rock Canyon*
(center) and *Old Gold*
(right); handwoven by
Webb Textiles.
M. E. Cranston;
tapestry, *Landscape* (left);
4 x 6 feet.
1965 (*California Design 9*)

In the context of changes in contemporary society and educational expansion in the fiber arts, the *California Design* exhibits provided a much-needed venue for the work of fiber artists and stimulated interest in the fiber crafts. The earliest change observable in the series was the transition from the display of practical textiles used in daily life to the display of wall hangings. The first eight *CD* exhibitions (1954—1962) presented almost exclusively works crafted for interior design needs, such as handwoven or printed fabric for upholstery fabric, casement cloth, room dividers, woven blinds, rugs, and placemats. Clifford Nelson, director of these early *CD* exhibitions, worked closely with the Southern California Handweavers' Guild to select works for the exhibitions.[3]

California Design 8 (1962) continued to showcase primarily textiles for interior design applications, including hand-loomed yardage by individuals or firms (fig. 3.2). In one dramatic catalogue photograph, a length of airy, handwoven fabric in shades of red unfurled from a large bolt. The fabric, designed by Webb Textiles, was exuberantly draped over a tentlike frame designed by Danny Ho Fong for Tropi-Cal (fig. 3.3). This display was outdone in *CD 9* (1965) when a length of nubby textured fabric was photographed outdoors, cascading down a rocky cliff. The cloth, designed by Robert Webb for Webb Textiles, was aptly named *Red Rock Canyon* (fig. 3.4).

In both *CD 8* and *CD 9* there were flat-weave rugs and thick-pile rya rugs showing the influence of modernist design, among them a hooked rug

by John Marko (fig. 3.8). Also in *CD 9* was Gere Kavanaugh's flowered rug in vivid psychedelic colors—red, orange, fuchsia, gold, and lime (fig. 3.5). These and other works showed a bold use of intense color. Renowned California fabric designer Dorothy Liebes had a great influence on color use by weavers, particularly in the 1940s and 1950s. Her pulsing combinations, such as blue with green, and fuchsia with orange, were readily adopted by California designers and artists and had an impact nationwide on fabrics for all uses.

As early as *CD 7* (1961) one-of-a-kind works—a wall hanging and a few tapestries—began to appear. The fiber wall art in these early exhibitions reflected modernist design influences of both the Bauhaus and Scandinavia. Wall hangings had more presence in *CD 8* and *CD 9*. They were done in a graphic style seen also in Scandinavian design, with a strong emphasis on subject matter in shallow, two-dimensional space. An appliqué and richly embroidered hanging by Jean Ray Laury, *Scarlet Garden* (fig. 3.6), showed the effective use of brilliant color and naturalistic forms. John Smith's graphic woven wall hanging, *Warriors,* featured blocklike figures in warm, earthy colors. On a larger scale was a tapestry designed by Mark Adams, *Great Wing,* woven at Aubusson, the renowned French weaving center (fig. 3.9). Its size—nine by ten and a half feet—and its technique were characteristic of modern European tapestry. The stunning colors, intricate surface design, and uplifting content conspired to create a breathtaking work. Ragnhild Langlet, born and trained in Sweden, exhibited the elegant monochromatic hanging *Trees,* which used an appliqué technique (fig. 3.7). The placement of applied fabric allowed light to pass through areas without patterning, backlighting the image.

In contrast to these more or less representational works, Lillian Elliott's *Autumn* in *CD 8* (1962) (fig. 3.10) was an abstract fabric collage composed of a variety of patterns and textures. Casual treatment of the fabric's raveled edges gave the piece an air of spontaneity. The work's originality anticipated the leading role Elliott would play in fiber art by experimenting with two- and three-dimensional forms of yarn, paper, gut, and basketry materials.

In 1962, the same year as *CD 8,* a key fiber art event occurred at the international level: the first *Lausanne Biennale* (Biennale Internationale de la Tapisserie) in Switzerland, a juried show organized to celebrate the revival of tapestry. The presence in this exhibition of innovative artists, such as Magdalena Abacanowicz of Poland, who used powerful, rough-textured, curved forms related to the human body, was indicative of a dramatic move away from traditional, smooth-surfaced, rectangular tapestries. The 1962 biennial did not include California artists, but future biennials did. The

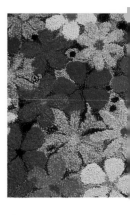

above:
Figure 3.5
Gere Kavanaugh,
hand-hooked rug.
1965 (*California Design 9*)

opposite, left:
Figure 3.6
Jean Ray Laury;
wall hanging,
Scarlet Garden;
appliquéd and
embroidered.
1962 (*California Design 8*)

opposite, right:
Figure 3.7
Ragnhild Langlet;
wall hanging, *Trees;*
appliquéd linen gauze.
1965 (*California Design 9*)

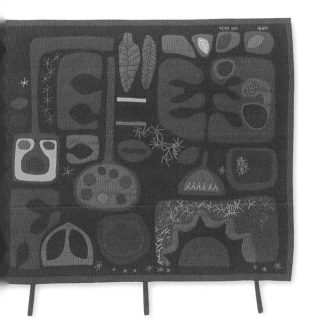

quality of the Lausanne exhibitions, as well as the publicity they generated, elevated fiber art to a new level of importance. Another key event of 1962 was the solo exhibition in Staten Island, New York, of the abstract work of New York artist Lenore Tawney, the first fiber artist who was part of New York's mainstream art scene, which accepted her works as fine art.

In *CD 9* (1965) the number of wall hangings increased. Two-dimensional woven hangings (fig. 3.11) by John Charles Gordon, Mary Buskirk, and Hal Painter were loosely woven with abstract designs and more frankly experimental

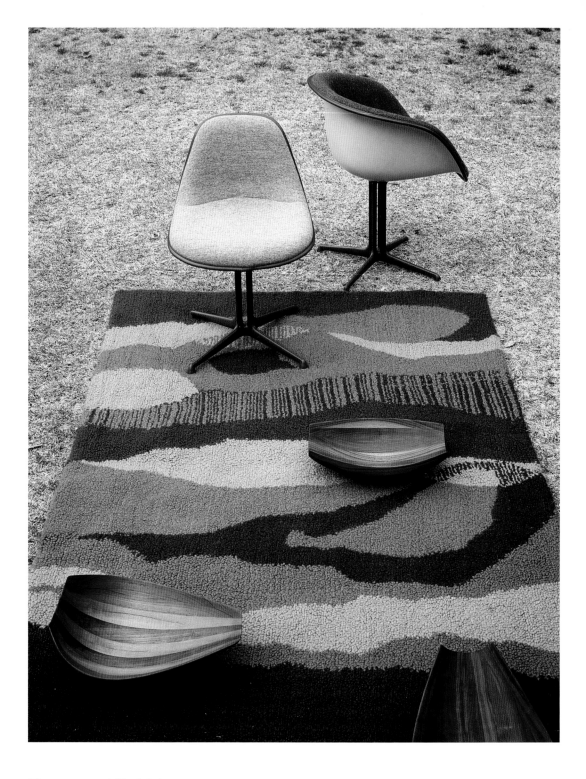

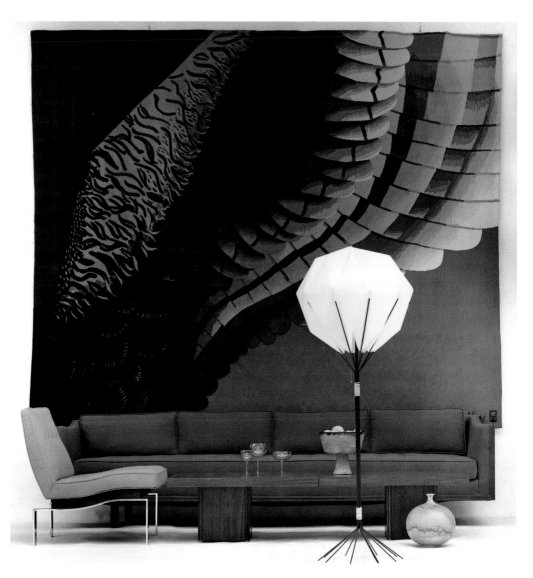

opposite:
Figure 3.8
John Marko,
rug,
wool,
72 x 46 inches.
Shown with wood bowls
by Richard J. Arpea and
chairs by Charles Eames
for Herman Miller.
1962 (*California Design 8*)

above:
Figure 3.9
Mark Adams, executed by
Paul Avignon at Aubusson;
tapestry, *Great Wing;*
9 x 10½ feet.
Shown with a footed bowl
by Beatrice Wood and an
earthenware bottle by
James Lovera.
1965 (*California Design 9*)

left:
Figure 3.10
Lillian Wolock Elliott;
wall hanging, *Autumn;*
appliqué with batik.
1962 (*California Design 8*)

opposite:
Figure 3.11
Group installation
photograph (shown
left to right):
Eleanor M. Kass;
triple-woven form;
linen, cotton, jute.
John Charles Gordon,
hanging with drops.
Mary Balzer Buskirk,
woven wall hanging with
fringe (8 feet).
Mary Balzer Buskirk,
woven wall hanging with
fringe (2 feet).
Hal Painter, open-tapestry
hanging, handwoven
(3 x 6 feet).
John Charles Gordon,
banner.
Janet Van Evera; yardage
for room divider, screen,
or wall hanging.
Trude Guermonprez;
space hanging, *Banner*
(28 x 8 x 7 inches).
M. E. Cranston-Bennett;
tapestry, *Tree;* wool, sisal,
jute (2 x 3 feet).
Mary Balzer Buskirk,
woven wall hanging.
1965 (*California Design 9*)

than the hangings in previous exhibitions. Even more noteworthy was the appearance of three-dimensional pieces alongside the two-dimensional works. Trude Guermonprez wove her "space hanging" *Banner* on the loom in two layers, a process called double weaving. The two layers were manipulated during the weaving process so that they intersected. When removed from the loom, the layers could be pulled apart and displayed to create a three-dimensional form. This unusual technique became widely imitated. In another dimensional hanging, a triple weave, Eleanor Kass combined linen and cotton with jute, an unusual material at the time, but one that was gaining widespread popularity.

More new materials appeared in *CD 10* (1968), as did work in larger scale, for example, John Charles Gordon's hanging of hemp, raffia, wool, and mahogany, measuring six by three feet (fig. 3.28, page 113). The artist sought out coarse yarns that looked as if they sprang from the natural world. Another work of impressive size was Ragnhild Langlet's abstract wall hanging of painted linen and appliqué, twelve by twelve feet, and ironically entitled *Mini* (fig. 3.12). The active surface of checkerboard patterning and dynamic curves was coupled with intense complementary blue/orange and black/white color combinations. A wall hanging by Barbara Waszak, *Del Norte,* combined weaving with beads, leather, wool, and old hardware, a mixed media celebration of excess that was not atypical during this period (fig. 3.13).

The influence of ethnic textiles became apparent in *CD 10*. In part because of increased interest in international travel, artists working in fiber

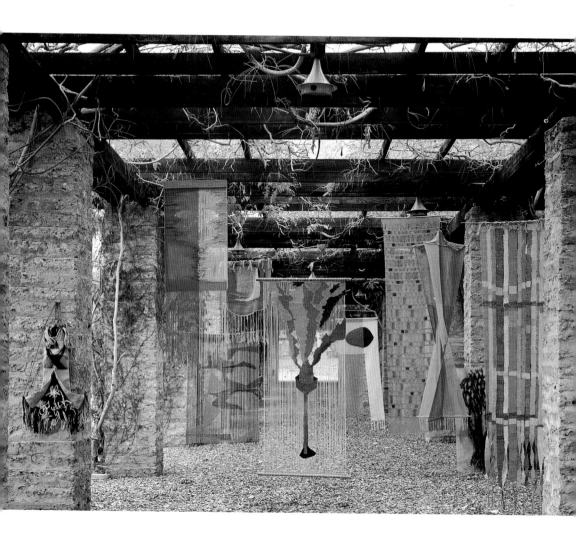

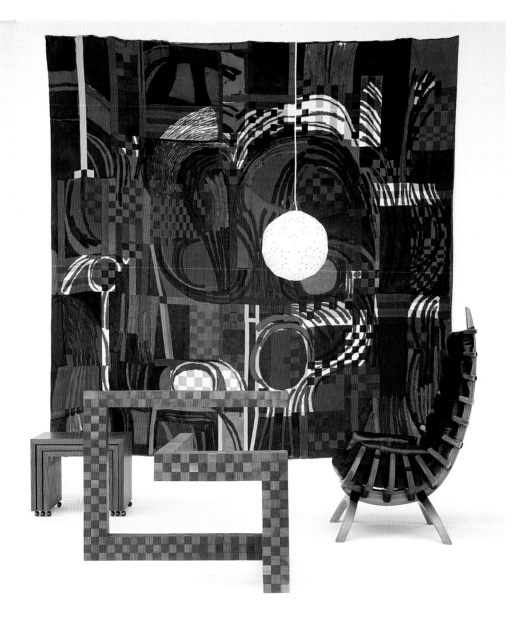

Figure 3.12
Ragnhild Langlet; wall hanging,
Mini; vat-dyed, painted linen and
appliqué; 12 x 12 feet. Displayed
with *Great Rib Chair* by Arthur
Espenet Carpenter; *Sculptron 106,*
do-it-yourself sculpture by Charles
F. Ulrich; geometric dymaxion
light fixture by Buckminster Fuller;
nestled end tables by John Caldwell
for Brown Saltman Co.
1968 (*California Design 10*)

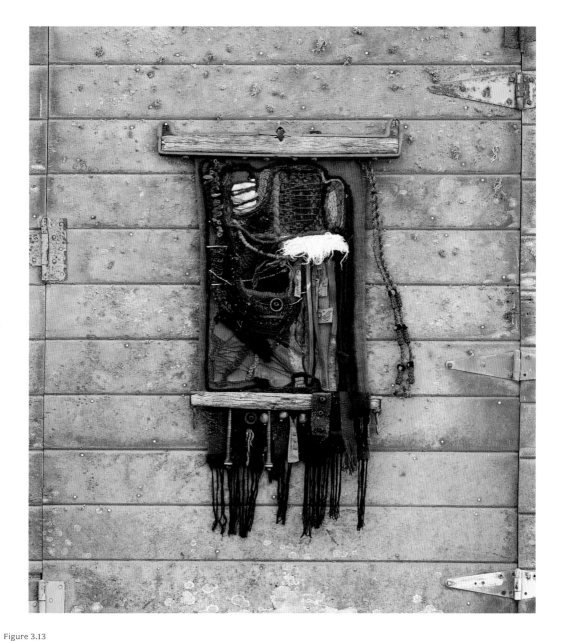

Figure 3.13
Barbara Waszak;
wall hanging, *Del Norte;*
ceramic beads, leather,
wool, old hardware, and
other materials;
31 x 50 inches.
1968 (*California Design 10*)

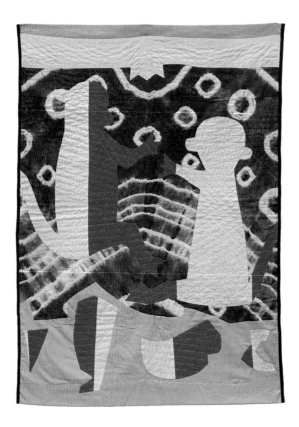

had begun to mine ethnographic and archaeological textiles for their unique structures, techniques, color combinations, and symbolic or ceremonial content. For example, pre-Columbian Peruvian weavers were expert dyers and colorists who used extraordinarily complex textile techniques. Various Indonesian peoples created complex patterning by employing ikat dyeing technique, which involved tying and then dyeing small sections of warp or weft yarn.[4] Fiber artists, many of them college educated, conducted in-depth research to learn more about ethnic textiles and traveled abroad to study textiles and, when possible, work alongside those who made them. Artists and researchers from abroad shared their knowledge with American artists. Yoshiko Wada, who came to the United States from Japan to study, disseminated information about Japan's *shibori*-dyed textiles from her base in Berkeley. Californians' proximity to Latin America and the Pacific Rim cultures made them particularly responsive to the aesthetic potential of the textiles indigenous to these cultures.

left:
Figure 3.14
Katherine Westphal;
wall hanging,
African Monkeys;
47 x 34 inches.
1968 (*California Design 10*)

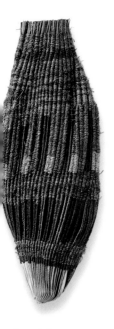

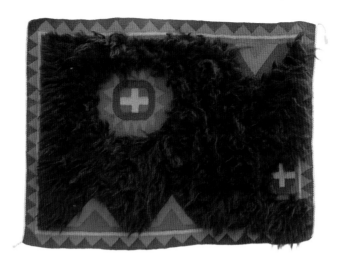

CD 10 included examples of batik and *plangi,* Indonesian dyeing techniques, for instance, were seen in Carol Ryoko Funai's wall hanging (fig. 0.2, page 10). Katherine Westphal exhibited *African Monkeys,* a combination of appliqué and patterned dyeing in bright colors, expressing her playful, original style (fig. 3.14). In her exploration of Scandinavian techniques, Carole Beadle, a student of Trude Guermonprez, reinterpreted Scandinavian design in a sumptuous rug with striking colors, deep pile, and imagery suggestive of northern sun and mountains (fig. 3.16).

Ed Rossbach had studied ethnic textiles extensively before he came to the University of California at Berkeley. Upon his arrival, he found that faculty and graduate students in the decorative arts department were researching topics such as California Indian baskets and Guatemalan and Peruvian textiles, among them Lila O'Neale, who had worked with the anthropologist Alfred Kroeber. He also discovered and made use of the department's textile collection, assembled by faculty members. Rossbach spent his years at the university exploring various Euro-American and ethnic textile techniques using contemporary materials, especially such humble items as plastic tubing and newspaper, in eloquent and innovative ways. Basketry was a special interest. Rossbach's sole work in the *California Design* exhibitions was a dimensional piece in *CD 10, Palm Basket,* made of plastic and *ixtle* (a plant fiber) woven around the splines of a palm leaf (fig. 3.15).

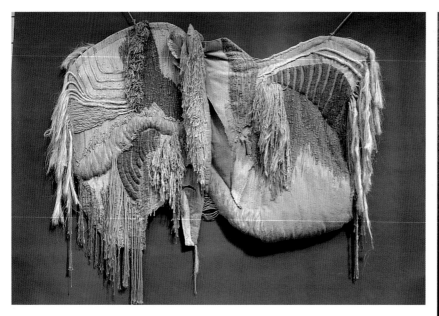

CD 11 (1971) was a banner year for fiber in the *California Design* exhibitions. Fiber entries that year were equal in number to those submitted for the usually larger ceramics category. Trends from earlier shows—the interest in natural forms and textures and in ethnic textiles—continued and were elaborated. Several important exhibitions contributed to the changes seen in *CD 11*. The 1967 *Lausanne Biennale* included three-dimensional work, as well as traditional tapestry. Americans interested in fiber took notice of this catalytic Lausanne exhibition. In 1969, the Museum of Modern Art in New York City mounted *Wall Hangings,* a show signaling an increasing acceptance of fiber art as a mainstream art form. The work of California artist Kay Sekimachi appeared in this MOMA exhibition. The same year as *CD 11,* *Deliberate Entanglements,* another fiber-centered exhibition, was presented, with an associated week-long conference, at the University of California, Los Angeles. On display were works by influential European fiber artists such as Magdalena Abacanowicz, Jagoda Buic, and Francoise Gross, as well as prominent American artists Sheila Hicks and Claire Zeisler. Bernard Kester, the show's organizer, was also a juror and exhibition designer for *California Design.* The Pasadena Art Museum installed a solo exhibition of the work of Magdalena Abacanowicz in connection with the conference. These exhibitions,

above, left:
Figure 3.17
Joan F. Austin;
wall relief;
handspun wools,
mohair, and other fibers,
double woven;
6 x 9 feet.
1971 (*California Design 11*)

above:
Figure 3.18
Gerhardt G. Knodel;
Dining environment;
woven cotton, linen, nylon,
mirror glass.
1971 (*California Design 11*)

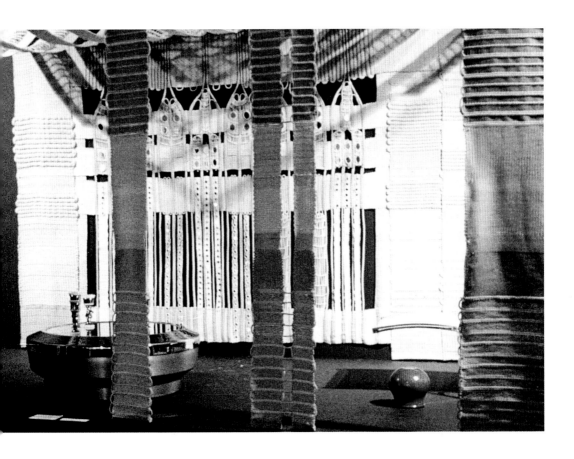

together with *CD 11*, gave California a presence in the international fiber art movement.

CD 11 was notable for the number of dimensional works exhibited, including Barbara Shawcroft's sculpted environment, *Arizona Inner Space,* mentioned earlier (fig. 3.19). In sharp contrast was Gerhardt Knodel's more tailored environment, designed to create a formal, defined dining area (fig. 3.18). Woven of cotton, linen, and nylon, it incorporated mirror glass intended to reflect the lighting within the space.

Typical of the time, a number of artists were inspired by and celebrated nature. For her large wall tapestry, Joan Austin used wool, mohair, and other fibers and double-weave techniques to join layers of cloth on the loom and form pockets that could be stuffed, creating a wall relief (fig. 3.17). Woven ribs, added fringe, and textured yarn of various sizes suggested organic forms such as moss, roots, and bark.

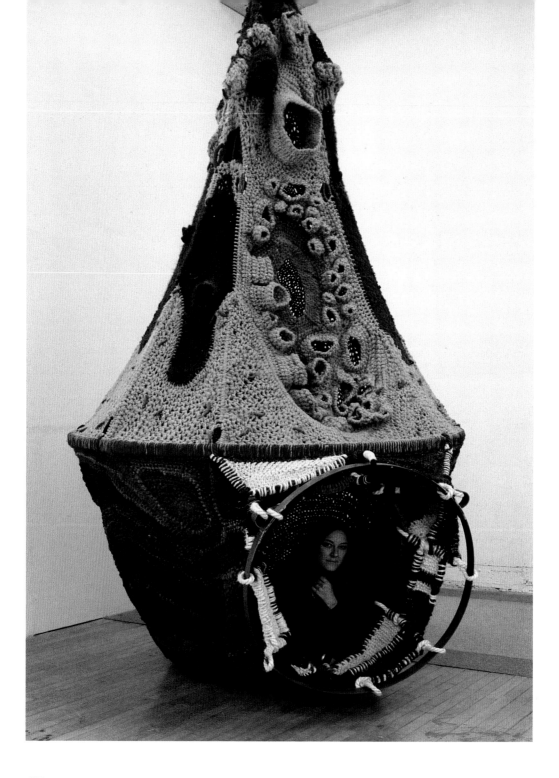

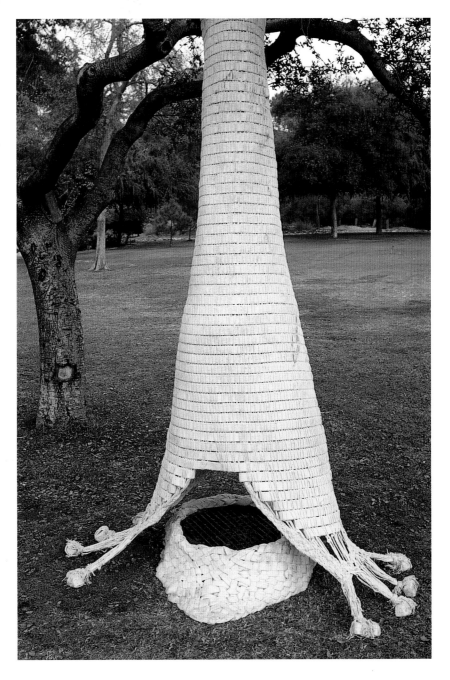

In *CD 11*, traditional techniques were used in new ways and on a large scale. Ted Hallman knitted a nine-foot-tall hanging sculpture, *Alby's Tree* (fig. 3.21). Neda Al-Hilali's mobile *Ship of Fools* was created in macramé, seen in the ubiquitous knotted plant hangers of the time (fig. 3.22). Gyongy Laky, a student of Ed Rossbach's, exhibited a large basket composed of tubes made from synthetic yarn in a rainbow of bright colors (fig. 3.24). Dyed textiles reached psychedelic proportions, echoing the tie-dyed T-shirts of the counter-culture, as in Marian Clayden's *Cool It,* two panels in fuschia, orange, purple, gold, and white. Special lighting designed for the work intensified the colors (fig. 3.23). (Clayden's fabrics were used in the New York production of the musical *Hair* in 1968.) Unusual materials in *CD 11* included asbestos fiber used in Bonnie MacGilchrist's woven *Fireplace with Hood* (fig. 3.20).

Expressive content also expanded in this exhibition. In her humorous commentary on consumer culture, *Computerized Matchmaker,* Ida Horowitz fashioned a machine of stuffed, pieced fabric (also known as soft sculpture) (fig. 3.29). The upper part was composed of arms that embraced images of people that were being fed into a machine that processed these eligible singles into raw data. The arms are simultaneously sheltering and diabolical.

Ethnic textiles continued to inspire fiber artists, among them James Bassler, whose wall hanging in a modified slit tapestry, in vibrant red, gold,

below, left:
Figure 3.21
Ted Hallman;
hanging sculpture,
Alby's Tree;
interlaced yarns;
4 x 4½ x 9 feet.
1971 (*California Design 11*)

below, right:
Figure 3.22
Neda Al-Hilali;
knotted mobile,
Ship of Fools;
various fibers;
3½ feet tall.
1971 (*California Design 11*)

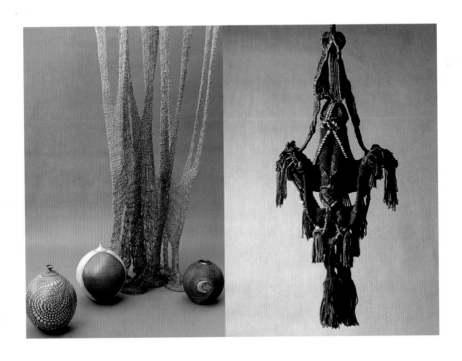

purple, and white, was reminiscent of ancient Peruvian textiles (fig. 3.27). Marianne Childress's *Kiva Ladder,* in leather, horsehair, and vegetable-dyed wools on a sapling scaffold, evoked the Pueblo ceremonial chamber (fig. 3.25).

Experimentation during this time was not limited to hand-made textiles, but was found in surface design as well. An asymmetrical, two-dimensional, hand-screened textile, *Beast in the Jungle* by Frances Butler, featured a montage of images, including two tigers, each rendered in a different graphic style, a reclining female figure, and a high rise building. It was designed for the manufacturer Mutabor (fig. 3.31).

In 1972, the year after *CD 11,* the highly influential book *Beyond Craft: The Art Fabric* was published, bringing together groundbreaking work in international textiles. The book was co-authored by fabric designer and collector Jack Lenor Larsen and Mildred Constantine, former curator at New York's Museum of Modern Art. Five California artists were selected for inclusion; two of them were Ed Rossbach and Kay Sekimachi. Rossbach's *Palm Basket,* exhibited in *CD 10,* was one of several examples of his work in the book. Representing Kay Sekimachi was one of her signature multiple-layer weavings. Sekimachi, a student of Trude Guermonprez, had expanded the technique of double weave. Using the challenging material of dyed nylon monofilament (fishing line), she made layers of open, springy fabric that

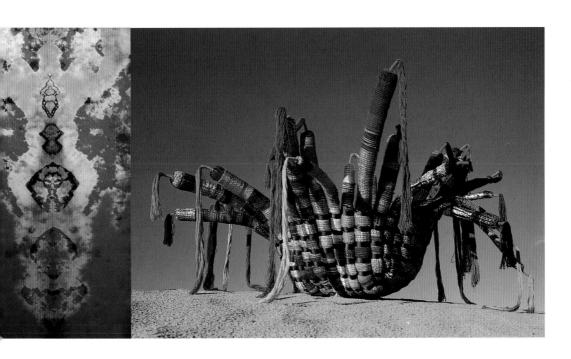

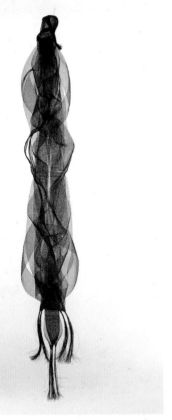

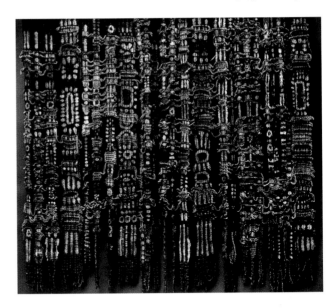

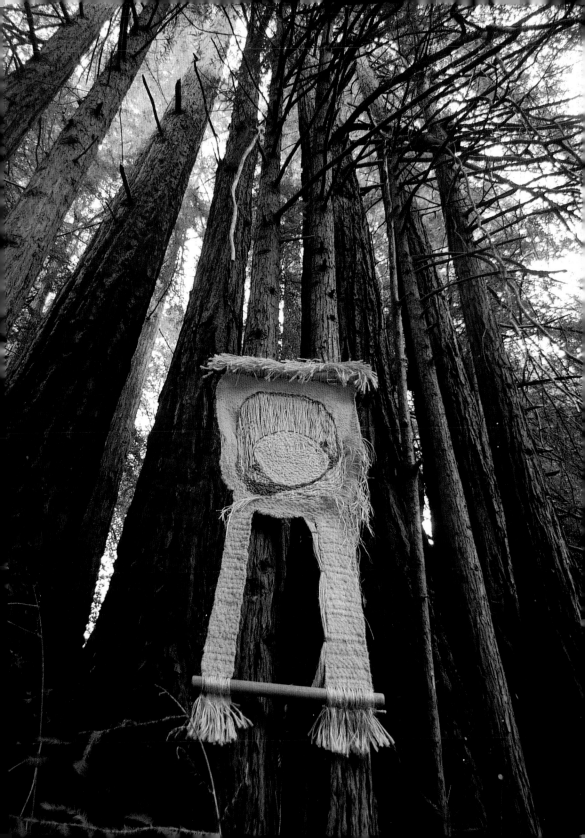

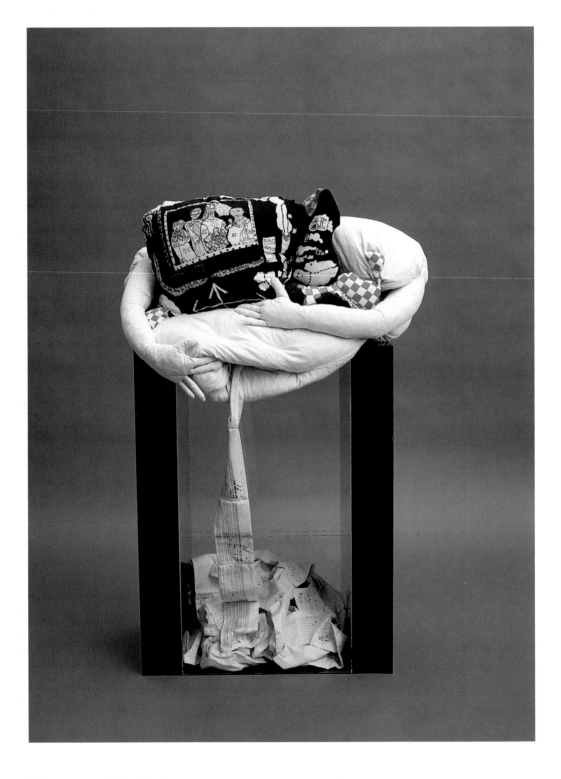

could be manipulated to achieve curved and angular shapes, resulting in a gossamer hanging of eloquent beauty. A piece similar to those in *Beyond Craft, Nagare VI* (fig. 3.26), appeared in *CD 11*. Sekimachi's monofilament work was also selected for the 1969 *Wall Hangings* exhibition and the 1973 *Lausanne Biennale*. Geraldine Scalone's blanket, woven in rich shades of red and purple stripes, used varied yarn textures and diameters and appeared in both *Beyond Craft* and *CD 11* (1971) (fig. 3.32). Scalone's intention was to create a ceremonial blanket, which would take on symbolic meaning over and above its traditional function of warming and comforting.

In 1975, the magazine *Fiberarts* was launched in North Carolina and quickly contributed to the growth of fiber art in the United States. The magazine disseminated information and observations about artists and exhibitions around the world. Initially a newsletter with black-and-white photographs, it soon became a four-color magazine. It continues to be published today.

Five years elapsed between *CD 11* (1971) and *CD '76*. In the intervening years, two new educational institutions opened in Berkeley, partly in response to the impending closure of the design department at U.C. Berkeley and partly in recognition of the increased interest in fiber art. The Pacific Basin Textile Art Center was established in 1972 by Inger Jensen and Pat McGraw, and Fiberworks was started by former Ed Rossbach student, Gyongy Laky, and other artists in 1973. Students came from across the country to take classes and workshops and expose themselves to the abundance of talent in the Bay Area. Both institutions maintained galleries that displayed contemporary work as well as ethnic textiles, adding to the Bay Area's fiber rich environment.

above, left:
Figure 3.32
Geraldine Scalone;
blanket;
wool and mohair,
hand-spun and hand-dyed.
1971 (*California Design 11*)

above, right:
Figure 3.33
Lia Cook;
weaving,
Interweave II (detail);
ikat weaving with
photographic
image transfer;
8 x 4 feet.
1976 (*California Design '76*)

opposite:
Figure 3.34
Tom M. Fender;
November Wall;
loom-woven construction,
wool, sisal;
8½ x 17½ feet.
1976 (*California Design '76*)

CD '76 reflected the maturing of fiber art in the mastery of technique, design, and concept visible in the exhibited works, and the artists' level of professionalism and sophistication. Lia Cook trained as a painter before she studied with Ed Rossbach. *CD '76* was her only association with the exhibition series. However, she exhibited in the 1975 and 1977 *Lausanne Biennials.* In her *CD '76* piece, *Interweave II,* Cook used both ikat dyeing techniques and photographic processes to produce bold, close-up images of plied yarns that emphasized their curvaceous lines (fig. 3.33). Another work building on a key characteristic of yarn—its tendency to twist—was Marian Clayden's untitled wall piece made of resist-dyed cotton twisted into skeinlike lengths. Their dyed patterns created dynamic movement across a kaleidoscopic surface (fig. 3.1, page 92).

left:
Figure 3.35
Irina Averkieff;
wall hanging;
tapestry-woven and dyed
fiber, sisal, and jute;
5 x 6 feet.
1976 (*California Design '76*)

opposite:
Figure 3.36
Mary Chesterfield;
Chandra,
environmental sculpture;
spray-painted sisal, steel,
neon lighting tubes;
16 x 20 x 20 feet.
1976 (*California Design '76*)

The influence of pioneering European fiber artists was apparent in Irina Averkieff's tapestry in her choice of materials (dyed sisal and jute), her vibrant colors, and the scale of her work. The work was cleverly shaped from individually woven, ruffled segments attached to a base. Each individual segment was worked with a gradation of red for a rich and sensual effect (fig. 3.35).

For *November Wall,* of wool and sisal, Tom Fender created large-diameter weft, wrapped weft yarns. As he worked the yarn into a fabric, he created large, free hanging loops. The resulting artwork presented a contrast of order and disorder. Its size and presence is reminiscent of the work of Eva Hesse (fig. 3.34).

Among the works in *CD '76,* one piece stands apart. *Chandra,* an environment by Mary Chesterfield, was the largest fiber structure ever shown in a *CD* exhibition. Measuring sixteen by twenty by twenty feet, it was composed of great quantities of sisal yarn, suspended from the ceiling and left to hang free, like a massive fringe. The sisal was sprayed with silver paint, and the structure's interior was lit with thirty-five pink neon tubes. The lighting was designed to evoke *Chandra,* a word meaning "the glow of moonlight" in Sanskrit, from which the title was derived (fig. 3.36).

An important addition to *CD '76* was the body covering section. An introduction to the catalogue chapter noted: "*California Design* for the first time includes a section on body coverings, not style, not fashion but fantasy,

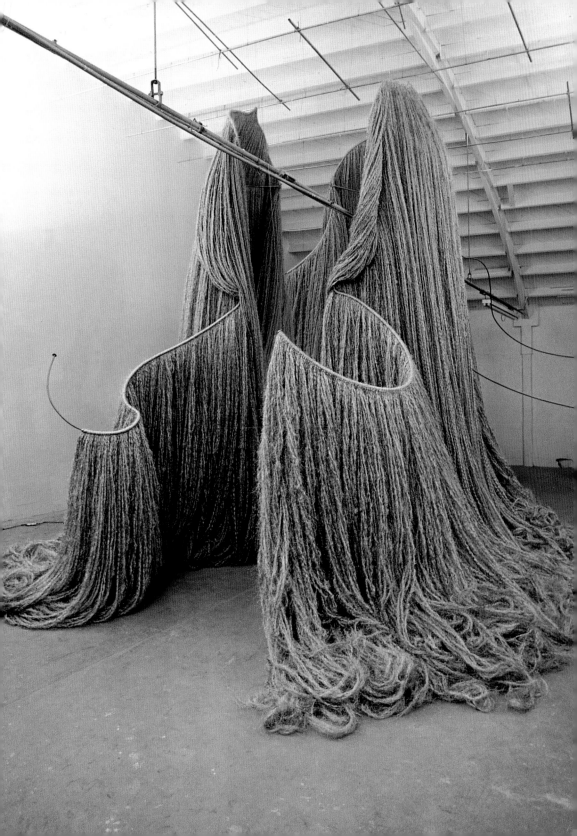

dreams, directions, possibilities or even repudiations, possibly even the way it might be." The section included jewelry and wearable art, much of it highly individual and expressive—even outlandish.[5] The works reflected, in part, the styles of flower children and hippies. Nicki Marx's *Shaman's Robe*, larger than lifesize and interwoven with horsehair, feathers, and leather, was more costume than clothing (fig. 3.37). In subsequent years, wearable art would become more visible, especially in the art communities across the United States.

In the years after *CD '76*, the permanence of fiber art on the American art scene was apparent. Galleries such as the Alrich Gallery in San Francisco handled the works of fiber artists like Lia Cook as well as painters, and serious collectors became interested in fiber art. A national organization, the Friends of Fiber Art, was formed in 1991 and brought together collectors, gallery owners, curators, and artists to promote fiber art through educational events such as conferences and to support museum exhibitions.

The new generation of teachers would assume their positions: Lia Cook at the California College of Arts and Crafts and Gyongy Laky at the University of California at Davis. The vitality of these programs attested to the viability and breadth of fiber art from traditional techniques and forms to work in mixed media, where fiber is one element expressing the artists' ideas.

1. Mildred Constantine and Jack Lenor Larsen, *Beyond Craft: the Art Fabric* (New York: Van Nostrand Reinhold Co., 1972).

2. The California College of Arts and Crafts was renamed the California College of the Arts in 2003. Long Beach State College is now California State University, Long Beach.

3. Members of the guild made nearly all of the textiles in *CD 1* (1955) through *CD 7* (1961). The jury system of selection was instituted for *CD 8*. The connection to the Southern

California Handweavers' Guild was made by Glenn Adamson, "Crafting an Identity: 21 Years of California Design." Lecture at symposium, "Revisiting 'California Design' Exhibitions: 1952—1976," Oakland Museum of California, May 8, 1999.

4. Examples of earlier use of ethnic weaving techniques appeared in Mary Meigs Atwater, *Byways in Hand-Weaving* (New York: Macmillan, 1954) and Harriet Tidball, *Peruvian Textiles, Unlimited, Parts 1 and 2*, Shuttle Craft Guild Monographs No. 25 and 26 (Lansing, MI: Shuttle Craft Guild, 1968 and

1969). In Else Regensteiner's book, *The Art of Weaving* (New York: Van Nostrand Reinhold, 1970), ethnic weaves were included as examples of textile art.

5. *California Design 11* (Pasadena: California Design, 1971), 141.

Figure 3.37
Nicki Marx;
Cape, *Shaman's Robe*;
feathers, horsehair,
leather;
80 x 34 x 4 inches.
1976 (*California Design '76*)

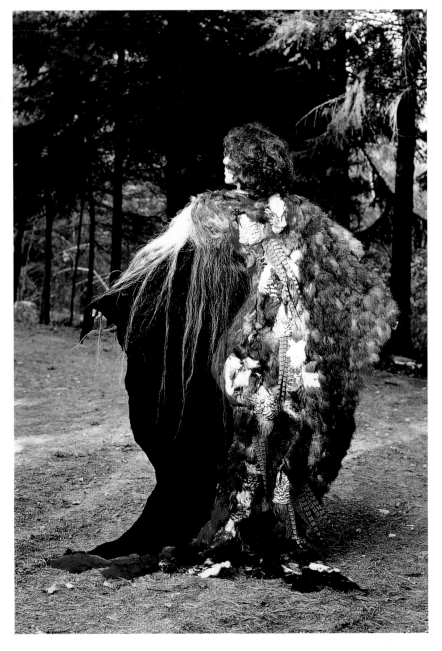

The Fiber Revolution

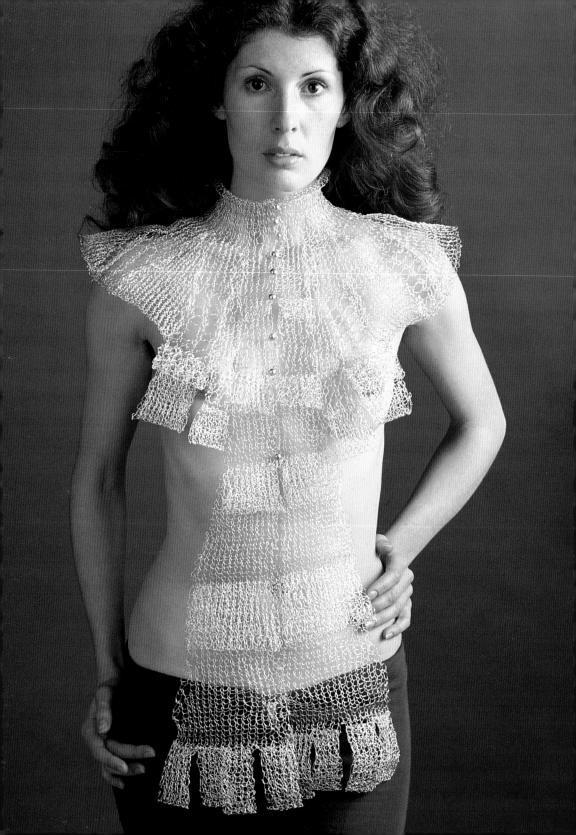

Chapter 4

Body Sculpture: California Jewelry

TONI GREENBAUM

No art form expresses the human spirit better than jewelry, which shares an intimacy with the physical, emotional, intellectual, and ethereal aspects of the personality. Studio jewelry—designed and fabricated by a single maker—was one of the most compelling facets of a craft renaissance that exploded in the United States immediately following World War II. Pockets of jewelry activity at this time existed throughout the United States, notably, the Cranbrook Academy of Art in Bloomfield Hills, Michigan; the School for American Craftsmen, first in Alfred, then Rochester, New York, and a few regional organizations such as the League of New Hampshire Craftsmen, with headquarters in Concord. But the studio jewelry movement was largely concentrated on the East and West Coasts. New York City and California contained the leading centers for such "modernist jewelry," as it is now termed, but they contrasted sharply.[1] Whether jewelers had studios in Greenwich Village, Midtown, or the outer boroughs, styles in New York City were fairly consistent and revolved around innovations launched by the three most original makers: Sam Kramer, Paul Lobel, and Art Smith.

In California, however, jewelry activity was not limited to one city; in the early years of the movement, regional styles were as diverse as the different landscapes. The jewelry created in each locale often reflected a design canon guided by the area's presiding muse or practiced by the metals faculty at one of the educational institutions situated throughout the state. Eudorah M. Moore, in her foreword to the catalogue for *California Design 11* (1971), cited the population's "frontier syndrome" of self-reliance and obsession with materials, along with the state university system's distinctive attitude toward artisanry, as fundamental reasons for its craftspeople's individualistic way of making works that "take on a life of their own and become a palpable experience."[2]

This was particularly true of jewelry, which embodied the detachment of California-made crafts from historic precedents and indigenous roots, thereby setting it apart from the remainder of the country.[3] Jewelers elsewhere in the United States had many opportunities to view the work of Californians, however. First, there were the national exhibitions that featured jewelry, sponsored by organizations such as the Museum of Modern Art and the American Craftsman's Council in New York City, the Walker Art

Center in Minneapolis, the Wichita Art Association in Kansas, and the Hickok Company of Rochester, New York. Of the thirty-two jewelers participating in *Objects: USA,* the landmark 1969 exhibition and book (supported by the S. C. Johnson Company of Racine, Wisconsin), ten lived in California at the time of the show, and three more had lived or soon would live there. Only three resided in New York. The most comprehensive and edifying way, however, to view jewelry from California, at least between 1965 and 1976, was along with objects in many other media as part of the *California Design* exhibition series and the superb catalogues that accompanied them.

Modernist jewelry in California was as unique as trumpeter Chet Baker's cool jazz or San Francisco's City Lights bookstore. From around 1940 until her death in 1964, Margaret De Patta was foremost among jewelers in the San Francisco Bay Area. A former painter, she had studied with Hungarian constructivist László Moholy-Nagy at the School of Design (New Bauhaus) in Chicago (fig. 4.4).[4] Along with Merry Renk and Florence Resnikoff (fig. 4.5) (both of whom exhibited in several *California Design* shows), she formed the Metal Arts Guild of San Francisco in 1951, an organization dedicated to unifying and promoting the studio jewelry community in Northern California by providing a forum for philosophical discourse and technical networking.[5] There is little question that De Patta was the greatest modernist jeweler in California. This is due to her originality in designing jewelry with the aesthetic rigor usually applied to painting and sculpture, to her status as a role model for other metalsmiths, and to the sheer artistry of her oeuvre. (Though she died too soon to exhibit in the *California Design* series, her husband, Eugene Bielawski, an industrial designer who also attended the School of Design, contributed a pair of eccentrically balanced "ear jewels" (fig. 4.2) made from gold and black pearls to *CD 10* in 1968.)

Unlike San Francisco, Los Angeles did not have a jewelry craftsman's guild per se, or a guru like De Patta, during the mid-twentieth century. Nonetheless, it possessed several fine schools, such as the University of California at Los Angeles, University of Southern California, and California State University at Long Beach, that taught metalsmithing earlier than those in most other areas of the country. Sam Kramer (fig. 4.3), arguably the leading modernist jeweler in New York, studied jewelry making around 1936 at the University of Southern California with Glen Lukens, the groundbreaking California ceramist known for his revolutionary dripped and pooled glazes. Kramer's penchant for highly textured surfaces, achieved by fusing ragged bits of metal and/or blobs of molten silver, was a result of his experience with Lukens (who was surely inspired by the state's rough, craggy terrain).[6]

page 122:
Figure 4.1
Arline Fisch,
capelet,
fine gold and silver wire (knit).
c. 1976 (*California Design '76*)

top left:
Figure 4.2
Eugene Bielawski;
earrings;
14k gold, black pearls.
c. 1968 (*California Design 10*)

top right:
Figure 4.3
Sam Kramer;
brooch;
silver, copper, agate;
c. 1948.
The Montreal Museum of Fine Arts, Liliane and David M. Stewart Collection, gift of Paul Leblanc. Photo: The Montreal Museum of Fine Arts, Giles Rivest.

bottom left:
Figure 4.4
Margaret De Patta;
brooch;
silver, stainless steel mesh, gold;
c. 1950.
The Montreal Museum of Fine Arts, Liliane and David M. Stewart Collection, gift of Paul Leblanc. Photo: The Montreal Museum of Fine Arts, Giles Rivest.

bottom right:
Figure 4.5
Florence Resnikoff;
pin;
gold-plated copper, plastic.
c. 1971 (*California Design 11*)

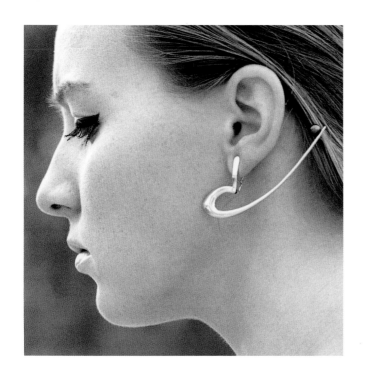

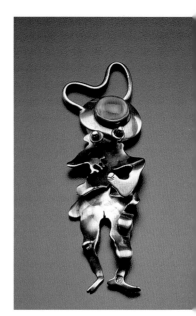

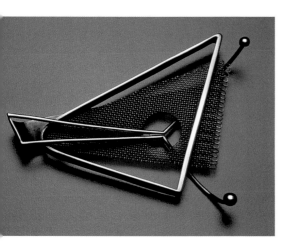

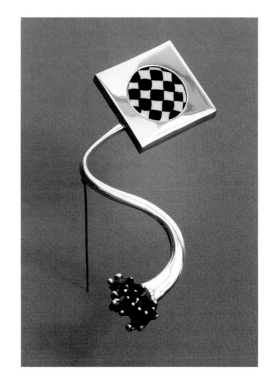

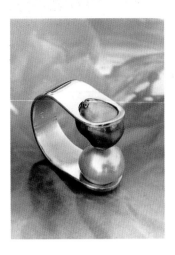

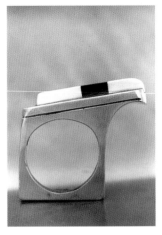

above, left:
Figure 4.6
Allan Adler;
Stirrup Ring;
14k gold, pearls.
c. 1968 (*California Design 10*)

above, right:
Figure 4.7
Esther Lewittes;
ring;
silver (lost wax cast),
ebony, ivory.
c. 1968 (*California Design 10*)

Los Angeles's preeminence in metals can also be attributed to the Arts and Crafts movement at the turn of the twentieth century, which emerged quite strongly in California.[7] Allan Adler, who worked in Los Angeles and its environs from 1940 until his death in 2002, was the son-in-law of Porter Blanchard, the renowned Arts and Crafts silversmith. Adler showed his clean, simple, modern jewelry, inspired by Scandinavian design (fig. 4.6), in *CD 9* (1965) and *CD 10* (1968). He also ran his own shop, which was the exception rather than the rule in California (unlike New York, where studio jewelers mostly sold their work from owner-operated stores).[8] Other than Nany's, a jewelry emporium in San Francisco, there were few venues through which local makers could market handmade jewelry.[9] West Coast jewelers, therefore, took full advantage of the sales and promotional opportunities afforded by California's system of state, county, and municipal fairs. These events, especially the *California Design* shows, financed in part by Los Angeles County, encouraged the participation of craftspeople.

Although the series began in 1954, the first exhibition to show jewelry was *CD 9* in 1965, which is curious, since jewelry played such a prominent role in California's post—World War II craft revival. All of the objects in *CD 9* were divided into two stylistic categories: "natural forms" and "elegance." Natural forms, the largest category, exemplified one of California's prevailing themes, inspired by the state's dramatic landforms and profusion of flora. Merry Renk (fig. 4.8) was represented in this section, as were Allan Adler (fig. 4.6), Svetozar Radakovitch, and Arline Fisch (figs. 4.1, 4.16), all three of whom would ultimately become "Living Treasures of California."[10]

Esther Lewittes (fig. 4.7) was the only jeweler to grace the "elegance" portion. In keeping with the other media in this section, the jewelry offering

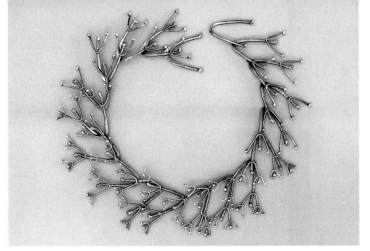

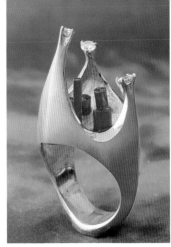

above, left:
Figure 4.8
Merry Renk,
necklace,
silver.
c. 1965 (*California Design 9*)

above, right:
Figure 4.9
Henry Rianda;
ring;
gold (lost-wax cast),
diamonds, ruby rods.
c. 1968 (*California Design 10*)

was relatively restrained. The catalogue attributed this to the population shift to city living and the emergence of the apartment dweller in California, giving rise to a need for "refinement of craftsmanship and materials, and a new look of elegance in his work."[11]

Although the major modern movements in painting and sculpture informed modernist jewelry design during the 1940s and 1950s (figs. 4.3, 4.4), the scene changed radically over the next twenty years. Jewelers began to take a less intellectual approach, no longer regarding a piece of jewelry as an autonomous object, but viewing the body as an armature or backdrop for highly sculptural statements (figs. 4.12, 4.14, 4.16). Nowhere was this transformation more pronounced than in California, where—especially during the late 1960s and the 1970s—jewelry was typified by a formalistic flamboyance (figs. 4.8, 4.13, 4.28). Along with larger scale and more unusual combinations of materials (some never before seen in jewelry) came sensuality, humor, and eroticism, in keeping with California's sense of fun and independent spirit.

CD 10 (1968) included much more jewelry than *CD 9* (1965). The show's catalogue was divided by medium, and the jewelry section was especially opulent. Jewelry from California was hitting its stride, while in the East, with the exception of the work of Kramer and Smith, the scene was tame by comparison. Some California examples were fairly outrageous, such as the huge, mobile face and neck-skimming gold-and-pearl earrings by Linda Woltjes Apodaca (fig. 4.13); Ray Hein's silver, gold-plate, teak, and rosewood sunglasses (fig. 4.28); Esther Lewittes's cantilevered ring (fig. 4.7); and Henry Rianda's spacescape gold ring with diamonds and ruby rods (fig. 4.9). The emphasis was clearly on eccentric forms. Almost all of the pieces were conceptually complex; necklaces and rings were the favored formats.

Jewelry in *CD 11* (1971) continued the trend toward the big, baroque, and body conscious, symbolizing California's generally permissive attitude. In 1974 the Museum of Contemporary Crafts in New York mounted *Baroque '74,* an exhibition dedicated to "exaggerated, elaborate surface ornamentation" inspired by Baroque, Victorian, Art Nouveau, and Art Deco traditions presented within a contemporary framework.[12] Necklaces became totally unrestrained, and some functioned more as "garments" than accessories, incorporating almost the entire body. Strikingly avant-garde were Claire Falkenstein's gold on copper harness (fig. 4.11); Mona Trunkfield's plastic and silver body jewelry (fig. 4.14); Arline Fisch's breast-covering silver halter (fig. 4.16); Frederick W. James's silver and rosewood collar (fig. 4.10); and Lynda Watson's two-part gold crossover neckpiece (fig. 4.12). Radical, oversized, and dramatic, they were without precedent.

below, left:
Figure 4.10
Frederick W. James;
collar;
silver, rosewood.
c. 1971 (*California Design 11*)

below, right:
Figure 4.11
Claire Falkenstein,
harness,
gold on copper.
c. 1971 (*California Design 11*)

opposite:
Figure 4.12
Lynda Watson,
two-part crossover
neckpiece,
gold.
c. 1971 (*California Design 11*)

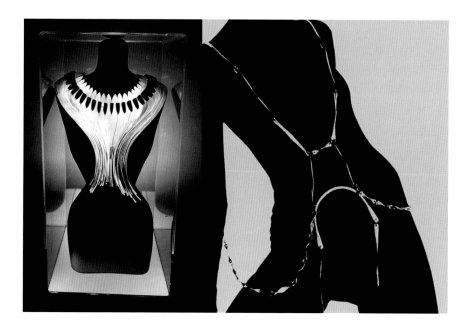

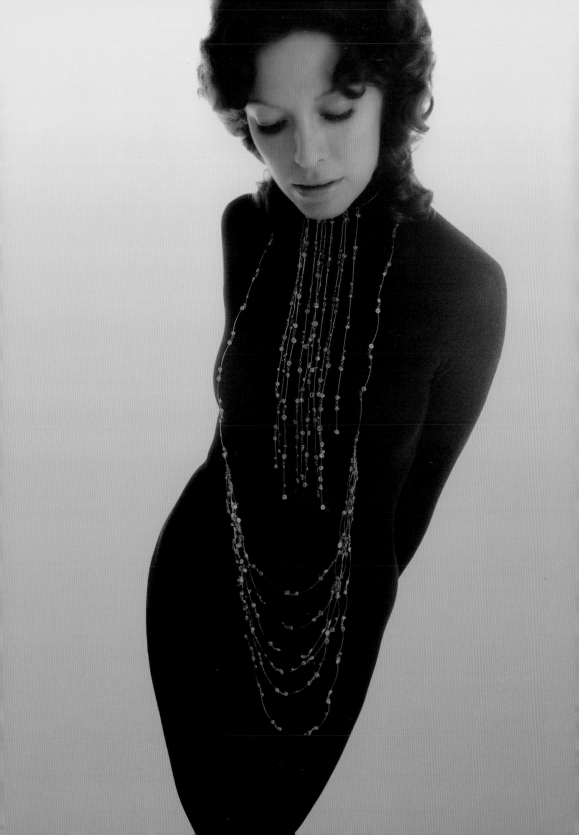

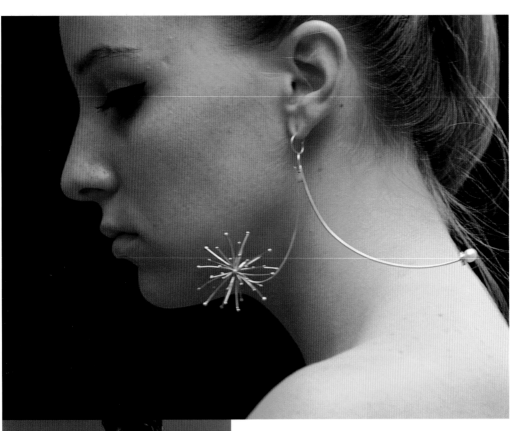

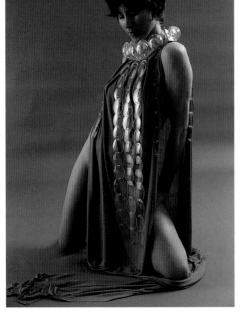

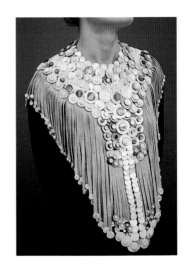

opposite, top:
Figure 4.13
Linda Woltjes Apodaca;
mobile earrings;
gold, pearls.
c. 1968 (*California Design 10*)

opposite, bottom left:
Figure 4.14
Mona Trunkfield;
body jewelry;
plastic, silver.
c. 1971 (*California Design 11*)

opposite, bottom right:
Figure 4.15
Faith Porter;
Shell Mail;
sculpture-construction,
buttons, suede.
c. 1976 (*California Design '76*)

right:
Figure 4.16
Arline Fisch,
halter,
silver.
c. 1971 (*California Design 11*)

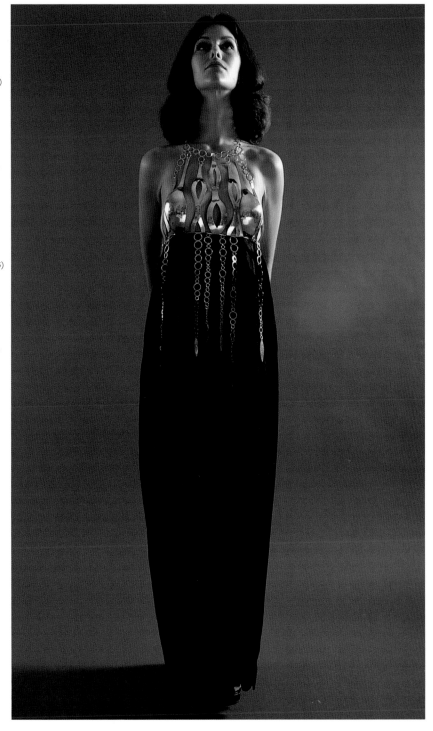

Rings—for example, those by Esther Lewittes, Ron Blanton, Everett MacDonald, and Arline Fisch—protruded wildly. Fisch's spread horizontally as well as vertically, thereby covering all of the other fingers. Brooches also were larger and more intricate. Florence Resnikoff's gold-plated copper and plastic pin (fig. 4.5) measured six inches in length. Bob Jefferson's gold-plated pin with pearls and moonstones (fig. 4.17) was even more impressive at seven inches. An exception was Ken Cory, who epitomized the California Funk movement with his small-scale but potent brooches. Cory resided in Oakland from 1963 to 1967 while attending the California College of Arts and Crafts, where he received a bachelor of fine arts in metalsmithing. Three pins—*Cube, Lever,* and *Shell* (fig. 4.18) from *CD 11* (1971)—were emblematic of Funk's subversive, anti-industry message and, although diminutive in scale, were related to Dada as well as the theatrical Fluxus movement. Like the state's own antiestablishment provocateur, Ken Kesey, and his counterculture troupe, the Merry Pranksters, many California jewelers from the 1970s displayed a ribald irreverence toward polite society, complete with witty sexual innuendos.

below, left:
Figure 4.17
Bob Jefferson;
pin;
gold-plate (forged), pearls,
moonstones.
c. 1971 (*California Design 11*)

opposite:
Figure 4.18
Ken Cory;
three pins: *Cube, Lever,*
and *Shell;*
mixed media.
c. 1969—70 (*California
Design 11*)

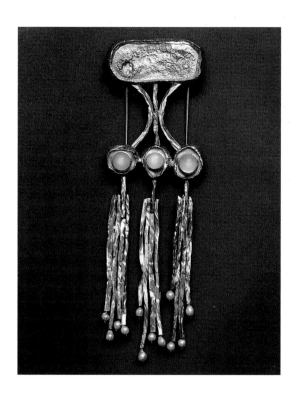

The last *California Design* exhibition, held in 1976, included not only a section of traditional jewelry but one devoted to "body covering," which existed somewhere between jewelry and clothing. In addition to a body stocking made from heat-molded nylon and Lycra, and robes of feathers, leather, and beads, there were pieces that were transitional but still closer to the jewelry format, such as Faith Porter's *Shell Mail* (fig. 4.15), a pectoral constructed from a carpet of buttons attached to suede, and Arline Fisch's capelet (fig. 4.1), knitted from fine gold and silver wire. Fashion designer Rudi Gernreich and "production craftsman" Chris Den Blaker collaborated on a black tube dress by the former and an aluminum bracelet by the latter that spiraled down the arm from shoulder to wrist (fig. 4.20). Den Blaker was also included in the jewelry section, where he showed similar pieces: a wrist gauntlet, a necklace, and a wraparound upper-arm band (fig. 4.19).

Three themes recurred in much of the jewelry in *CD '76*: flora and fauna, hidden or invisible elements, and the occult—all relating to California's dreamy, esoteric lifestyle, which reached its apex in the 1970s. Animal parts, such as tusks, teeth, bones, feathers, fossils, and fur, were regarded as suitable materials for jewelry, on a par with semiprecious stones and pearls. Surrealistic pieces incorporated entire components, both actual and rendered. Prime examples were Marcia Lewis's *Naturaliste* brooch (figs. 4.22a,b), built around a real bird skull; Sandra Callison Guerard's operable silver whistle and lips; Anthony Lugo's *Auditory Shrine* necklace (fig. 4.24); and Joseph R. Addotta's hinged four-face gold ring (fig. 4.26).

below:
Figure 4.19
Chris Den Blaker;
wrist gauntlet, necklace,
and armband;
aluminum.
c. 1976 (*California Design '76*)

opposite:
Figure 4.20
Chris Den Blaker and Rudi
Gernreich (collaboration),
armpiece and jersey tube,
aluminum and nylon.
c. 1976 (*California Design '76*)

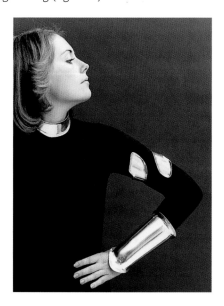

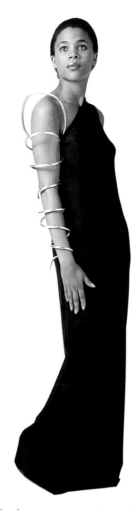

Several pieces had secret compartments, most notably Jeanne Keefer's *Award of Merit for the Pure in Heart* brooch (fig. 4.21), fabricated from opal, pearls, and Delrin, a lightweight, durable polymer patented by DuPont in 1956 as a substitute for nonferrous metals. *Sawtooth Mountain Sunrise* (fig. 4.25), a cloisonné enamel brooch by Carol Wilcox, connoted an otherworldliness in sync with California's spiritual bent, as did the patterning of agates in Arthur Korb's belt buckle and *Moon Medal;* the enamel work in Rose Lee Baron's necklace *Cloud Series I* (fig. 4.23); and the overall construction of Hal Ross's three *Other Worlds* and *Space Series* neckpieces (fig. 4.27). The jewelry in *CD '76* was especially outstanding. A humanistic energy and the courage to take aesthetic and technical risks were apparent in almost all of the entries.

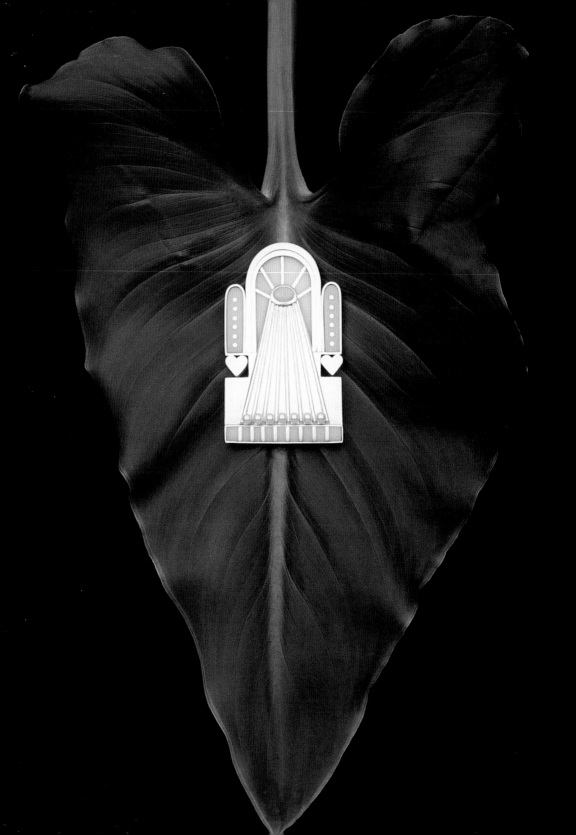

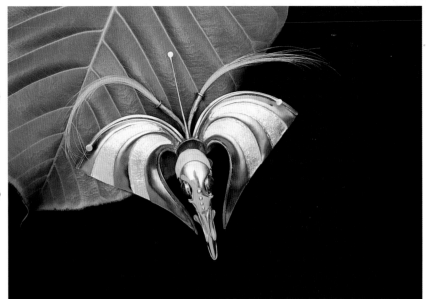

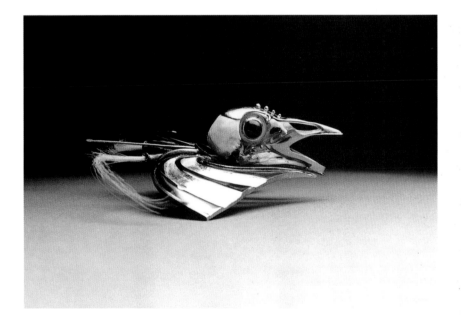

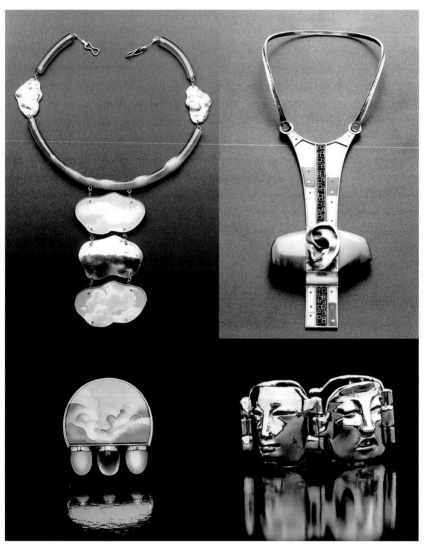

top left:
Figure 4.23
Rose Lee Baron;
necklace, *Cloud Series I*;
plastic, enamel.
c. 1976 (*California Design '76*)

top right:
Figure 4.24
Anthony Lugo;
necklace, *Auditory Shrine*;
sterling silver, gold, bronze,
ivory, ebony.
c. 1976 (*California Design '76*)

bottom left:
Figure 4.25
Carol Wilcox;
pin, *Sawtooth
Mountain Sunrise*;
cloisonné enamel, gold
granulation, topaz,
moonstone.
c. 1976 (*California Design '76*)

bottom right:
Figure 4.26
Joseph R. Addotta;
Masks ring;
gold.
c. 1976 (*California Design '76*)

opposite:
Figure 4.27
Hal Ross;
necklace, *Other Worlds*
and *Space Series #2*;
gold-plated sterling silver,
rutilated quartz, malachite.
c. 1976 (*California Design '76*)

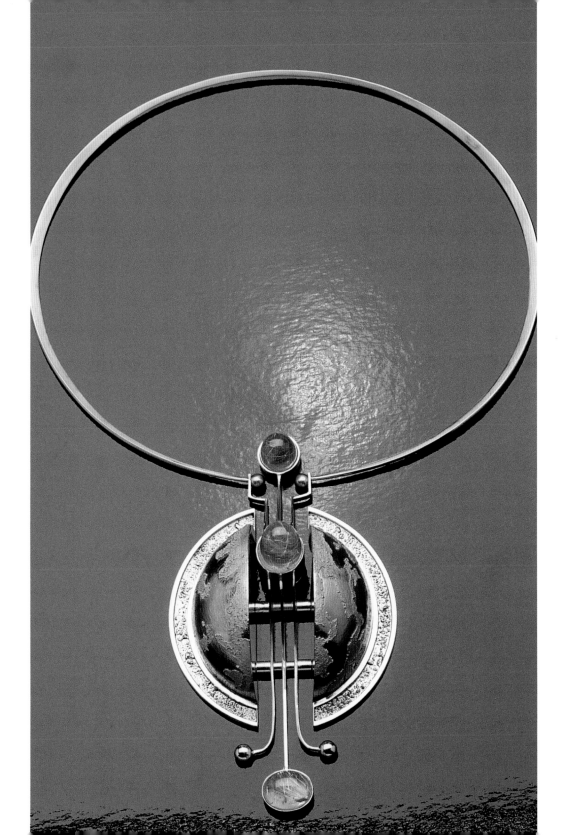

For the first half of the twentieth century, high art was centered in New York; California, by comparison, a region far more laid-back and earthy, provided a fertile ground for a "new craftsman" movement to take root and grow. California welcomed the anti-establishment lifestyle and process-oriented—rather than result-oriented—value system necessary for the *act of making* that is the hallmark of crafts.[13] Due to a passion for materials and handwork, and an overall affinity with the body and its relationship to both the natural and cosmic worlds, jewelry has enjoyed a particularly rich and varied development in the state. Judging from the work in the *California Design* series, jewelry has comprised some of the most innovative as well as outrageous statements. Few regions have forged a more exhilarating model of experimentation, freedom, wit, sex, and spirituality than California with its vanguard jewelers, some of whom, like Margaret De Patta, Ken Cory, Svetozar Radakovitch, and Arline Fisch, have taught or otherwise inspired subsequent generations of studio jewelers, both within California and beyond.

1. Toni Greenbaum, *Messengers of Modernism: American Studio Jewelry, 1940—1960* (Paris-New York: Montreal Museum of Decorative Arts/Flammarion, 1996). The appellation "modernist jewelry" was coined in the mid-1980s and refers to studio jewelry made between 1940 and 1960 whose design reflects the major movements in modern art: Cubism, Constructivism, Surrealism, and Abstract Expressionism.

2. *California Design 11* (Pasadena: Pasadena Art Museum, 1971), 9.

3. Ibid.

4. *The Jewelry of Margaret De Patta: A Retrospective Exhibition* (Oakland: Oakes Gallery/Oakland Museum of California, 1976).

5. The Metal Arts Guild of San Francisco (MAG) had seven additional founding members: Peter and Virginia Macchiarini, Francis Sperisen, Bob Winston, Irena Brynner, Vera Allison, and Byron Wilson.

6. Toni Greenbaum, "California Dreamin': Modernist Jewelers in Los Angeles, 1940—1970," *Metalsmith* 22, no. 1 (Winter 2002), 40—41. Although known primarily as a ceramist, Glen Lukens also taught

courses in metalworking and jewelry making during his tenure in the USC School of Architecture. A perfectionist, he would comb the desert and mountainous regions of the southwestern United States for raw materials with which to create his tactile vessels.

7. *California Design 1910* (Pasadena: California Design Publications, 1974). This exhibition was the twelfth in the *California Design* series.

8. Other exceptions were Everett Macdonald (Laguna Beach), who opened his shop in 1947; Peter Macchiarini and Franz Bergmann (San Francisco); and Esther Lewittes (Los Angeles).

9. Toni Greenbaum, "Tea and Jewelry: Modernist Metalsmithing in San Diego, 1940—1970," *Metalsmith* 22, no. 3 (Summer 2002), 26—33. Due to the paucity of small, specialized galleries in the 1940s and 1950s, California jewelers were dependent upon organizations that sponsored crafts exhibitions, such as the Creative Arts League of Sacramento (founded 1952), which showed statewide makers, and the Allied Craftsmen of San Diego (founded 1947), which often featured work from the Los Angeles area, as well as San Diego.

10. *Living Treasures of California* was the fourteenth biennial exhibition organized by the Creative Arts League and held at the Crocker Art Museum in Sacramento in 1985. The selection committee honored nineteen crafts professionals, all of whom lived and worked in California for at least twenty-five years. In addition to Adler, Fisch, and Radakovitch were Robert Arneson, Sam Maloof, Eudorah M. Moore, Florence Resnikoff, June Schwarcz, Peter Voulkos, and Beatrice Wood, among others.

11. *California Design 9* (Pasadena: Pasadena Art Museum, 1965), 114.

12. *Baroque '74* (New York: Museum of Contemporary Crafts, 1974). Californian Mona Trunkfield figured prominently in this multimedia exhibition.

13. *California Design '76* (Pasadena: Pacific Design Center, 1976), 8—9. Moore credits this "movement" with resynthesizing maker, material, and process.

Figure 4.28
Ray Hein;
Shades;
silver, gold-plate, teak,
rosewood.
c. 1968 (*California Design 10*)

Chapter 5

The "Leading Wedge" of Ceramics

JO LAURIA

The *California Design* exhibitions presented a kaleidoscope of splendidly diverse and beguiling ceramics, ranging in scale and concept from a humble, functional cigarette cup to a monumental room-sized fountain sculpture with cascading water. The ceramic objects, all chosen for their aesthetic excellence, reflected the latest and greatest trends in modern craft and design, as each prominent designer/craftsman strove to create ingenious works that answered the needs and aspirations of contemporary life.

The post—World War II years of the late 1940s and early 1950s were marked by a crafts revival that brought a proliferation of new pottery concepts and a maturation of established principles, both in educational institutions and in studios. What has come to be recognized internationally as the West Coast movement in clay traces its evolution to this period marked by a convergence of talented artists who established studios in California, and by a blending of traditions from Europe and Asia (fig. 5.2). The intensely creative period that followed the 1960s and 1970s was characterized by conceptual explorations, freewheeling experimentation with materials, and a radical shift toward abstraction and monumentality. During this flash-point in the state's ceramic history, individualism, artistic freedom, and a fearless frontier approach infused the field with tremendous vitality, creating a distinctly California aesthetic. This newly congealing style in West Coast ceramics was given traction in the *California Design* exhibitions, as they showcased, celebrated, and validated new approaches and aesthetically challenging works. "Materials are explored, manipulated and re-explored," wrote Eudorah M. Moore in the foreword to *CD 11* (1971). "Work expresses feelings, concepts, and moods, it becomes, in a good many cases, a social statement. This type of adventure with ideas and materials is the leading wedge."[1]

The *California Design* exhibitions offered keyhole views of this progressive development. Generally, in the first seven exhibitions, craft objects—made of ceramic, glass, metal, wood, fiber, and fabric—played a minor role, often serving as visual accents to the furniture. The ceramics in these early exhibitions were domestically scaled functional forms or decorative objects suitable for use or display in the home environment.

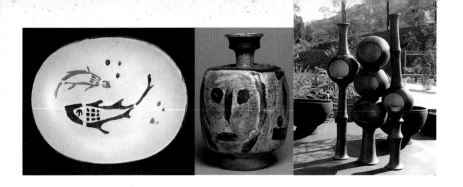

The most frequently exhibited ceramic artists were the well-known Southern California studio potters Gertrud and Otto Natzler, Vivika and Otto Heino, Harrison McIntosh, Rupert Deese, Polia Pillin, Marian Moule, and Raul Coronel; and production designers Malcolm Leland and La Gardo Tackett of Architectural Pottery. The submissions included an array of serving pieces, decorative objects, and landscape accessories: vases, bowls, covered jars, pitchers, bottles, tureens, cigarette cups, ashtrays, bird shelters, and garden planters (figs. 5.4, 5.5, 5.6).

The so-called West Coast clay revolution of the early 1950s, launched by Peter Voulkos and students at the Otis Art Institute in Los Angeles, appeared to have little effect on the ceramic entries of *CD 1* through *CD 7* (1954–1961). Rebel artists associated with this movement—Voulkos himself, John Mason, Jerry Rothman, and Henry Takemoto, among others—were creating large, challenging works that pushed clay into the realm of abstract, expressive sculpture. Though a few works of these artists were featured in the early exhibitions, they could not be categorized as groundbreaking. They were modestly scaled functional forms—mostly vases, jars, and tiles. This can be seen in the exhibited work of Voulkos, who had one or two pieces selected for the design annuals from *CD 2* (1956) through *CD 5* (1959), more than any of the other artists in the group. Typical was *Face Vase,* exhibited in *CD 2,* a nine-inch, four-sided vessel with faces painted on the sides, covered in a tan matte glaze (fig. 5.3). Although a handsome form with engaging imagery, *Face Vase* is small, utilitarian, and conventional. It was representative of Voulkos's early production-style work, which he would send to design showrooms.[2] Similarly, John Mason recalls that his vases and tiles selected for the exhibitions were not radical, as the emphasis of the shows at the time was on function and display. Fundamentally, these exhibitions were a showcase for objects that could be used as interior decoration, and the potters were aware of this.[3]

page 142:
Figure 5.1
Kenneth P. Wilson,
Moon Pot,
stoneware,
21 inches high.
1968 (*California Design 10*)

above, left:
Figure 5.2
Evelyn and Jerome Ackerman for Jenev;
oval plate, hand decorated clay;
14 inches diameter.
1955 (*California Design 1*)
Courtesy of Evelyn and Jerome Ackerman.

above, center:
Figure 5.3
Peter Voulkos;
Face Vase;
stoneware, glazed;
9 inches high.
1956 (*California Design 2*)
Courtesy of Treadway Gallery.

above, right:
Figure 5.4
Raul A. Coronel,
set of three planters.
1960 (*California Design 6*)

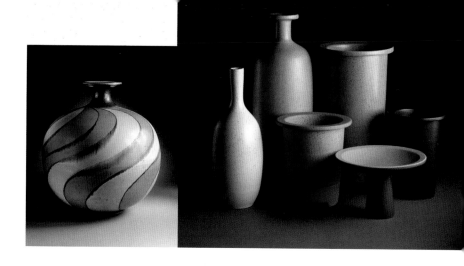

above, left:
Figure 5.5
Harrison McIntosh,
vase,
stoneware.
1968 (*California Design 10*)

above, right:
Figure 5.6
Harrison McIntosh for
Metlox Potteries, group
photograph (left to right):
bud vase, bottle vase,
flowerpot and saucer,
cylinder vase, compote,
and flowerpot.
1956 (*California Design 2*)
Courtesy of Peter Brenner.

"Radical" would be a more appropriate term to describe the transformation that occurred in the ceramic submissions when Moore took over as director of the series in 1962 and instituted new policies and procedures. Numerous ceramic works in *CD 8* (1962) through *CD '76* could still be classified as functional forms or gemlike decorative objects. Most notable were the graceful and well-designed hand-thrown vases and bottles of the Natzlers, Heino, McIntosh, Laura Andreson, and James Lovera. By the 1960s, these potters were recognized nationally (and the Natzlers internationally) for their significant contributions to clay and glaze formulation and firing techniques, and for their elegantly proportioned shapes derived from German Bauhaus aesthetics and Asian pottery traditions. Also noteworthy were the exotic, brilliantly lustered, or jewel-toned glazed pots of Dada artist and potter Beatrice Wood, whose individualistic approach to ceramics and eccentric lifestyle were perceived as quintessentially Californian (figs. 5.8, 5.9, 5.10; see also fig. 3.9, page 99).

But as early as 1962 (*CD 8*), perceptible changes in the ceramic selections can be charted, including an increase in scale, a more daring use of materials, and an embrace of the experimental. The glorious double-page group photograph in the *CD 8* catalogue portraying the "Parker Pattern and Foundry Company electric compact wagon, loaded with and surrounded by pots from California craftsmen" (fig. 5.7) features compelling examples of the more inventive, larger sculptural vessels that the jurors had begun to include. Although based on traditional forms, these highly textured and decorated supersized vases, bowls, covered jars, "floor pots," and planters reflected the developments of the early 1960s, as ceramists began to liberate themselves from the tyranny of function.

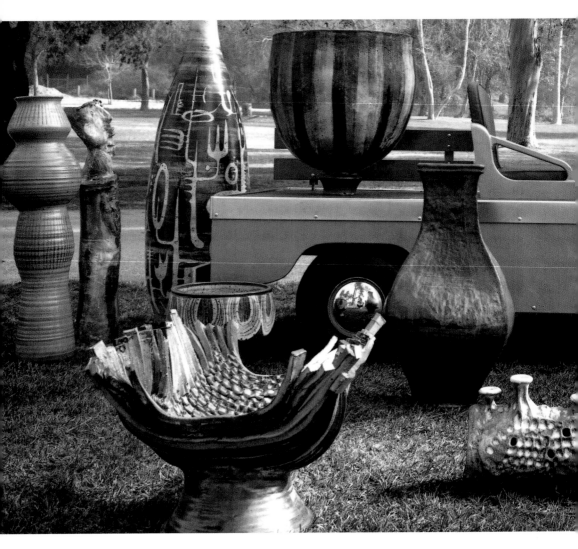

Figure 5.7
Parker Pattern and
Foundry Company,
electric compact
wagon, loaded with
and surrounded by
pots from California
craftsmen.
1962 (*California Design 8*)

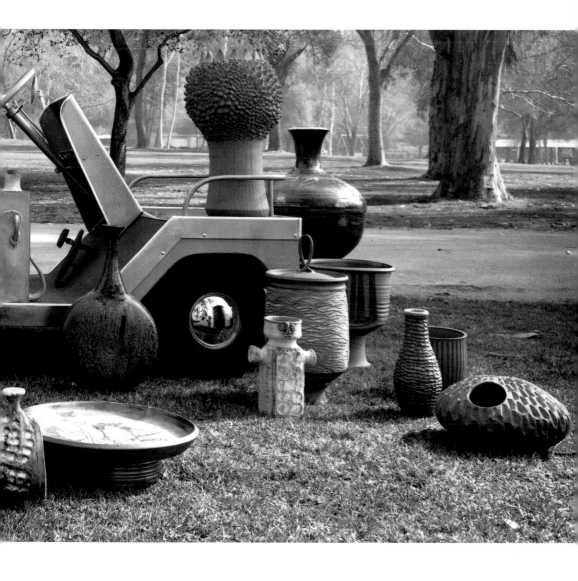

The "Leading Wedge" of Ceramics

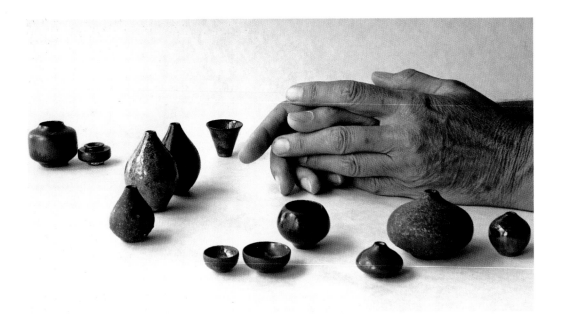

above:
Figure 5.8
Gertrud and Otto Natzler;
group of miniature pots,
with Gertrud's hand used
for scale.
1971 (*California Design 11*)

One of the earliest demonstrations of this newfound freedom was David Cressey's unglazed stoneware sculpture *Ladies' Day,* featured in *CD 8* (fig. 5.16). The four-foot-wide work was assembled from thrown hollow forms suspended on steel poles and anchored to a wood base. Cressey intended the abstracted figures to artfully represent a linear progression of women, hence the title (see page 154). Another forward-looking work by Cressey, shown in *CD 10* (1968), was *Fey Stone,* a two-foot-high vertical sculpture covered by a deep yellow "volcanic" glaze—a surprisingly bold and colorful treatment for an object of such large scale (fig. 5.11). Cressey wanted the title of this purely abstract, multi-appendaged sculpture to express "the imaginative invention, the design value" of his experiments in clay.[4] His works exploited the power of sculptural volume to activate the surrounding space and had little to do with traditional pottery. They forecast the more challenging work that would invigorate ceramics in the next decade.

In successive exhibitions, the winds of stylistic change blew at gale force, dramatically altering the character of the ceramic selections. The *California Design* exhibitions from *CD 9* (1965) to *CD '76* chronicled this decade of whirlwind transitions. Aesthetics expanded from a celebration of the earthy and organic to include aggressive manipulation and intense decoration, the wry

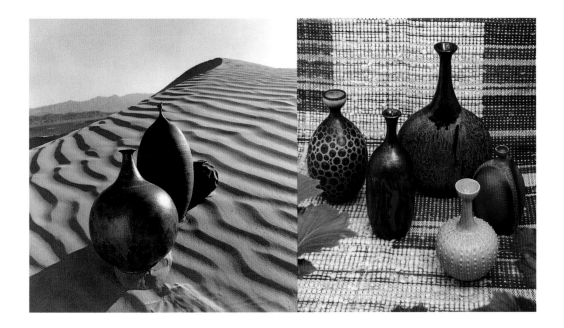

humor and cultural critique of the Funk movement, and architecturally scaled freestanding sculptures and installations that left behind the boundaries of craft and entered the territory of the fine arts. As the New York publication *Residential Interiors* proclaimed about *CD '76,* the exhibitions had become vehicles to showcase "intriguingly diverse stylistic trends . . . commenting on the free-flying crafts . . . where the mood is anti-functional," and that objects selected for exhibition were to be considered "works of art."[5]

The late 1960s and early 1970s saw the blossoming of the hippie and counterculture movements, which promoted "back to the earth" lifestyles and gave birth to a global ecological consciousness. This reverence for nature was expressed by ceramic artists who used clay, frequently in an unglazed and undecorated state, to represent geological formations, natural landscapes, and earthly textures. Such substantial works as *Landscape Wall* by Faith Hornbacher in *CD 11* (1971) (fig. 5.14), *Branch Vase* by Michi Itami Zimmerman in *CD 11* (1971) (fig. 5.15), and *Wall Relief* by D. J. Sutherland in *CD 10* (1968) (fig. 5.12) emulated organic shapes, patterns, rhythms, textures, and colors. The undulating, stratified, craggy, and eroded forms, modeled out of gritty, red-brown stoneware clays, appeared only one step removed from the raw earth of which they were made.

right:
Figure 5.11
David Cressey;
sculpture, *Fey Stone;*
glazed ceramic.
1968 (*California Design 10*)
Courtesy of the archive.

below:
Figure 5.12
D. J. Sutherland,
Wall Relief,
clay.
1968 (*California Design 10*)

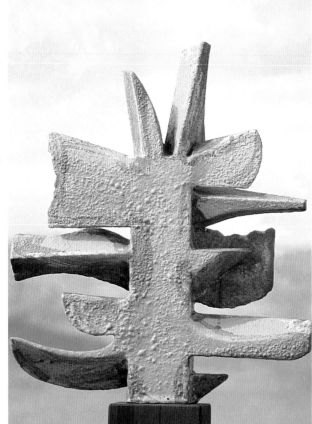

below:
Figure 5.13
Rhoda Le Blanc Lopez,
fountain (detail),
ceramic,
8 feet high x 5 feet wide.
1971 (*California Design 11*)

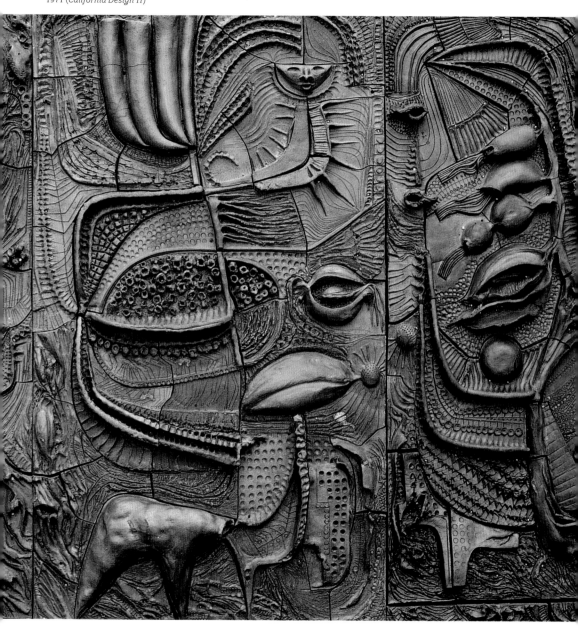

Figure 5.14
Faith Hornbacher,
Landscape Wall,
stoneware and rope.
1971 (*California Design 11*)

Figure 5.15
Michi Itami Zimmerman,
Branch Vase,
stoneware.
1971 (*California Design 11*)

Two remarkably ambitious ceramic fountains exhibited in *CD 11* (1971) were tours de force of creative naturalism. Rhoda Le Blanc Lopez's immense five-foot-wide and eight-foot-high fountain contained abstracted plant imagery carved in coarse, unglazed stoneware clay (fig. 5.13). As part of her complex schema, Lopez fashioned seedpod-shaped spouts from which water streamed in crossing paths whose patterns animated the design and intensified the splashing sound of the liquid. When in operation, this intensely detailed fountain provided both visual and aural stimulation.

Elaine Katzer's *Organic Water Wall,* also in *CD 11,* was even more impressive in size and complexity. Katzer used clay and running water to create a holistic architectural environment. The modular walls were constructed of hollow stoneware stacking units and enclosed a water pump. Copper tubing ran in a trench for eighteen feet along the top of the eight-foot-high clay walls. The walls were divided into two sections by a wooden passageway—to create a walk-through environment—and stood in a huge pool of water from which the internal pump drew. Katzer intended the water to provide "the glazing surface for the clay": as it continuously trickled down from the top of the wall, it made the natural-fired clay glisten as if covered by a glossy glaze. When the water reached the bottom, it splashed into the surrounding pool to be recycled (fig. 5.17).[6]

Organic Water Wall must have shocked the visitor who encountered it within museum walls, as it looked like a great natural sandstone cliff with water seeping out of its cracks. Of this experience, Moore wrote: "Standing in the shadow of these massive forms one has a feel of the eroding earth, yet withal a sense of nature's enfolding oneness with man."[7] *Organic Water Wall* launched Katzer's ceramic career. It was originally built in 1969 as part of her master's exhibition at California State University, Long Beach, and it prompted her to specialize in fountains and large-scale sculptures.

below, left:
Figure 5.16
David Cressey;
sculpture, *Ladies' Day;*
unglazed stoneware;
4 feet wide.
1962 (*California Design 8*)

opposite:
Figure 5.17
(multiple views)
Elaine Katzer,
Organic Water Wall,
stoneware,
8 feet high x 18 feet long.
1971 (*California Design 11*)
Full view courtesy of
Elaine Katzer.

The "Leading Wedge" of Ceramics

Two other considerable fountains made of hollow stacking units, both from Katzer's *Tribesman* series, were featured in *CD 11* (1971) and *CD '76* (fig. 5.18). *Tribesman #6* (*CD 11*), composed of five standing totems, was approximately nine feet tall and covered a length of almost twelve linear feet when installed. Katzer based the heads of these totems on prehistoric carved stone axe-head tools she saw in a display case at the National Geographic Museum in New York City. This work was the first in the fountain series to be dramatically decorated with underglazes and oxides. Katzer used the limited palette of black, white, and brown to graphically "illustrate the dimensional form through surface line drawing."[8]

The largest of Katzer's works shown in the *CD* series was the modular interlocking mural *Sea Chanty*, eight feet high by twenty-two feet wide (fig. 5.20). Installed in a bed of sand in *CD '76*, the piece reveled in water imagery. The rolling curlicue patterns referred to the movements of the sea, a sensation that resonated with Katzer, an avid body surfer. To her limited color scheme, Katzer added blue to symbolize both ocean and sky; the rippling white forms represented billowy clouds floating above the water.[9] Although at the time of its exhibition *Sea Chanty* was not a functioning fountain, Katzer transformed it a year later (1977) into a freestanding, two-sided working model, which was commissioned for the outside courtyard of the Chula Vista Library, in Chula Vista, California.[10] "This work in scale and concept indicates the interest and applicability of craftsmen's creativity to architectural projects," Moore wrote about *Sea Chanty* in the catalogue. "It is hoped that in seeing these works of major scale architects will become aware of this rich resource."[11]

right:
Figure 5.19
Elaine Katzer,
fountain (three of five
standing totems) from
the *Tribesman* series,
stoneware.
1976 (*California Design '76*)

below:
Figure 5.20
Elaine Katzer,
Sea Chanty,
stoneware,
8 x 22 feet.
1976 (*California Design '76*)
Courtesy of Elaine Katzer

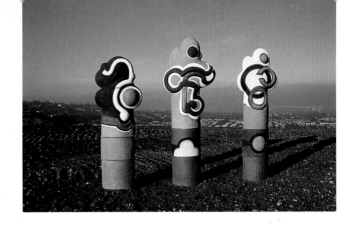

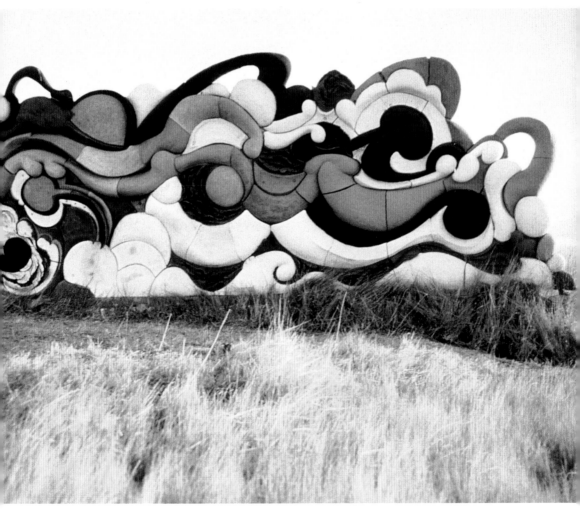

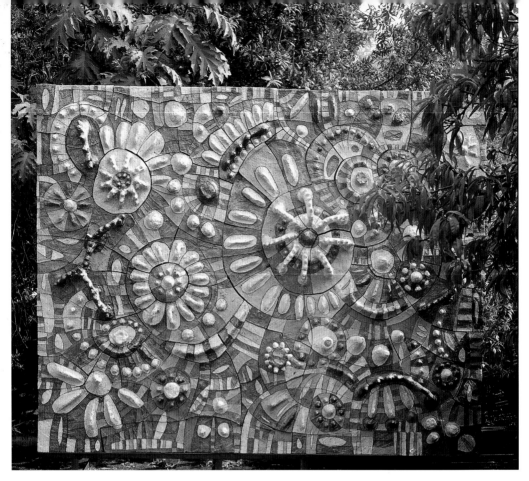

opposite, top:
Figure 5.21
Stan Bitters;
mural, *Penny Arcade;*
clay;
8 x 10 feet.
1965 (*California Design 9*)

opposite, below:
Figure 5.22
Stan Bitters,
big and small
Lolly Pop discs,
ceramic with chrome
steel bases,
8 feet high.
1968 (*California Design 10*)

right:
Figure 5.23
David Cressey for
Architectural Pottery,
fountain,
stoneware,
13 feet high.
1965 (*California Design 9*)

Moore's statement applied equally to two other pieces: Jerry Rothman's walk-through garden retreat, *In Central Park,* in *CD 9* (1965), constructed of painted clay stacking units (fig. 5.25), and the *Cactus Wall* by David Middlebrook in *CD '76,* a nine-foot-high and twelve-foot-long array of stacking ceramic blocks that functioned like a colossal sundial—the moving shadows cast by the projecting cactus spines indicated the time of day. One of the docents touring the exhibition referred to *Cactus Wall* as "an exercise in optics" created by an artist who "came from the East and was intrigued with Western mystique"[12] (fig. 5.24).

Adrian Saxe's *Untitled Wall Sculpture* was another optical exercise but on a more cerebral level (fig. 5.26). According to Saxe, this wall work of arranged modular domes was part of a series of "formal geometric groups" that dealt with his interest in "set theory and games as sources for visually organizing perceptual experience." By varying the glazes on the domes through "systematic color schemes" and controlling their reflective properties to produce shiny, matte, and highly textured surfaces, Saxe manipulated the optical "reading" of the space occupied by the sculptures.[13] These early works, shown in 1971, were the genesis of his longtime involvement with optical distortions, later realized in his wall mirror pieces and functioning oil lamps.

below, left:
Figure 5.24
David Middlebrook,
Cactus Wall,
ceramic,
9 x 12 feet.
1976 (*California Design '76*)

below, right:
Figure 5.25
Jerry Rothman;
sculpture/garden retreat,
In Central Park;
clay;
9 x 13 x 7 feet.
1965 (*California Design 9*)

opposite:
Figure 5.26
Adrian Saxe,
Untitled Wall Sculpture,
glazed ceramic.
1971 (*California Design 11*)

Alongside these monoliths of restrained decoration were displayed intriguing smaller abstract sculptures by Ralph Bacerra and Jun Kaneko, included in *CD 10* (1968) and *CD 11* (1971). Definitely more playful than the behemoths, these works flaunted their saturated red and orange glazes, metallic lusters, and whimsical patterns of stripes, wavy lines, dots, and squiggles. Such bold colors and decorative designs were stylistically aligned with the low-fire/bright-glaze craze that swept California in the 1960s, and their mysteriously animated shapes—the sculptures seemed capable of walking on their ceramic "legs"—showed the edgy influence of the Funk movement, which also originated in that decade (figs. 5.27, 5.29, 5.30).

In *CD '76* there was a crescendo of highly ornamented and thematically bizarre ceramics that were the legacy of Robert Arneson, the founding father of Funk ceramics.[14] Hallmarks of Arneson's work (and of the movement he inspired) were iconographic parody, provocative sociopolitical and sexual content, offbeat and often rude humor, purposely irreverent use of materials, and rejection of the doctrines of function.

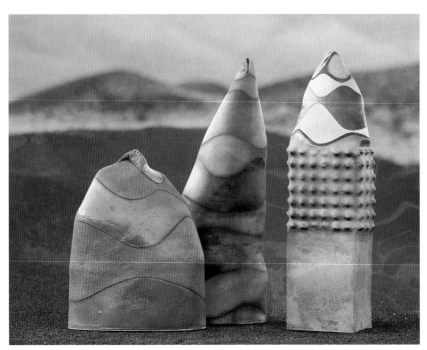

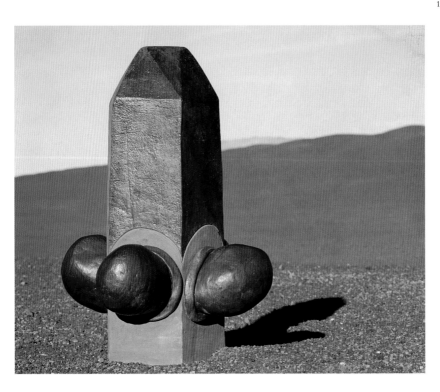

left:
Figure 5.27
Ralph Bacerra,
three forms,
stoneware.
1968 (*California Design 10*)

below:
Figure 5.28
Jerry Rothman;
sculpture, *The Style No. A;*
ceramic.
1968 (*California Design 10*)

opposite, top:
Figure 5.29
Ralph Bacerra,
three sculptural forms,
glazed earthenware.
1971 (*California Design 11*)

opposite, bottom:
Figure 5.30
Jun Kaneko,
sculptural form,
Sanbon ash,
glazed ceramic.
1971 (*California Design 11*)

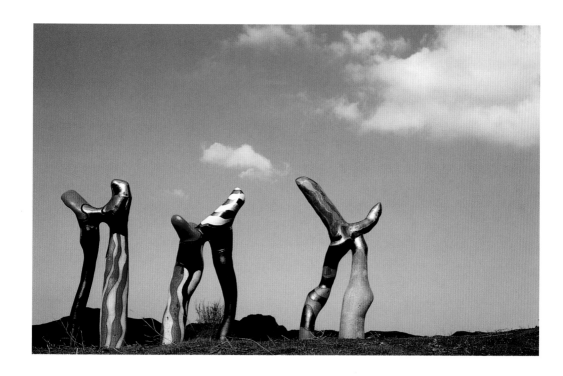

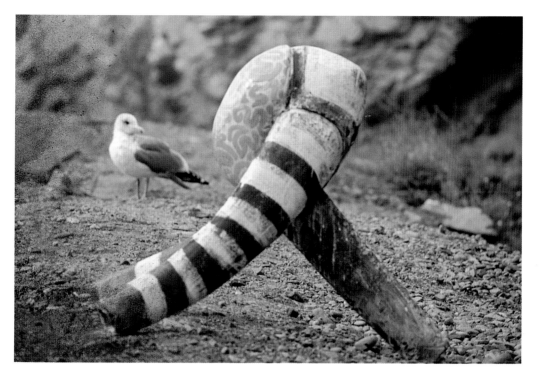

The "Leading Wedge" of Ceramics

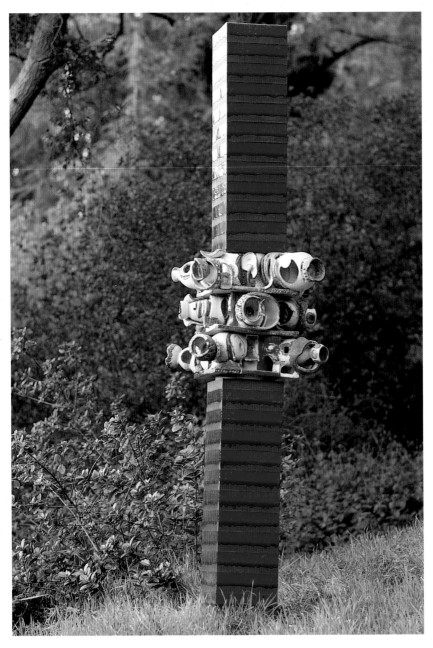

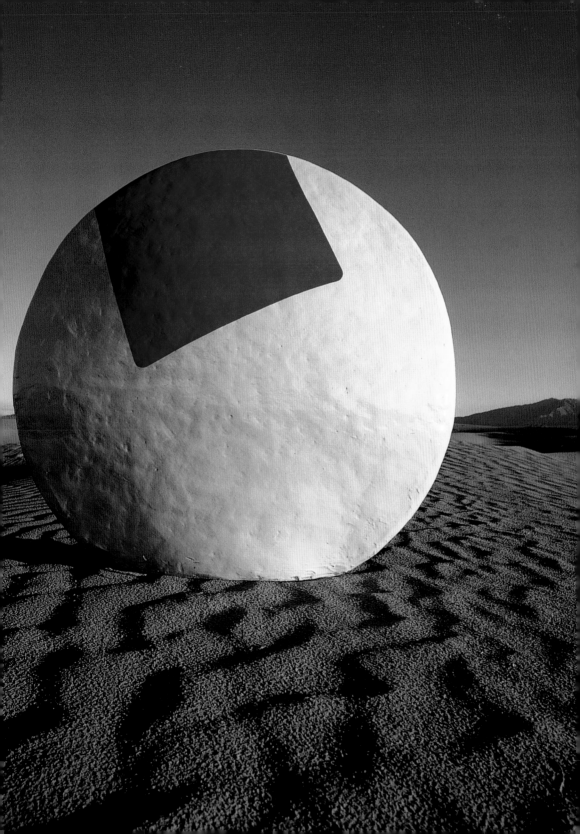

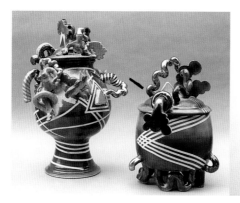

opposite:
Figure 5.33
Vaea Marx,
sculpture,
ceramic with low-fire
glaze.
1968 (*California Design 10*)

top left;
Figure 5.34
Viola Frey,
two covered pots,
14 inches (left) and
Farm Landscape (right),
glazed stoneware.
1971 (*California Design 11*)

top right:
Figure 5.35
Les Lawrence;
plate, *Made in U.S.A.-B*;
photo silk screen on
stoneware.
1976 (*California Design '76*)

bottom left:
Figure 5.36
Jim Pensyre,
two teapots,
earthenware.
1976 (*California Design '76*)

bottom right:
Figure 5.37
Phil Cornelius,
Group of lidded jars,
stoneware.
1971 (*California Design 11*)

By the time of *CD '76,* Funk had traveled up and down the coast of California and had been significantly diluted, downgraded from a philosophical movement to a stylistic one. There were a few sociopolitical pieces, such as Les Lawrence's *Made in U.S.A.-B,* a plate with silk-screened female nudes surrounded by impish cupids and hearts, commenting on the commercialization of love and sex in American culture (fig. 5.35). In general, however, the works were less hard-hitting than the gritty and controversial statements of earlier, purer Funk objects.

"Funk Lite" would be a more apt description for the ceramics in *CD '76,* which were a mixed bag of weird forms, sophomoric and lighthearted humor, vibrantly charged and jarring glazes, and appropriated popular-culture symbols. Examples of these eccentric funk hybrids included Jim Pensyre's space-age spinning teapots covered in shiny red, blue, and orange glazes and sparkly lusters; Anna De Leon's seductively decorated dog sculpture with a vulgar pink snout, *Sofia on a May Day;* Florence Cohen's brilliantly glazed, gold- and silver-lustered box, *Secret Paths,* with a eerily disturbing cyclops eye perched atop; Erik Gronborg's group of five wacky mugs sporting a peculiar combination of decorative elements; Carol Lebeck's uncanny

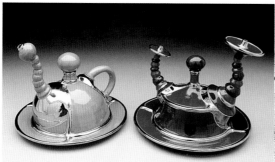

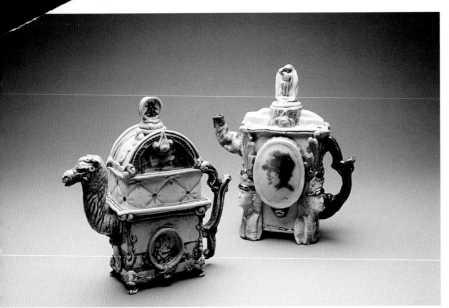

left:
Figure 5.38
Ron Carlson;
two teapots;
porcelain, with decals and
luster (left); silk screen
and luster (right).
1976 (*California Design '76*)

opposite, top:
Figure 5.39
Erik Gronborg;
set of five cups (three
shown);
porcelain, luster glazes
and decals.
1976 (*California Design '76*)

**opposite, bottom
(clockwise from left):**
Figure 5.40
Michael J. Lopez;
sculpture, *Thaw Series #4;*
ceramic with low-fired
luster glaze.
1976 (*California Design '76*)

Figure 5.41
Anna De Leon;
sculpture,
Sofia on a May Day;
porcelain with overglazes.
1976 (*California Design '76*)

Figure 5.42
Lukman Glasgow,
*The Helping Hand in
Dreaming of a Skyscape,*
clay with lusters.
1976 (*California Design '76*)

Figure 5.43
Florence Cohen;
box, *Secret Paths;*
stoneware, luster glaze;
5 inches high.
1976 (*California Design '76*)

assemblage, *Cup of Reclaimed Objects;* and Ron Carlson's humorous parodies of eighteenth-century English Staffordshire teapots (figs. 5.36, 5.38. 5.39, 5.41, 5.45). Several works seem to have been selected solely to provide comic relief. Fulfilling this objective were Michael Lopez's great melting lump, *Thaw Series #4;* Lukman Glasglow's surreal *The Helping Hand in Dreaming of a Skyscape;* David Furman's cheery homage to his dog, *Molly on ¾ Couch;* and Florence Pugh's amusing *Duck Cups* (figs. 5.40, 5.42, 5.44, 5.46).

From these diverse examples, it is clear that the post—*CD 9* (1965) exhibitions were weighted toward inventive, one-of-a-kind ceramics created by craftspeople working as studio artists, as opposed to designer-craftsmen employed by industry to design production wares. Moore recognized and applauded the great surge of creativity in the field engendered by these individuals: "The work of the craftsmen is stimulating and tantalizing to be exposed to, and the free rein their imagination can be given can only be broadening and titillating to the vision of any creative person."[15]

The steady decline after *CD 9* (1965) in the number of production ceramics included indicated that mass-produced ceramics were aesthetically staid. Except for a few outstanding industrially produced floor and wall tiles by Interpace, and planters and sand urns by Architectural Pottery, production pieces were in short supply in the remaining exhibitions.

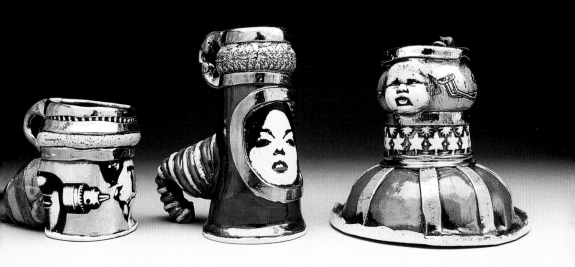

The "Leading Wedge" of Ceramics

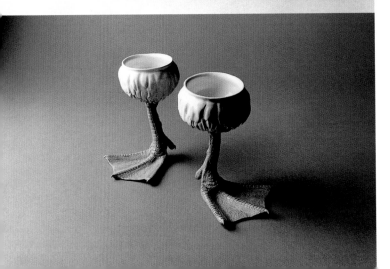

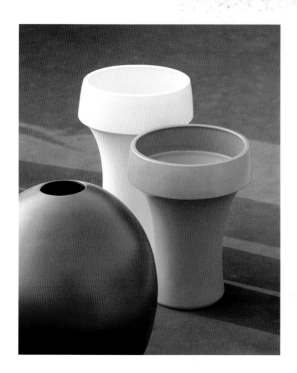

The Los Angeles—based Interpace was committed to hiring established studio ceramic artists to create original designs and new glazes for the company's tile and dinnerware production. This approach fostered experimentation and resulted in inspired designs suitable for mass production—notably the simple but visually stimulating spirals of the "Rondaly" pattern for floor or wall tiles (fig. 5.48).

A similar situation prevailed with Architectural Pottery. Nurtured by founders Rita and Max Lawrence, who gave designers free rein, and under the expert direction of production manager David Cressey, this company pioneered innovative sculptural planters and sand urns for indoor as well as outdoor settings. The planters were available in a range of shapes, colors, and sizes from the modest to the monumental. They featured acute geometric shapes (such as the *Hourglass* design by La Gardo Tackett) and curvy spherical forms; the glaze choices were bright glossy blue, yellow, orange, olive green, matte white, and matte black. By the mid-1960s, Architectural Pottery planters had become the iconic landscape and interior accessory of the modernist environment, popularized by such vanguard architects as Pierre Koenig, who used them extensively in his *Case Study Houses* (#21, 22, 25, and 28) (figs. 5.47, 5.49).[16]

Selections from the Interpace and the Architectural Pottery lines were well represented throughout the *CD* series, and these manufacturers were repeatedly cited by Moore as "outstanding among industries employing designer craftsmen," whose designs for domestic, commercial, and architectural spaces were "in truth creating our environment."[17]

Considered collectively, the ceramics shown in the *California Design* series illustrated many of the dramatic developments that occurred in the field. From a focus on functionalism at midcentury to the gradual privileging of ideas over materials and techniques, the works ranged from the classical to the cutting edge. Beautifully profiled pots—intimate, precious, and elegant—began to share display space with weighty sculptural vessels—organic, volumetric, and gestural—which in turn seemed to grow into monumental, abstract, freestanding sculptures and fountains that reflected the broader movements in the fine arts toward grand scale, authority, and nonobjectivity. The ceramic objects featured in the *California Design* exhibitions offered a full plate of innovation, vision, and wit. Imbued with great artistic merits and design nuances, the works continually demonstrated creative expressiveness and versatility, as they responded to the cultural and ideological changes of their time. Indeed, the ample eye-stopping and thought-provoking ceramic works both engaged and satisfied the appetites of even the most sophisticated connoisseur, meeting and exceeding the expectations of the "design-intoxicated postwar generation."[18]

Figure 5.49
Architectural Pottery; a group of sand urns and planters (left to right): *IN88* and *SC18* by staff designers, *TT28* by La Gardo Tackett, *A20* by Marilyn Kay Austin, and *INB10* by staff designers; ceramic. 1965 (*California Design 9*)

1. *California Design 11* (Pasadena: California Design, 1971), 9.

2. Interview with Sam Jornlin, director, Peter Voulkos Archive, May 7, 2004.

3. Interview with John Mason, May 15, 2004.

4. Interview with David Cressey, May 11, 2004.

5. *Residential Interiors* (New York), April 1976, quoted in Landes Furniture Company publicity clips.

6. Interview with Elaine Katzer, May 2, 2004.

7. *California Design 11*, 125.

8. Katzer interview.

9. Ibid.

10. Ibid.

11. *California Design '76* (Pasadena: California Design, 1976), 99

12. Harriet L. Axelrad, docent script for *California Design '76*, n.d., 1.

13. Interview with Adrian Saxe, May 19, 2004.

14. Robert Arneson was a professor in the ceramics department (and was ultimately appointed the head of the program) at the University of California at Davis. He worked there from 1962 until his death in 1992.

15. Eudorah M. Moore, "The Designer Is Knocking—Are You Listening?" Speech at National Home Fashions League, Illinois chapter, January 7, 1969.

16. Elizabeth Caffry Frankel, "Architectural Pottery: Marketing Modern Design," master's thesis, Bard Graduate Center for Studies in the Decorative Arts, 2000.

17. Eudorah M. Moore, "The Designer Is Knocking."

18. *Los Angeles Times Home Magazine*, February 13, 1972.

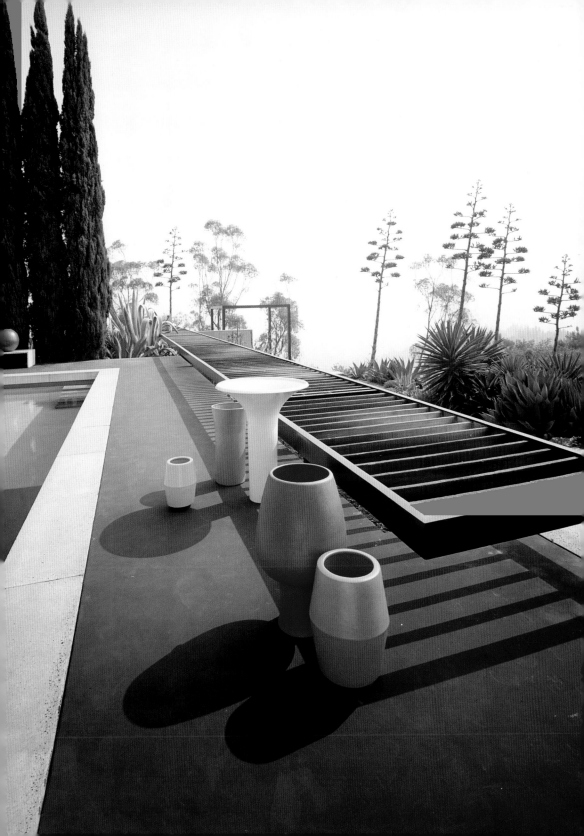

Chapter 6 Sculpture and Functional Objects in Glass, Metal, and Wood

SUZANNE BAIZERMAN

While ceramics and fiber dominated craft participation in the *California Design* series, mediums of glass, metal, and wood definitely had a presence. Work in these three mediums showed early evidence of artists challenging limitations posed by craft traditions. However, the *CD* exhibitions documented an earlier period in their development as fine art media as compared to ceramics and fiber.

For example, the *California Design* exhibitions documented the early development of studio glass, the term that describes one-of-a-kind works in glass made by artists in individual or shared studios as opposed to designs for mass production. Compared with works in other media, there were consistently fewer glass objects in the exhibits. Until the early 1960s, glass artists in the *CD* exhibitions created stained-glass windows and glass room dividers. Made primarily from preformed glass, these pieces were intended for use in architectural and interior-design settings. Svetozar Radakovitch's large stained-glass window, in *CD 8* (1955) (fig. 6.1), for example, featured abstract geometric forms that reflected the influence of modernist ideas on studio practice. Work in stained glass continued to be presented throughout the *CD* series, alongside the new hot glass pieces made by artists coming out of university programs.

Within and outside the United States, glass technicians in factories had long produced objects from hot glass, molten glass freely formed at the end of blowpipes or blown into molds. It was not until the early 1960s that studio artists in the United States began to experiment with hot glass. The best-known example was at the University of Wisconsin, Madison, where ceramics professor Harvey Littleton identified the potential of glass as a medium for individual artists. Under the guidance of glass-industry professionals, he developed a kiln small enough to be used in a studio setting and formulated an appropriate glass mixture. These developments launched the American studio glass movement.[1]

One of the students in Littleton's first class was Marvin Lipofsky. After graduating in 1964, he was hired by the University of California, Berkeley, to establish a glass studio program, the second in the country. That same year, Robert Fritz, another student of Littleton's, began a program at what is now San Jose State University. These two artists thus established California as an early center of studio glass in the United States.

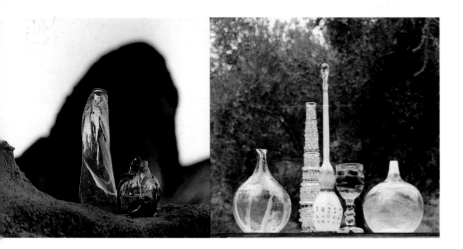

Works of both Lipofsky and Fritz were exhibited in *CD 9* (1965), shortly after their arrival in California, and were photographed together for the catalogue (fig. 6.2). The awkward forms indicated that controlling the thick molten glass to create large three-dimensional works was difficult and in its early stages. *CD 9* also featured functional items, such as blown glass objects—vases, a decanter, and a glass—by Southern California artist John Burton. Burton, known as the father of contemporary lampwork, was another early figure in the development of glass as an art medium (fig. 6.3).[2] Dorothy Thorpe's glass objects, their clean lines influenced by modernist aesthetics, were made in factories overseas: green luster stemware in Germany; a lead glass bowl in Mexico; salt and pepper shakers in Japan; and Discus stemware in Czechoslovakia (fig. 6.4).

Fritz and Lipofsky exhibited again in *CD 10* (1968). Fritz's piece was an elaborate glass fountain (fig. 6.5). Lipofsky's work was composed of parts joined together with epoxy, sandblasted, and copper-plated—new strategies for treating glass (fig. 6.7). A ten-inch-tall rectangular bottle by Richard Marquis, one of Lipofsky's students, bore the image of a landscape (fig. 6.6). James Wayne's ambitious hot glass work, twenty inches tall with its base, was an abstract interpretation of the muscle-bound mythic hero *Herc* (fig. 6.8). The piece's balance and symmetry indicated the artist's growing skill in working glass.

The works selected for *CD 11* (1971) clearly demonstrated that studio glass artists had achieved greater control over their material, allowing them to blow larger, more complex forms. This exhibition had the largest number of glass objects in the series—a total of thirty-four—reflecting an excitement about the burgeoning field. The impact of such programs as the

page 174:
Figure 6.1
Svetozar Radakovitch;
window model;
stained glass, bronze;
44 x 99½ inches.
1962 (*California Design 8*)

above, left:
Figure 6.2
Robert C. Fritz,
bottle,
free-blown glass,
14 inches.
Marvin B. Lipofsky,
expanded side form bottle,
free-blown glass.
1965 (*California Design 9*)

above, right:
Figure 6.3
John Burton;
Elegance, Yellow Dewdrops,
Goblet, and two pieces
entitled *Colored Globe;*
handwrought glass.
1965 (*California Design 9*)

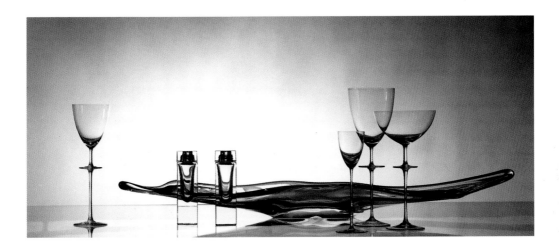

above:

Figure 6.4

Dorothy C. Thorpe; group of three designs: long narrow bowl with carved gardenias, glass, made in Mexico; Discus stemware, glass, made in Czechoslovakia; salt and pepper shakers, lead crystal, made in Japan.

1965 (*California Design 9*)

Great California Glass Symposium series, from 1968 to 1987, sponsored by the California College of Arts and Crafts (co-sponsored by the University of California, Berkeley, glass program until it closed in 1974), was evident. Artists and students from throughout the state attended the symposiums, where they learned about new techniques and exchanged ideas with scores of artists from elsewhere in the United States and from Europe.

As a result of experimentation spawned by these events and the availability of better raw materials for glass making, the work in *CD 11* was larger, more refined in detail, and more conceptual. Esteban Prieto, son of the legendary Mills College professor Antonio Prieto, blew a bottle with handles, an example of exquisite classic form and superb control of the medium (fig. 6.14). In Fred Lucero's *15 Dots Inside with You,* a carefully finished, smooth exterior surface contrasted with an interior that conveyed an ambiguous message in a dot pattern (fig. 6.10). Paula Bartron's fused cup and saucer was an artful object of contemplation but pointedly impractical for use (fig. 6.9). Likewise, in *Moon Bottles,* John Lewis left the interpretation of the dreamy moonscapes to the observer (fig. 6.12). James Wayne used impressed lettering and fuming (a thin metallic film sprayed on the surface) to transform the appearance of the glass in his blown vase (fig. 6.13). John Alfred Anderson's *Boot Vase* presented an unlikely form in glass, perhaps a counterpart to Cinderella's glass slipper. He varied the surface with shiny and matte finishes (fig. 6.11).

The greater variety of objects selected for *CD '76* suggested a growing interest in conceptual art. Several examples of stained glass exemplified these trends. In an untitled work, Jad King reworked a damaged stained glass window by substituting his own revision, an image of a hand wiping

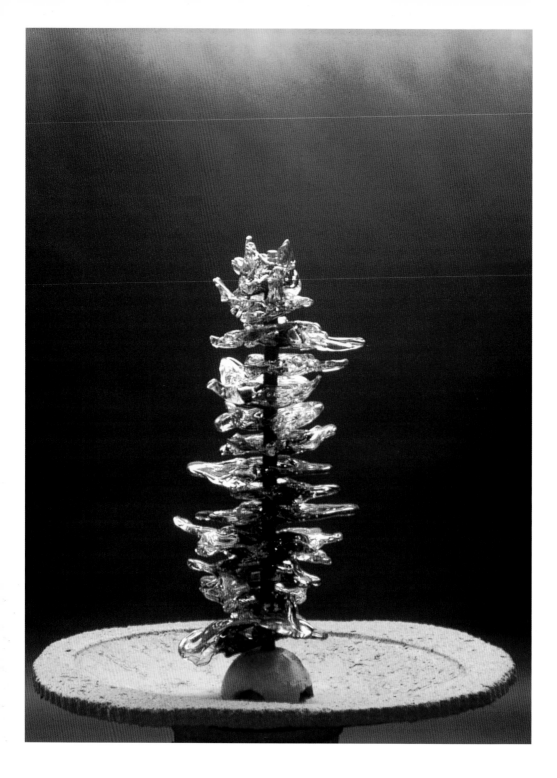

opposite:
Figure 6.5
Robert C. Fritz;
fountain;
concrete base with
assembled glass forms,
free-blown glass.
1968 (*California Design 10*)

below:
Figure 6.6
Richard Marquis,
rectangular bottle
with landscape (far left),
glass, 10 inches.
Shown with Cecile McCann
vase, Peter Pilat bottle,
Jerrold D. Meek vase, and
Ted Goldberg goblet.
1968 (*California Design 10*)

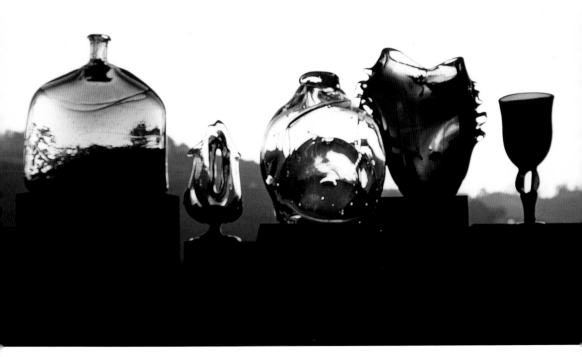

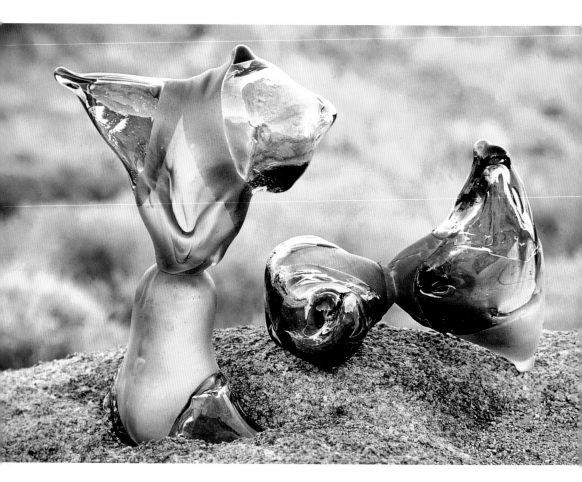

Figure 6.7
Marvin B. Lipofsky;
glass form, sandblasted
and copper-plated in
areas, epoxy-joined (left);
tall glass form,
sandblasted, and
epoxy-joined (right).
1968 (*California Design 10*)

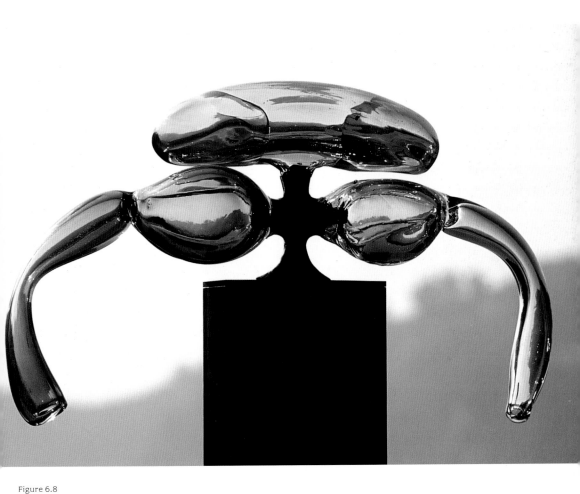

Figure 6.8
James Wayne;
sculpture, *Herc*;
free-blown glass;
bronze, wood;
20 x 30 inches.
1968 (*California Design 10*)

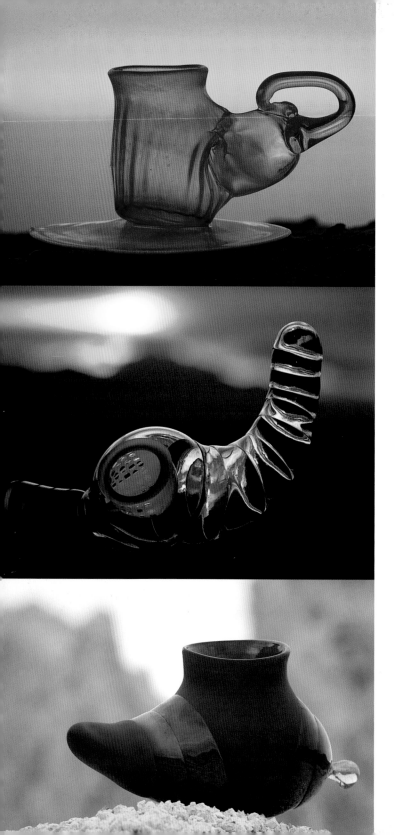

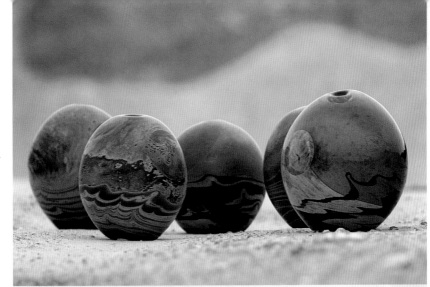

top:
Figure 6.12
John Lewis;
group of *Moon Bottles:*
Arctic Wind Storm, Lunar
Fission, Morning Calm,
Reflected Moon, and
Suspended Moon;
blown and lustered glass;
each about 4 to 4½ inches.
1971 (*California Design 11*)

bottom:
Figure 6.13
James Wayne;
vase form;
blown glass, textured,
and fumed;
11 inches.
1971 (*California Design 11*)

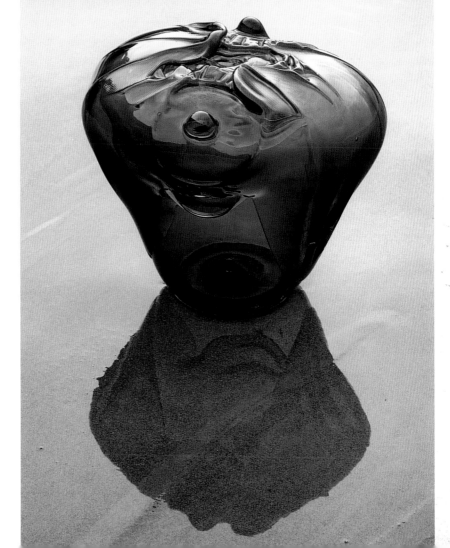

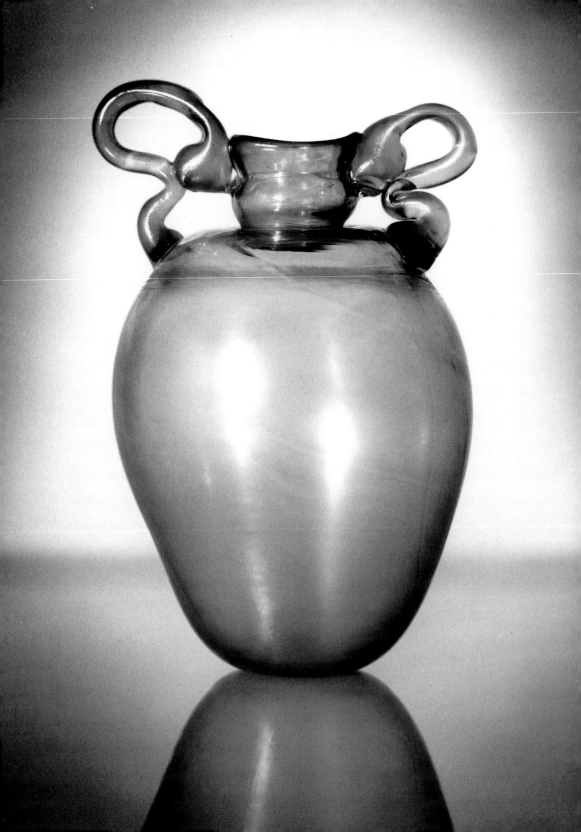

away part of the old image, perhaps symbolizing the challenge to tradition under way in studio glass at the time (fig. 6.16). In Richard Posner's *The Big Enchilada,* the viewer is invited to decode the surreal narrative involving a shadowy figure, an open door, and a dog (fig. 6.17). Jane Marquis's large cubelike shape (fig. 6.18), worked on a steel frame, gained strength and presence from the intricate network of metal surrounding the glass and the careful placement of stunning colors. Chad Lynde saluted the nation's bicentennial in a playful Pop Art perfume bottle in three colors and mixed media: red (macaw feather), white (sterling silver), and blue (blown glass) (fig. 6.15).

The innovative pieces in the *California Design* exhibitions only hinted at what the next thirty years would bring. Artists such as Marvin Lipofsky, Richard Marquis, and John Lewis, all exhibitors in the *CD* series, matured and gained international stature, and many new glass artists followed. Glass programs, both in universities and in private institutions such as the Pilchuck Glass School in Stanwood, Washington, and Urban Glass in Brooklyn, New York, have flourished. International collaborations and partnerships with artists and factories abroad have also stimulated continued innovation.

Objects made of metal followed a different course than those of glass. California did not play as influential a role in metalwork as it had in glass, ceramics, and fiber. In the *CD* series, metal objects stood in contrast to jewelry, which explored metal in an intimate relationship to the body. These objects, though not as numerous as jewelry, were designed for functional use and

left:
Figure 6.19
Porter Blanchard,
coffee service,
handwrought pewter.
1965 (*California Design 9*)

opposite;
Figure 6.20
Frederick Lauritzen;
partial coffee service
(coffeepot, sugar bowl,
and water pitcher);
sterling silver, rosewood.
Shown with a sterling
silver ladle by George
Corpuz on a washable-
foil wallpaper designed
by Philipp Yost for
Murals, Inc. Wallpaper
Manufacturing.
1962 (*California Design 8*)

display, primarily in the home. Some designers, for example, Allan Adler
(fig 4.6, page 126) and Arline Fisch (figs. 4.1, page 122; 4.16, page 131), exhib-
ited both jewelry and other metalwork.

Like other media chosen for the *CD* series, the metalwork on display
reflected changing times and aesthetic values and artists' desire to explore
experimental ideas. In the 1950s through most of the 1960s, the *CD* exhibi-
tions were dominated by tableware, from the casual to the formal, and by
containers such as bowls. By the 1970s, artists had departed from such tra-
ditional forms to create fountains, enameled panels, sculptural hardware,
and nonfunctional objects conceived primarily as sculpture rather than
intended for domestic use.

Early *CD* exhibitions featured tableware and other functional pieces
by well-established silversmiths influenced by Art Deco, Bauhaus, and
Scandinavian designs, as well as by trained Scandinavian metalsmiths who
immigrated to the United States. Frederick Lauritzen's coffeepot, sugar
bowl, and water pitcher were exhibited in *CD 8* (1962). Lauritzen had studied
with German-trained teacher Herman Gurfinkel, and his elegantly shaped
metalwork showed the influence of European designers, one of them being
Johan Rohde (fig. 6.20). Lauritzen later taught at California State University,
Northridge, in Southern California.

One of the best-known California metalsmiths was Porter Blanchard,
who exhibited in *CD 9* (1965) when he was in his late seventies. He was rep-
resented by a stunning, diagonally leaning, pewter coffee service (fig. 6.19),
along with more traditional flatware and pewter plates. Blanchard was from
Massachusetts and had been trained by his silversmith father. He began his
career making raised metal objects in Arts and Crafts and colonial revival
styles. In 1923 Blanchard moved to Los Angeles, and by the 1930s his work
had taken a different direction, employing the same techniques and still

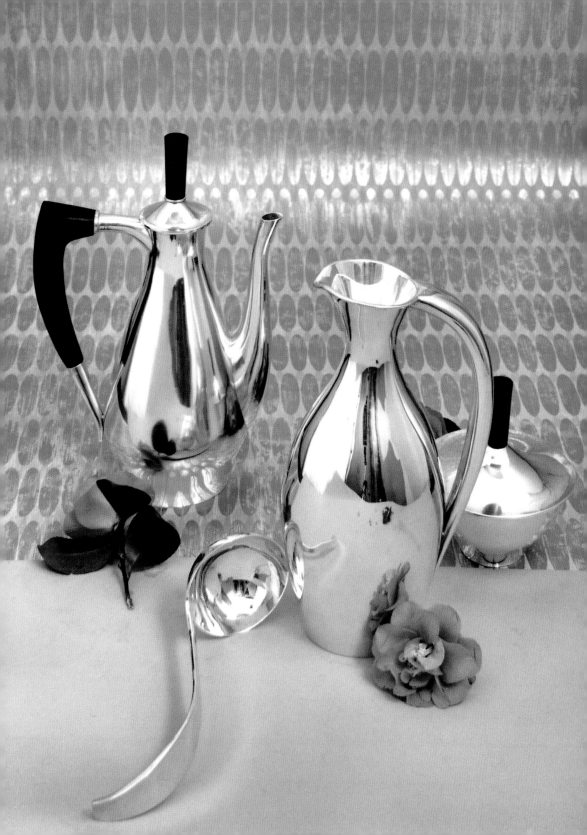

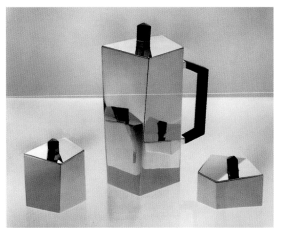

left:
Figure 6.21
Zaven Zee Sipantzi;
coffee service (coffeepot,
creamer, sugar);
hand-formed sterling
silver, ebony.
1971 (*California Design 11*)

opposite, top:
Figure 6.22
Zaven Zee Sipantzi;
coffeepot (part of a
set of tray, creamer, and
sugar bowl);
hand-raised sterling silver.
1968 (*California Design 10*)

opposite, bottom:
Figure 6.23
Left to right (back row):
Al Ching, creamer,
sterling silver;
Allan Adler, teardrop
salt and pepper shakers,
sterling silver;
Charles R. Escott,
standing covered bowl,
sterling silver;
Michael Lacktman,
coffeepot, sterling silver
and rosewood.
Left to right (front row):
Donald T. Chadwick, proto-
type place setting (spoon,
fork, knife),
stainless steel;
Michael Lacktman,
salt and pepper shakers,
sterling silver;
Alvin A. Pine, set of six
forks (two shown), forged
sterling silver;
Alvin A. Pine, ladle, forged
sterling silver;
Michael Lacktman,
cigarette canister,
sterling silver.
1968 (*California Design 10*)

stressing function over decoration, but expressing the elegant lines of the Art Deco style seen in the coffee service. Blanchard never forgot his roots. His traditional pewter plates also appeared in *CD 9* (1965).

Allan Adler, Blanchard's son-in-law, was one of the few metalsmiths (aside from copper-enamelists) in the early *CD* exhibitions. His work, reflecting the aesthetics of Scandinavian design, appeared in *CD 1* (1954—1955) and *CD 2* (1956). Adler's name then disappeared from the series until *CD 9* (1965), when he showed a single silver butter knife, part of a set, followed in *CD 10* (1968) by a teardrop-shaped set of salt, pepper, and sugar shakers in the Scandinavian tradition (fig. 6.23). Zaven Zee Sipantzi's coffeepot in *CD 10*, another Scandinavian-influenced piece, was a highly reflective, curvaceous organic form related to the work of Hans Christenson, a designer with the Danish firm Georg Jensen (fig. 6.22). Sipantzi's polygon-shaped coffeepot, creamer, and sugar bowl also reflected light beautifully. The set was reminiscent of the earlier work of Erik Magnussen (fig. 6.21).

Alongside the Scandinavian-inspired works were pieces related to the experiments occurring in ceramics and fiber in the United States, specifically in the use of asymmetrical, earthy, textured surfaces and humor. Among such works were Svetozar Radakovitch's cast bronze door pull in *CD 9* (1965) (fig. 6.26) and Carole Small's hand-raised, double-spouted teapot with textured surface in *CD 11* (1971) (fig. 6.25). In form and texture, Richard William

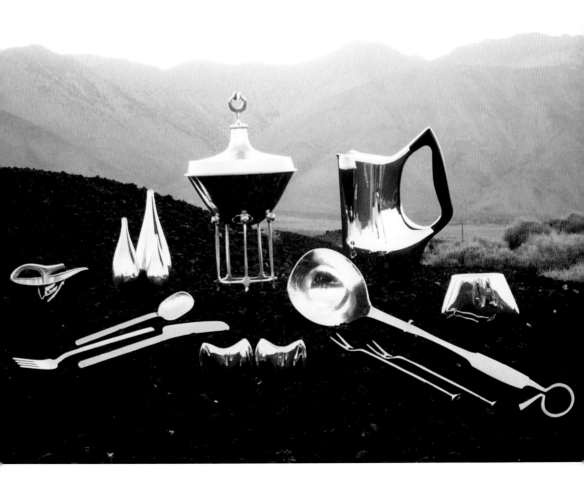

Sculpture and Functional Objects in Glass, Metal, and Wood

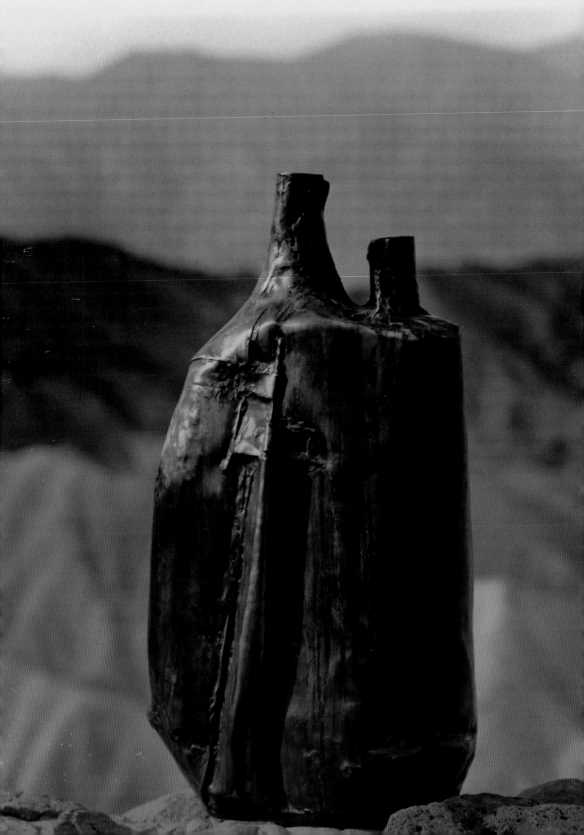

opposite:
Figure 6.24
Richard William Mills,
welded bottle,
copper,
25 inches.
1965 (*California Design 9*)

right:
Figure 6.25
Carole Small;
double-spouted teapot;
hand-raised sterling silver,
moonstones, cut crystals,
agate handle.
1971 (*California Design 11*)

far right:
Figure 6.26
Svetozar Radakovitch;
door pull;
bronze, lost-wax process.
1965 (*California Design 9*)

below:
Figure 6.27
Arline Fisch;
dresser set and "hand"
mirror;
silver, wood.
1965 (*California Design 9*)

Mills's roughly welded bottle with two spouts in *CD 9* (1965) looked at first glance like a ceramic vessel (fig. 6.24). Arlene Fisch's humorous dresser set in *CD 9* included a gently macabre "hand" mirror (fig. 6.27).

In *CD 11* (1971), an array of small, jewel-like metal objects was included in the section on jewelry. David La Plantz's wine container was clearly a modern form but with the attributes of an amusing animal (fig. 6.28). Joe Apodaca exhibited an understated, anatomically correct perfume bottle of sterling silver (fig. 6.29). Humor was present in *CD '76*. Eileen G. Hill's miniature container in sterling silver, bronze, and wood brought together basic geometric shapes in a formal yet whimsical arrangement joined by tiny metal tubes (fig. 6.30). Garry Knox Bennett's suggestive *None* was a wall clock of plated metal, complete with moving, fur-trimmed lips (fig. 6.31).

On a larger scale were two pieces in *CD 8* (1962) that celebrated the potential of metal to imitate natural textures and arrangements. Charles and Dextra Frankel exhibited a fountain composed of many small leaflike parts, and Roger Darricarrere showed a heavily textured bronze wall panel, about four feet square, that resembled tree bark. In *CD 9* (1965) a candelabra resembling birds in flight was submitted by Victor Ries.

Among the abstract designs was Gene Thompson's handsome aluminum gate with a matrix of carefully defined openings in various sizes, shown in *CD 10* (1968) (fig. 6.32). In *CD 11* (1971), C. Carl Jennings, a Northern California metalsmith/blacksmith, exhibited a forged gate with well-placed three- and four-sided polygons (fig. 6.33). Ruth Asawa was known for working wire as if it were a stiff yarn to create complex knitted, organic shapes. Her *Wire Cross* in *CD 10* was a delicate form made from tied bundles of galvanized wire (fig. 6.34).

A special subcategory of metals included those with enameled surfaces. In the process of making these works, finely ground glass, colored with metal oxides, was fused to a metal surface in a kiln. This ancient technique was widely adapted for richly colored modernist accessories in the post—World War II era. Work of enamelists was a staple feature of the early *CD* exhibitions. Most were small and often made from purchased or commissioned copper forms available in various sizes and shapes. Enameled objects were most numerous in *CD 9* (1965), when they were exhibited by eleven artists. The number declined drastically in *CD 10* (1968) and *CD 11* (1971), and by *CD '76* there were none; enameling had drifted out of fashion. Two artists well known in the field, Annemarie Davidson and June Schwarcz, both exhibited bowls in *CD 8* (fig. 6.35). Davidson explored her distinctive style of carefully wrought designs on enameled metal. Schwarcz changed her style of work. She soon became known for a more individual style, seen in her

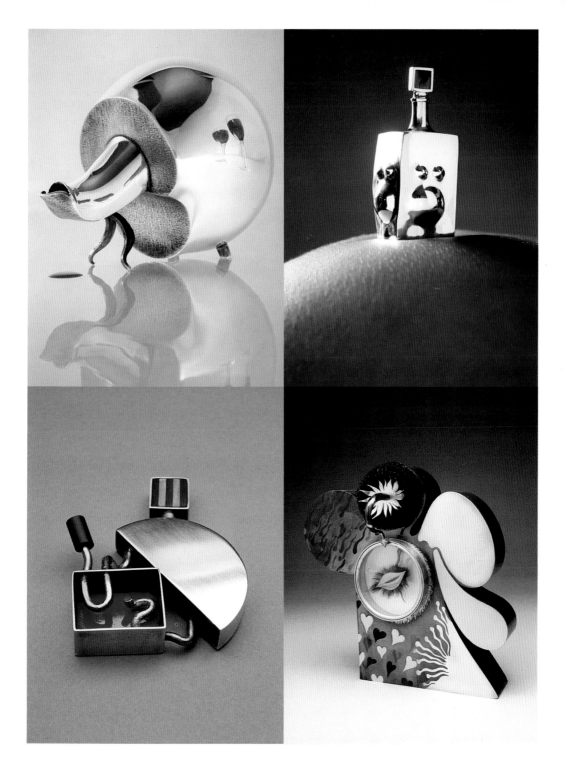

Sculpture and Functional Objects in Glass, Metal, and Wood

opposite:
Figure 6.32
Gene Thompson;
gate;
aluminum, single sand
casting;
5 x 7 feet x 4 inches.
1968 (*California Design 10*)

above:
Figure 6.33
C. Carl Jennings,
gate,
forged metal,
8 x 10 feet.
1971 (*California Design 11*)

right:
Figure 6.34
Ruth Asawa;
Wire Cross;
tied, galvanized wire;
4½ feet in diameter.
1968 (*California Design 10*)

Sculpture and Functional Objects in Glass, Metal, and Wood

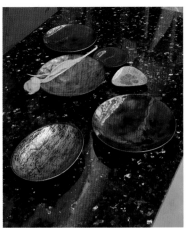

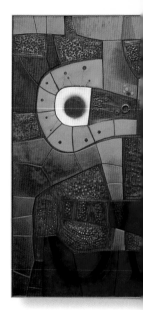

enameled panel on wood *CD 10* (1968) (fig. 6.37), which employed electroforming, a plating process whereby metal is deposited on a conducting surface to create a raised, abstract design, suggesting organic forms. Both Davidson and Schwarcz, now in their eighties, have enjoyed long and distinguished careers.

Paralleling developments in other metalwork, enameled metals grew in scale and abstraction, seen in two vibrant panels: one three-by-eight-foot mural by Jackson and Ellamarie Woolley *CD 8* (1962) (fig. 6.36) and a two-by-three-foot panel by Ellamarie Woolley, *Summer,* in *CD 9* (1965) (fig. 6.38).

While furniture played a major role in the *California Design* series, it was not the only type of wood object exhibited. Relatively small functional and display pieces were also included, as was wood sculpture. Turned wood bowls might have been the quintessential objects for adorning the home in the 1960s and 1970s. Traditionally, wood turning on a lathe had been confined to furniture legs and simple bowls. In the post—World War II era, turned wood began to take on a more modern profile.[3]

One nationally known, pioneering wood turner was Bob Stocksdale, whose work was exhibited in *CD 8* (1962) through *CD 11* (1971). For more than fifty years Stocksdale worked in his Berkeley studio, exploring form in beautifully shaped bowls and plates. His exotic materials, from almond wood to zebrawood, revealed luscious grains in many patterns and colors, which he used to great advantage (figs. 2.2, page 72; 6.39 and 6.40). Another turner in the *CD* exhibitions was Merryl Saylan, who exhibited a rice server and bowls of bird's-eye maple in satisfying forms in *CD '76* (fig. 6.41). Richard J. Arpea used a different technique. His walnut and teak bowls in pear and watermelon shapes, shown in *CD 8,* were formed in the manner of a barrel, with shaped, narrow strips manipulated and joined to form the vessels (fig. 6.42).

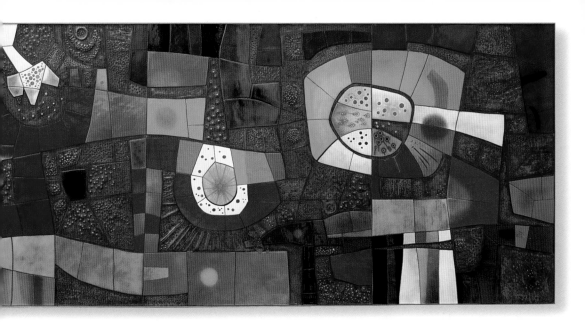

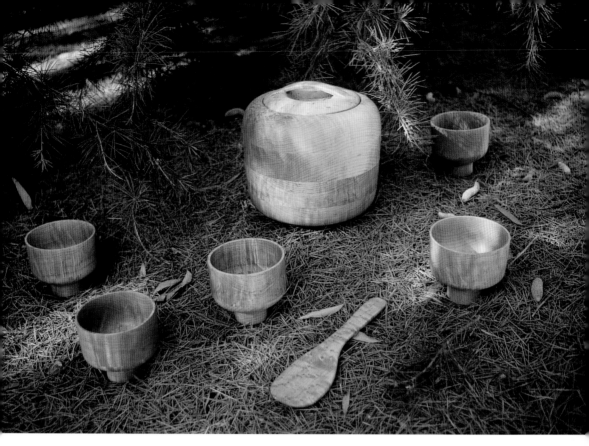

above:
Figure 6.41
Merryl Saylan,
rice server and bowls,
bird's-eye maple.
1976 (*California Design '76*)

right:
Figure 6.42
Richard Arpea,
three staved bowls,
walnut and teak.
1962 (*California Design 8*)

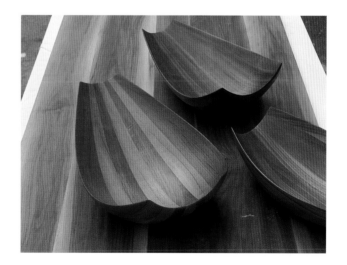

Sculpture and Functional Objects in Glass, Metal, and Wood

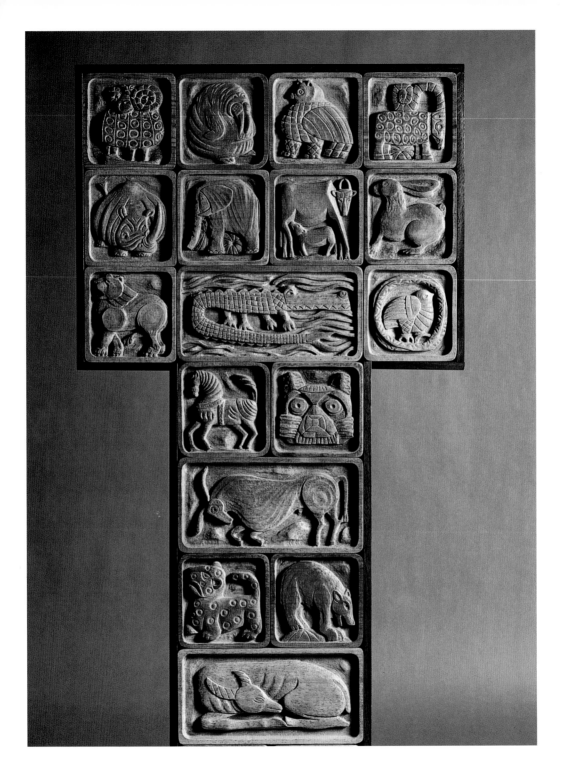

opposite:
Figure 6.43
Evelyn Ackerman,
Animal Block Series,
carved wood,
9 x 9 and 9 x 19 inches.
1971 (*California Design 11*)

right:
Figure 6.44
Dennis Longo;
koa, birch, and rosewood
container.
1976 (*California Design '76*)

far right:
Figure 6.45
Benjamin Serrano,
carved wood sculpture.
1971 (*California Design 11*)

below:
Figure 6.46
Carl Johnson;
sculpture, *Wood Five;*
3 feet high.
1976 (*California Design '76*)

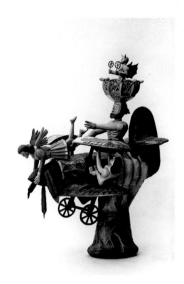

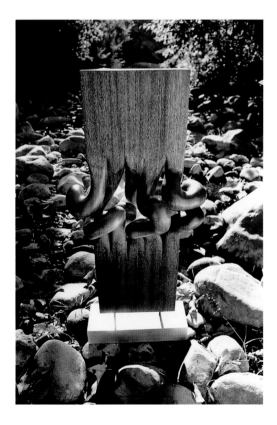

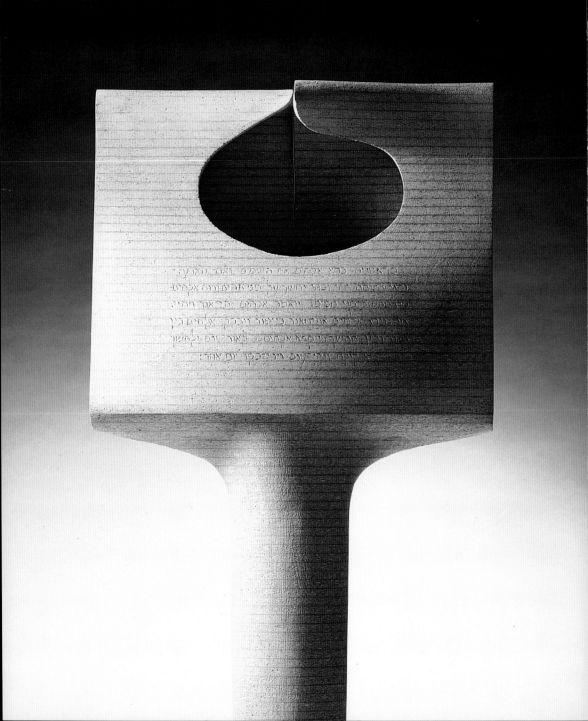

The range of wood objects became more heterogeneous in later exhibitions. Dennis Longo's container of koa birch and rosewood in *CD '76* combined an oversized, turned handle with a bold chevron pattern to create a strong visual presence (fig. 6.44). In *CD 11* (1971) Evelyn Ackerman showed the *Animal Block Series* for children—clever designs expressed in nine-inch squares of carved wood. Each block could be assembled in infinite arrangements (fig. 6.43). Benjamin Serrano artfully fused a traditional Hispanic carved folk-art form with a modern message—a large hand holding a biplane aloft, perhaps a prayer for a safe flight (fig. 6.45)—shown in *CD 11* (1971). Another intriguing sculptural piece, *Wood Five,* in *CD '76* (1976) was impressively executed in mahogany by Carl Johnson (fig. 6.46). The central, curling wood shapes mimicked twisted, coiling yarn, in sharp contrast to the surrounding smooth wood surfaces and sleek aluminum base. John Kapel's powerful *Monolith,* in *CD 11,* made of laminated particleboard with an inscription in Hebrew, was designed for a religious context. A large upper block was inscribed with a quotation from Genesis describing the first day of creation and loomed over its more slender base. A gracefully curving shape divided the inscribed, upper block (fig. 6.47).

Today, galleries around the United States feature the work of artists who create artworks in glass, metal, and wood. Many of these galleries come together to participate in the large, national exhibition known as *SOFA* (Sculptured Objects and Functional Art), two shows held annually in Chicago and New York. The high level of skill, ingenuity, and sophistication reflected in the works show the development of artists in the thirty years since the *California Design* series. Today's artists also enjoy the support of professional organizations such as the Society of North American Metalsmiths and the Glass Art Society and institutions like the Wood Turning Center of Philadelphia. These entities have embraced collectors as well as artists, and collectors have formed their own organizations such as the Art Alliance for Glass, to support exhibitions and other projects.

1. For a detailed early history of the American studio glass movement: Robert A. Cohen, "Origins of the Studio Glass Movement," *Glass Studio,* issue no. 32 (1982), 36—42, 51—55.

2. Lampwork, also known as flamework, is defined as "[t]he technique of forming objects from rods and tubes of glass that, when heated in a flame, become soft and can be manipulated into the desired shape," The Corning Museum of Glass online Glass Glossary. See also: *John Burton, Glass: Handblown, Sculptured, Colored, Philosophy and Method* (New York: Bonanza Books, 1967).

3. For a detailed history: Edward S. Cooke, Jr., "Turning Wood in America: New Perspectives on the Lathe," in Matthew Kangas, John Perreault, and Edward S. Cooke Jr., *Expressions in Wood: Masterworks from the Wornick Collection* (Oakland: Oakland Museum of California, 1996), 43.

Chapter 7

Designing the California Lifestyle

JO LAURIA AND SUZANNE BAIZERMAN

"To Californians there is California and there is the rest of the country," wrote Patricia Degener in her article *Go Californian for Comfort* in the April 18, 1976, *St. Louis Post Dispatch*. "Far from being upset by any stigma of provincialism, Californians view with equanimity and fleeting wonder the fact that the rest of the country hasn't the good sense to live in California." This statement by journalist Degener encapsulates the prevailing attitude held by many Californians that they enjoy a unique and desirable lifestyle—casual, progressive, cool—that is exclusive to the Golden State. The accouterments that serviced and sustained this lifestyle were featured in the *California Design* exhibitions, and several of these objects, mostly by industrial designers, reflected and contributed to the California design culture beyond the usual categories. The state's fast-paced, on-the-edge design industry was, and still is, recognized for setting national trends. Many of the products were created in support of the outdoor lifestyle so prevalent in California. Some anticipated the revolution in "extreme" sports gear, while others enriched the domestic environment and provided essentials for the children of baby boomers. Considered as a whole, these objects are too significant and engaging to overlook, though they do not fit neatly into the other sections of this book.

A portfolio of various vehicles, mechanical devices, gadgets, household accessories, sports, and play equipment—ingenious as well as quirky—makes a fitting conclusion to this celebration of the contributions of California designers to late-twentieth-century design. In the words of Eudorah M. Moore, "The California way of life creates needs with which its designers must comply, for unique implements of living for fun or for function. *California Design* presents products to broaden the scope of life in the sky, on the ocean, in the desert, in gardens, swimming pools and even in trees."[1]

The most fascinating products that broadened "the scope of life in the sky" included a pair of two-seater gyroplanes—the *McCulloch J-2*, in *CD 11* (1971) and the stylish *Sky Skooter*, painted in dazzling candy-apple red, in *CD 8* (1962)—along with the *Swallowtail* hang glider, a human-sized kite developed for the California sport of soaring off coastal cliffs, in *CD '76* (1976). These aeronautical wonders were designed for the amateur aviator (figs. 7.1, 7.2, 7.3). Created for the delight of water-sports enthusiasts were a variety

of ocean-faring vessels and vehicles, showcased in *CD 10* (1968), *CD 11* (1971), and *CD '76* (1976). Innovations in the synthetic materials of fiberglass and plastics made possible the production of lightweight boating equipment, such as the compact sailboat manufactured by Accurate Systems and the *Yak-Yak* canoe from Fleet Products that weighed less than fifty pounds and was claimed to be unsinkable (fig. 7.6).

More futuristic in concept was the prototype *Hydrobike,* which combined a NASA hydrofoil shape with a conventional outboard motor, resulting in a water-bike that handled like a motorcycle but was powered with "rocket-like lift outs." The *Terragator,* a six-wheel-drive amphibious car designed by Andy Stewart, had a special jet for water propulsion—the ultimate cruising vehicle for the would-be frogman (figs. 7.4, 7.5).

For crossing more traditional terrain, California designers put on their racing caps and created vehicles that "eased down the road" in style. The smartly designed *Manx* fiberglass dune buggy, produced by the Bruce Meyers Company, was sold in kit form and was especially popular among sports enthusiasts who met at buggy rallies (fig. 7.7). The buyer would purchase a Volkswagen Beetle, cut down the frame, and customize it with the *Manx* kit. The buggy exhibited in *CD 11* (1971) had taken the prize at an October 1968 race between La Paz and Tijuana, covering a thousand miles in twenty-seven

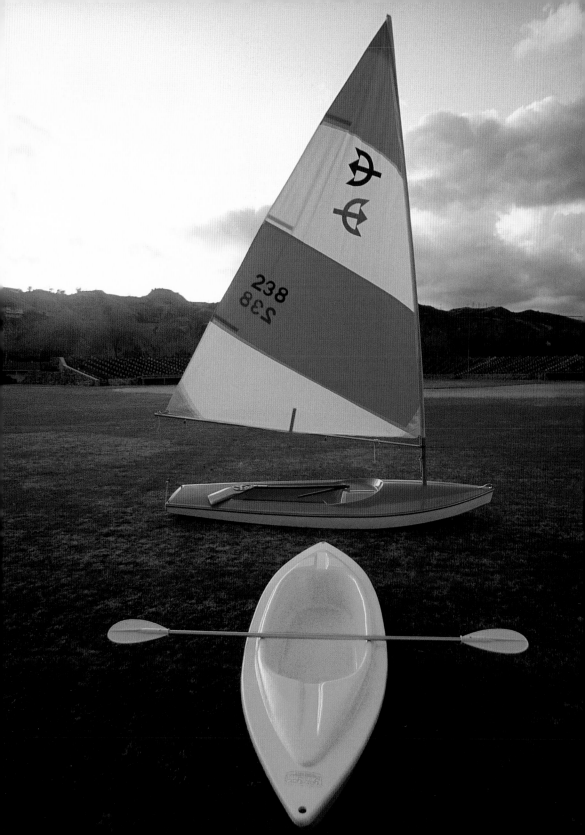

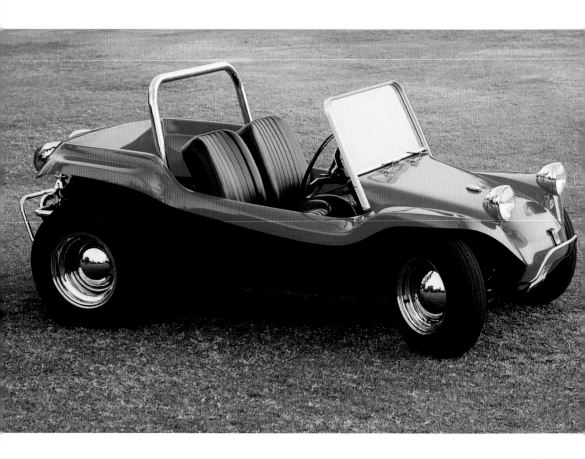

hours. Lauding the dune buggy's simple and direct design, Moore commented: "It represents a great kind of outdoor activity and personal involvement typical of California. Packaged as a kit, the whole idea is that you put it together yourself. In California we have this mass of home mechanics, which is one of the great strengths of a country."[2]

 Traveling at less velocity but every bit as stylish was A. D. Stump's *Custom-built Bicycle* (fig. 7.8), shown in *CD '76* (1976) and considered the Rolls Royce of touring bikes. Stump engineered the cycle to be lighter and faster than standard versions available at the time. Its chrome frame was durable and weighed only eighteen pounds, compared with the usual twenty-three to twenty-six pounds. Custom-decorated by Stump, with exquisite detailing and lavish touches of gold leaf, the bicycle reflected the designer's earlier training as a jeweler.

Figure 7.7
Bruce F. Meyers for
B. F. Meyers Co.;
dune buggy, *The Manx;*
fiberglass.
1968 (*California Design 10*)

Figure 7.8
(multiple views)
A. D. Stump;
Custom-built bicycle;
chrome, steel, aluminum.
1976 (*California Design '76*)

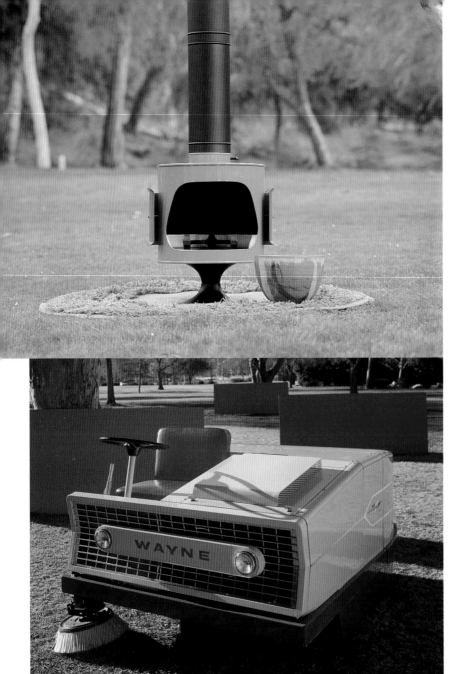

left, top:
Figure 7.9
Gerald L. Jonas for
Firedrum, freestanding
fireplace and cast-iron
log rest, metal.
Displayed with rug
designed by Philipp
Yost, manufactured
by Savnik and Company,
and stoneware bowl by
Rhoda Lopez.
1965 (*California Design 9*)

left, below:
Figure 7.10
Lewis and Tweedie for
Wayne Manufacturing Co.,
power sweeper,
6 x 7 feet.
1962 (*California Design 8*)

opposite, top:
Figure 7.11
Dave Workman and Tim
Uyeda of Design West, Inc.
for the Marine & Recreation
Components Division of
Jabsco Products ITT;
recreational vehicle toilet,
the *Malibu;* plastic, poly-
propylene, stainless steel.
1976 (*California Design '76*)

opposite, bottom:
Figure 7.12
From right to left:
tackle box, plastic,
designed by Tim Uyeda
of Design West, Inc.
for Vichek; scuba
equipment, designed
by McFarland Designs
for Healthways;
cruising shell, fiberglass,
designed by Stuart Blue
for Seawind; oars and
bronze oarlocks on
cruising shell, designed
by Jerry L. Hurst;
scuba system, designed by
Douglas Deeds for Nautilus
Systems Corporation,
fiberglass.
1976 (*California Design '76*)

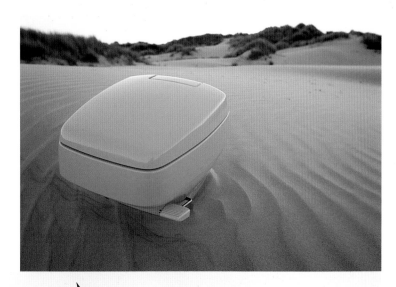

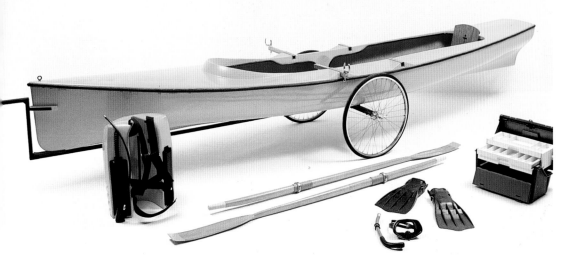

Designing the California Lifestyle

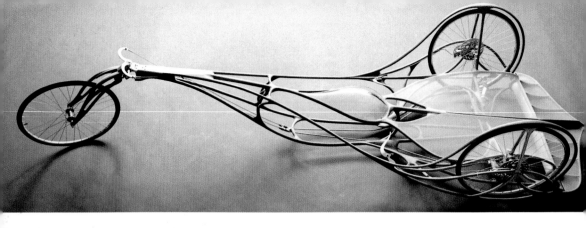

The most eccentric land cruiser was undoubtedly Michael Jean Cooper's *Three-Wheeled Vehicle* (fig. 7.13) in *CD '76*. Also called the *Downhill Racer,* this vehicle worked by gravity. Cooper originally designed the racer to partici- pate in an artists' soapbox derby sponsored by sculptor Fletcher Benton in San Francisco as part of the San Francisco Museum of Art's Soap-Box Car competition, but the vehicle was not finished in time to enter. Cooper did, however, test it on another track and proved that it picked up considerable speed going downhill. The racer was designed for speed; comfort took a backseat position. The driver lay prone and looked through the bubble shield, steered by means of foot stirrups, and stopped by squeezing the hand brakes. Sitting in the driver's seat of this derby car implied engaging in a full-body-contact sport. To museum visitors, it looked more like a surrealist sculpture than a functional vehicle. When touring the show, Tom Bradley, Los Angeles mayor at the time, paused to admire the strange contraption. Never one to miss a photo opportunity, he straddled the vehicle and proclaimed it L.A.'s solution to rapid transit.[3]

California designers also turned their attention to conquering the last frontier—the open terrain of the wilderness. A. I. Kelty was an avid hiker and designed the now-famous *Kelty Backpack* out of necessity, shown in *CD 9* (1965) (fig. 7.14) The Army-surplus rucksacks he had been using on his moun- tain climbs were heavy and awkward, with their U-shaped wood frames and thick canvas. Starting in his kitchen and garage, Kelty constructed his back- packs of nylon and lightweight aluminum frames that shifted the weight from the shoulders to the hips. He also added the padded shoulder straps for cushioning and comfort. Nick Clinch, an explorer for *National Geographic* magazine, dubbed Kelty "the Henry Ford of backpacking . . . By taking the weight off the hiker's shoulders and putting it on the hips, he took the misery out of the sport."[4]

above:
Figure 7.13
(multiple views)
Michael Jean Cooper;
Three-Wheeled Vehicle
(also known as
Downhill Racer);
laminated oak, aluminum,
nylon, bicycle wheels,
Plexiglass;
28 inches x 50 inches x
13 feet.
1976 (*California Design '76*)

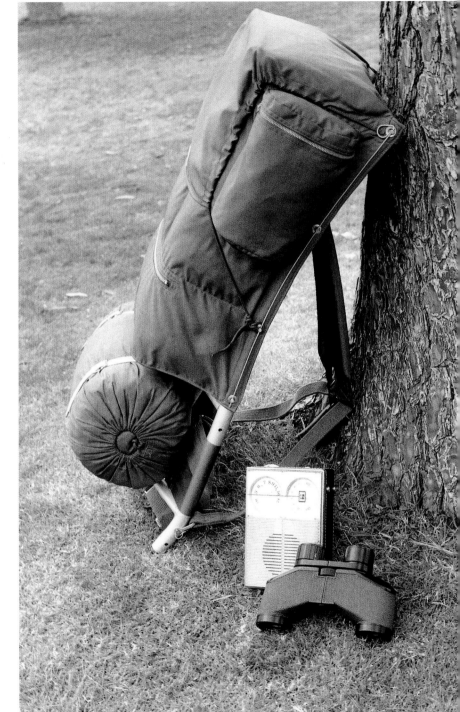

right:
Figure 7.14
A. I. Kelty for A.I. Kelty
Mfg. Co.;
Kelty Backpack;
aluminum, nylon.
Displayed with
James Kelso's portable
transistor radio designed
for Packard-Bell and
Paul Maquire's
custom compact
Binoculars designed for
D.P. Bushnell & Co.
1965 (*California Design 9*)

left and below:
Figure 7.15
(multiple views)
Elsie Crawford for Jacques;
multipurpose children's
toy, *World;*
wood.
1968 (*California Design 10*)

left and below:
Figure 7.15
(multiple views)
Elsie Crawford for Jacques;
multipurpose children's
toy, *World;*
wood.
1968 (*California Design 10*)

opposite:
Figure 7.16
Ruth and Svetozar
Radakovitch,
children's climber,
galvanized pipe and
magnesite.
1965 (*California Design 9*)

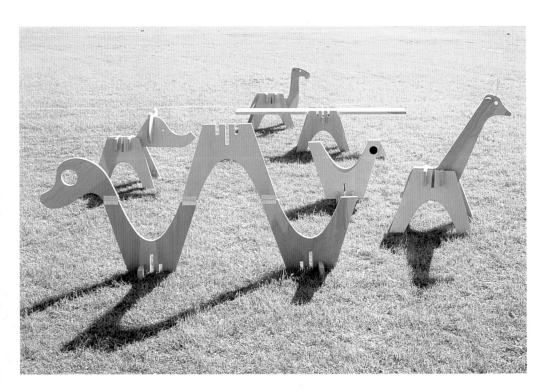

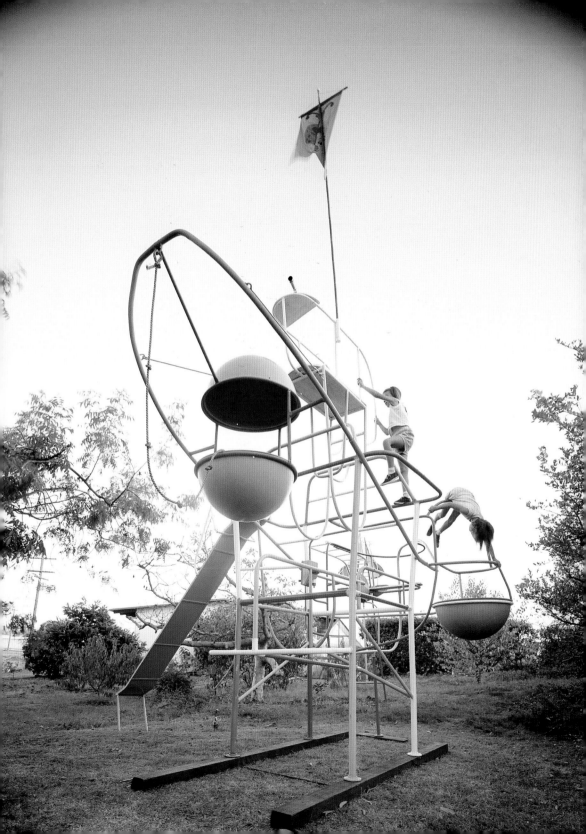

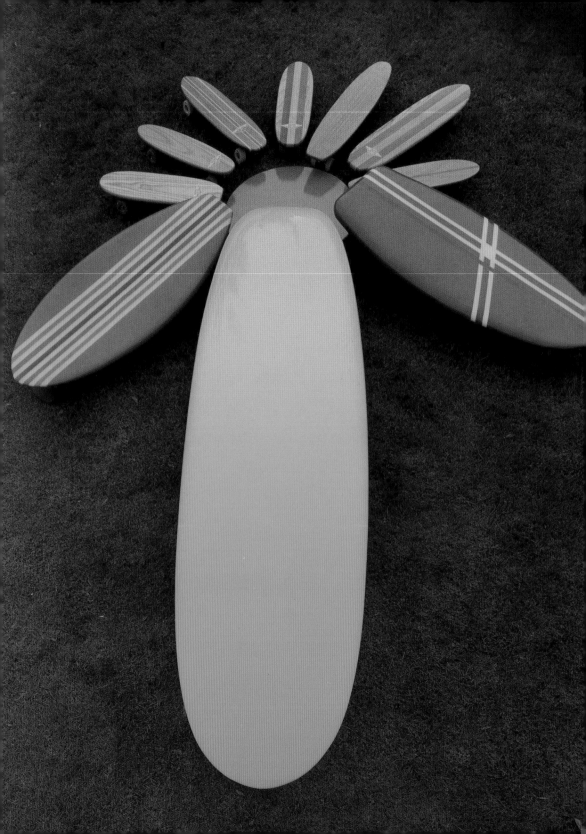

opposite:
Figure 7.17
Wake Wailer surfboard designed by Dale Velzy, and two *Belly Boards* designed by Bill Salyer for Cooley and Associates, polyurethane and fiberglass.
Skim board designed by George Cooley and Don Mastrangelo, laminated marine plywood.
Skateboards (fifth and seventh from left) designed by Richard Trantum for Cooley and Associates, Uba wood and interwoven fibrous material.
Skateboards (first, second, fourth, and sixth from left) designed by staff at the Vita Pakt Corporation; oak, laminated ash, or mahogany.
Super Surfer skateboard (third from left) designed by Hobie Alter for Vita Pakt, laminated exotic woods.
1965 (*California Design 9*)

top right:
Figure 7.18
James Budge for Windskate; *Windskate,* plastic sail for skateboard;
8 x 12 feet.
1976 (*California Design '76*)

bottom right:
Figure 7.19
Douglas Deeds for H.M.S Marine, Inc.;
sailing cart, *Scat;*
fiberglass, aluminum;
52 inches x 80 inches x 20 feet.
1971 (*California Design 11*)

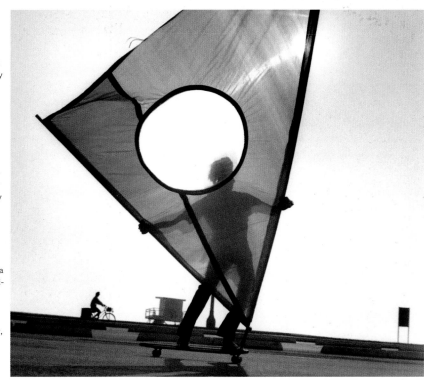

Well-designed specialty products were not limited to sporting equipment. Also featured in the exhibitions were specialized items created for the domestic sphere, particularly leisure and entertainment activities. Home entertainment systems, and the furniture to house them, became a dynamic design category by *CD 10* (1968). Exemplary were stereo and loudspeaker components produced by Arnold Wolf Associates for James B. Lansing Sound. Such products as the *JBL 88* loudspeaker system blended seamlessly with interior décor and provided chic, contemporary acoustical equipment for entertaining in style (fig. 7.20). Installed behind the round grille was a woofer, and the rectangular section screened a tweeter and an acoustical port. Arnold Wolf referred to this design as a "clear statement of purpose." The strong graphic treatment of the grille frame created a "pleasing visual rhythm" when the speakers were arranged in stereo pairs, either vertically or horizontally.[5] These units were obviously designed to appeal to both the discriminating listener and the connoisseur of fine furnishings.

The one object that most keenly celebrated the singular California lifestyle appeared in *CD '76*. The *Sand Star* outdoor whirlpool spa, designed by Cleo Baldon for Hydro-Spa, Inc., offered the benefits of luxurious and therapeutic soaking au naturel in the Shangri-la of one's own backyard (fig. 7.21). Prefabricated of fiberglass, the spa was designed with whirlpool jets that delivered a hot hydro-massage. Moreover, this model provided ample seating at various water depths so that the hot-tub experience could be shared communally. Placed in front of the backdrop of the great California landscape, the *Sand Star* spa epitomized the laid-back California lifestyle and demonstrated splendidly the creative diversity of design shown throughout the exhibition series.

above:
Figure 7.20
Robert Onodera and
Arnold Wolf;
Arnold Wolf Associates
for James B. Lansing;
JBL 88 Nova Bookshelf
loudspeaker system;
walnut and fabric grille
cover.
1968 (*California Design 10*)

right:
Figure 7.21
Cleo Baldon;
manufactured by
Hyrdo-Spa, Inc.;
Sand Star whirlpool spa;
fiberglass.
Displayed with planters
on the deck designed
by Guillermo Gomez for
Chiru Enterprises.
1976 (*California Design '76*)

1. *California Design 8* (Pasadena: Pasadena Art Museum, 1962), 38.

2. Sue Nirenberg, "Behind the California Vision," *House Beautiful* 110, no. 10 (April 1968), 66–68.

3. Harriet L. Axelrad, docent script for *California Design '76*, n.d., 4.

4. *Los Angeles Times*, January 15, 2004, sec. B14. "Asher Kelty, 84; Innovations Made Backpacking Popular," Obituary by Dennis McLellan.

5. Interview with Arnold Wolf, April 30, 2004.

Suggested Reading

Albrecht, Donald. *The Work of Charles and Ray Eames: A Legacy of Invention*. New York: Harry N. Abrams in association with the Library of Congress and the Vitra Design Museum, 1997. An exhibition catalogue.

Anderson, Jeremy. *The Furniture of Sam Maloof*. New York: W.W. Norton in association with Smithsonian American Art Museum 2003. An exhibition catalogue.

Bray, Hazel. *The Potter's Art in California, 1885 to 1955*. Oakland: Oakland Museum Art Department, 1980. An exhibition catalogue.

Constantine, Mildred, and Jack Lenor Larsen. *Beyond Craft: The Art Fabric*. New York: Van Nostrand Reinhold, 1972.

Cooke, Edward S., Jr., Gerald W. R. Ward, and Kelly H. L'Ecuyer. *The Maker's Hand: American Studio Furniture, 1940—1990*. Boston: MFA Publications, 2003.

Eidelberg, Martin, ed. *Design 1935—1945: What Modern Was: Selections from the Liliane and David M. Stewart Collection*. New York: Harry N. Abrams in association with Le Musée des Art Décoratifs de Montréal, 1991. An exhibition catalogue.

Eidelberg, Martin, ed. *Messengers of Modernism: American Studio Jewelry 1940—1960*. Paris: Flammarion in association with Le Musée des Art Décoratifs de Montréal, 1996.

Herman Miller Furniture Company. *20th Century, Landmarks in Design. Vol. 5, The Herman Miller Collection 1952: Furniture Designed by George Nelson and Charles Eames, With Occasional Pieces by Isamu Noguchi, Peter Hvidt, and Others*. New York: Acanthus Press, 1995. First published 1952 by Herman Miller Furniture Company.

Kelsey, John, and Rick Mastelli. *Furniture Studio: The Heart of the Functional Arts*. Free Union, VA: The Furniture Society, 1999.

Kirkham, Pat, ed. *Women Designers in the U.S.A.: Diversity and Difference, 1900—2000*. New Haven: Yale University Press in association with Bard Graduate Center for Studies in the Decorative Arts, 2002.

Lauria, Jo. *Color and Fire, Defining Moments in Studio Ceramics: 1950—2000*. New York: Rizzoli in association with the Los Angeles Museum of Art, 2000.

Lynn, Martha Drexler. *American Studio Glass, 1960—1990*. New York: Hudson Hills Press, 2004.

MacNaughton, Kay Koeninger, and Martha Drexler Lynn. *Revolution in Clay: The Marer Collection of Contemporary Ceramics*. Seattle: University of Washington Press, in association with Scripps College Ruth Chandler Williamson Gallery, 1994. An exhibition catalogue.

Nelson, George. *Chairs*. New York: Whitney Publications, 1953. Reprinted in *20th Century Landmarks in Design*. Vol. 3, *Chairs*. New York: Acanthus Press, 1974.

Rapaport, Brooke Kamin, and Keven L. Stayton. *Vital Forms: American Art and Design in the Atomic Age, 1940—1960*. New York: Harry N. Abrams in association with Brooklyn Museum of Art, 2001. An exhibition catalogue.

Acknowledgments

Many people have contributed their knowledge and their best efforts to this book. Certainly no one deserves more credit for making this project possible than Eudorah M. Moore. She was the visionary organizer and guiding force behind five of the *California Design* exhibitions (from 1962 to 1976) and their accompanying catalogues. Her marketing savvy increased the profile of the exhibitions, gaining recognition for the dynamic artists who worked in California. Because of what Moore put into these complex exhibition projects, using her tremendous drive, intellectual energy, and boundless imagination, she has left a legacy for scholars as well as the general public to study and appreciate.

The Oakland Museum of California acquired the archives of the *California Design* exhibitions in 1997, thanks to the combined efforts of Moore, Lois Boardman, and Marcia Chamberlain. Boardman, who worked as the program director on the exhibitions (and ultimately headed the California Design nonprofit organization), had the foresight to look after the archives during the twenty years following the exhibitions. Chamberlain, longtime friend of the Oakland Museum's craft collection and former professor of crafts at San Jose State University, recognized the historic importance of the archival materials. When a permanent home was needed, she approached the museum.

In addition to arranging for their transport, Chamberlain worked with Dr. Debra Hansen, San Jose State University School of Library and Information Science, to enlist a graduate student intern to process them. Lori Lindberg earned her master's degree organizing the collection and preparing a finding aid, which is accessible on-line.[1] For Lindberg's expertise and dedication as well as Chamberlain's and Hansen's support, we are deeply grateful.

While using the archives to research an article, Jo Lauria, independent curator and coauthor of this volume, met Suzanne Baizerman, Imogene Gieling Curator of Crafts and Decorative Arts at the Oakland Museum of California, another researcher who appreciated the importance of these materials and was excited by the objects. Together the two of us conceived of a book to celebrate these visionary, vitally important exhibitions and provide a much-needed look at the amazing objects displayed in them. When Chronicle Books editor Alan Rapp heard about the archive collection at the Oakland Museum he urged us to submit a proposal, and we are most grateful for his lively enthusiasm for the project. We also commend Jan Hughes and Bridget Watson for their expert editorial assistance, Tera Killip for shepherding the book's production, and Brett MacFadden for his well-designed and visually exciting graphic treatment of the book.

We would be remiss if we overlooked the numerous other individuals who have added a human dimension to these pages. In addition to Eudorah M. Moore, Lois Boardman, and Marcia Chamberlain, we also thank Bernard Kester, Arthur Espenet Carpenter, John Kapel, Donald Chadwick, Charles Hollis Jones, Gerald McCabe, Arnold Wolf, David Cressey, Elaine Katzer, Sam Jornlin, Adrian Saxe, and Jerry and Evelyn Ackerman for their time and input. To our expert contributing authors, Donald Albrecht and Toni Greenbaum, we extend our sincere appreciation for the incisive and thoughtful essays that have enriched the content of this book.

We had practical help and much encouragement from three individuals, Thomas Frick, Maile Pingel, and Nathalie Senécal. Frick's editorial guidance on the various essays enhanced their structure and style. Pingel, a professional editorial researcher, organized the databases and captions with steadfast attention to every detail. Senécal's background as an architecture historian added a unique perspective to her research and editorial input. We thank them for their invaluable contributions. Finally, it is to the Oakland Museum of California that we owe a huge debt of gratitude for their support and advocacy of this project. Special credit must go to Dennis Power, director, and Philip Linhares, chief curator of the art department, for their insightful decision to ultimately acquire the archives and assure their preservation and proper storage in perpetuity at the museum.

Jo Lauria and Suzanne Baizerman

1. The finding aid can be accessed through the website of the Online Archive of California Finding Aids: http://www.oac.cdlib.org/ (search for "museums," then scan the alphabetical list for "California Design Collection").

Index